Little Traverse Bay, Past and Present

Little Traverse Bay

Past and Present

MICHAEL R. FEDERSPIEL

WITH CONTEMPORARY PHOTOGRAPHS BY REBECCA ZEISS

A Painted Turtle book
Detroit, Michigan

18 17 16 15 14 5 4 3 2 1

ISBN 978-0-8143-3819-3 (cloth) / ISBN 978-0-8143-3820-9 (e-book)
Library of Congress Control Number: 2013950619

Maps at chapter openers courtesy of Clarke Historical Library,
Central Michigan University.

∞

Designed by Brad Norr Design
Typeset by Brad Norr Design
Composed in Centaur, Avenir, and Bellevue

To Mary, Adam, Kate, and Matt,
with thanks for sharing my past,
present, and future

Contents

Acknowledgments

In the movie *Somewhere in Time*, actor Christopher Reeves checks into a room at Mackinac Island's Grand Hotel and wills himself back in time. Once transported, he emerges into a place that lives in both the past and the present. In many ways one can have the same experience today wandering the streets in Petoskey or Harbor Springs or admiring the homes of Harbor Point, Bay View, Wequetonsing, or Roaring Brook. The sepia-toned Little Traverse Bay of 1900 is often still there in plain sight—or perhaps just hidden behind a current façade. Sadly, there are also instances where evidence of the past has simply been destroyed or replaced. Without historical perspective, people see only what is modern in the region and do not realize the extent to which the past is still present. But, hopefully, after turning these pages, they will gain a greater appreciation of what *is* here by understanding what *was* here.

This book would not have been possible without individuals' and institutions' generous support. Central Michigan University's Clarke Historical Library is a starting point for anyone researching northern Michigan. Many images from its collection are used in this book, and its print material provided valuable background information. I thank director Frank Boles and scanning technician Pat Thelan, who are to be congratulated on the work they do to preserve Little Traverse Bay history. Beginning in 2008, Clarke Library staff scanned the entire photo collections—over five thousand images—of the Little Traverse Historical Society and the Harbor Springs Area Historical Society. The Clarke retained digital copies (which are available to researchers there), and the originals were returned to their northern Michigan homes. Having these images preserved and now available digitally was invaluable as this book was being assembled.

The Little Traverse Historical Society has, since 1905, worked to preserve the region's rich history. It maintains a significant archive and operates a museum located in the former Pere Marquette

railroad depot on Petoskey's waterfront. The society is a proud and valuable steward of Little Traverse Bay history, and this book would not have been possible without access to its vast photo archive and its self-published regional history monographs. To support the society and its initiatives, my profits from this work are being donated to the museum's endowment fund at the Petoskey Harbor Springs Area Community Foundation.

Finally, I want to thank Rebecca Zeiss, whose glorious images grace this book's pages. She patiently studied hundreds of old pictures to discover the right angles and places to shoot and then worked magic with her camera. She not only captures what remains (or has been lost), she also reminds us of just how beautiful this region is today. She has somehow managed to be both a documentary photographer and an artist—a very difficult combination. Rebecca's creative vision brings beauty to this book, and I am very fortunate to have her as a collaborator and as a friend.

Michael R. Federspiel

This documentary experience revealed a world to me I would not have entered if it had not been for the opportunities presented to me by the Clarke Historical Library under the direction of Dr. Frank Boles. I wandered in as a graduate student and was caught up in the whirlwind of historic adventure. There I became acquainted with Mike Federspiel, also an active major force at the Clarke, and was invited to join this sleuthing rephotography of Petoskey, Michigan. When I often felt overwhelmed by the magnitude of this task, it was Mike's knowledgeable expertise of our subject that kept me on course in the process of re-vision. The challenges of finding the subject, the light, and the angle were all daunting—especially while dealing with northern Michigan weather. Through all this, my partner, Clint Burhans, was invaluable with his photographic knowledge, advice, and assistance.

Rebecca Zeiss

Introduction
The Making of Modern Little Traverse Bay

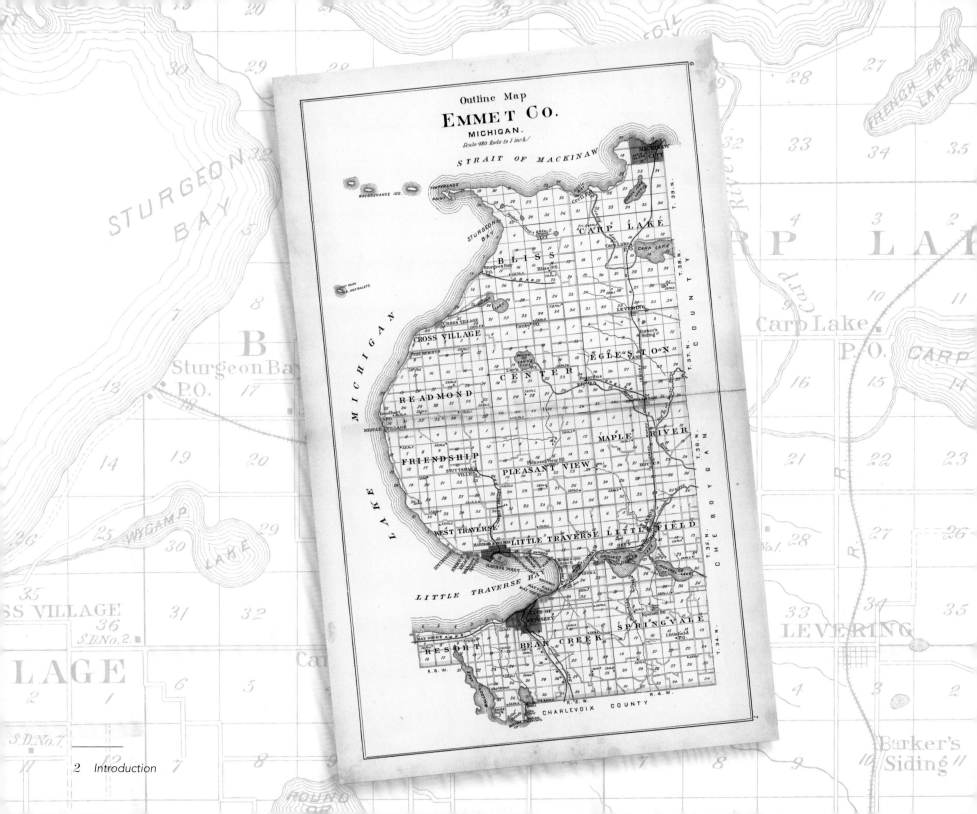

*H*iram O. Rose must have been extremely pleased and excited as he walked Petoskey's bustling streets in 1900. The village was exploding with activity and he was largely responsible for it. Just twenty-five years before, Bear River (as the settlement was known) consisted of only a few white settlers living on the river's west bank and local Native Americans who had for years congregated there. In 1852 Andrew Porter founded a Presbyterian mission and school there, and he had been joined in 1864 by Hazen Ingalls who, with his family, owned a lumber mill on the river. Now the village center had shifted east, and Petoskey had six thousand year-round residents, welcoming at least an additional fifty thousand summer visitors. It boasted fourteen hotels that could together accommodate two thousand guests—and offer them fresh lobster dinners and entertainment provided by the hotels' orchestras. There was also an opera house (where Mark Twain had spoken), three railroad stations constantly filled with passengers and freight, and dozens of businesses catering to people's every need and want. So what had caused this dramatic growth? In fact, it was a combination of local and regional factors that transformed the entire Little Traverse Bay region and created an economy that remains in place today.

Leaders

An important figure in the city's history is its namesake, Ignatius Petoskey (Neyas Pe-to-se-gay). Said to have been born in 1787 to Kes-way-gah, a Native American woman, and Antoine Carré, a French fur trader working for John Jacob Astor at Mackinac Island. Petoskey became a successful fur trader himself and, after living at Middle

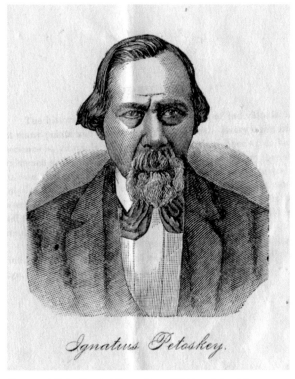

Ignatius Petoskey.

(Courtesy of Clarke Historical Library, Central Michigan University)

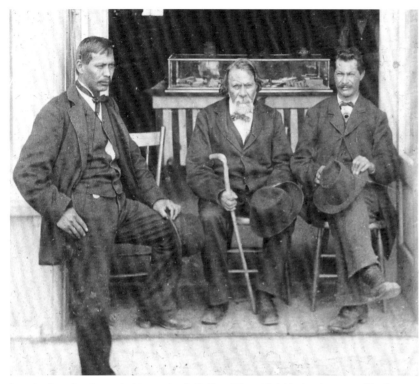

Ignatius Petoskey (*center*) with sons Louis (*left*) and Enos (*right*) in the doorway of Bazil Petoskey's store on Lake Street, 1878. (Courtesy of Little Traverse Historical Society)

family became wealthy. Before his death in 1885 Petoskey, known as "Chief" Petoskey, had given the town its name.

Hiram Obed Rose was another early leader in Petoskey's rapid development. Born in Niagara County, New York, in 1830, he moved as a child to Coldwater, Michigan. In 1852 he joined thousands of other young men in the California gold rush, returning to Michigan with enough money to start a career. His first business

Village and then Little Traverse (Harbor Springs), he built a home at the Bear River's mouth in the 1830s. He acquired land east of the river, using provisions of a treaty between the Native Americans and the U.S. government and his own resources, and before long he and his family owned hundreds of acres. With the arrival of the railroad and hundreds of prospective land buyers (like Hiram Rose), the Petoskey

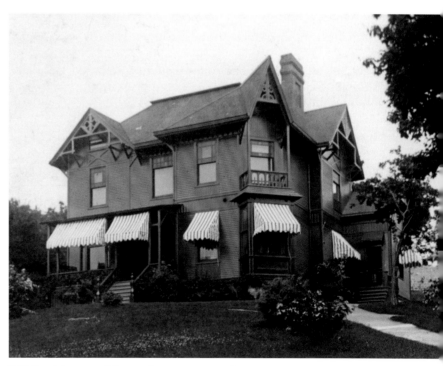

H.O. Rose's home on Arlington Avenue. (Courtesy of Little Traverse Historical Society)

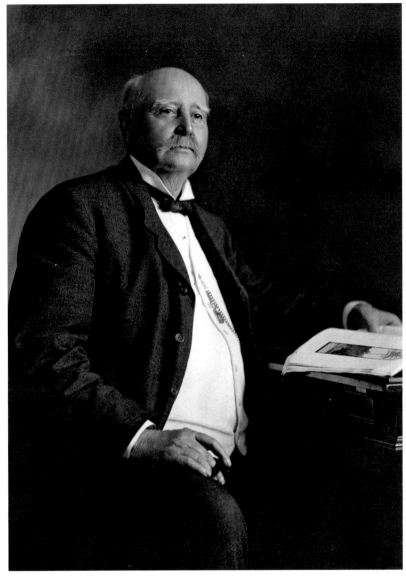

venture was at Northport, where he invested in lumber and a store, eventually constructing a dock and warehouse. From there he moved on to Traverse City and then Charlevoix, where he partnered with Amos Fox in several businesses. Soon his thoughts turned further north—to the limestone cliffs at what is now Petoskey. He knew that there would soon be a rail line running to Little Traverse Bay and that a shrewd businessman could be very successful. In the summer of 1873, Rose relocated, buying two hundred waterfront acres from Ignatius Petoskey and opening a makeshift store in Petoskey's home. He then likely used his influence with the railroad

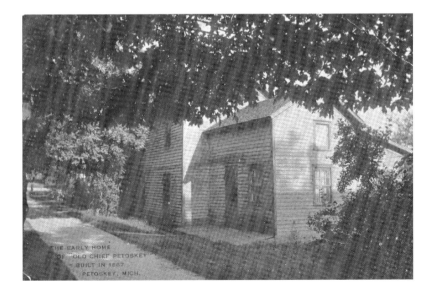

Above: Hiram Obed Rose. (Courtesy of Little Traverse Historical Society)

At right: Ignatius Petoskey's home, Lake Street. (Courtesy of Little Traverse Historical Society)

company to locate the railroad terminal (and therefore, eventually, the city center) east of Bear River rather than west, where Andrew Porter and Hazen Ingalls's small Bear River settlement was. The decision to place the depot on what soon became Lake Street was very advantageous to both Rose and Ignatius Petoskey, who owned most of the adjacent land.

Rose built a beautiful home and became a significant force in Petoskey's early development until his death in 1911. In 1874 he opened a store on Mitchell Street, built a dock, and founded the Michigan Limestone Company. In 1883 he traded property for a 25 percent share in the new luxurious Arlington Hotel, and when the hotel expanded in 1897, he leased additional property and access to the waterfront. In 1892 he gave the Chicago and West Michigan Railroad a right of way that enabled it to build a station and to run tracks on Petoskey's waterfront (conveniently right next to his limestone quarry, thus allowing him to transport his product at a reduced cost). Rose's relationship with the railroads proved beneficial for him, the railroad, and the region's growth. However, neither Ignatius Petoskey nor Hiram Rose could supply the people

and goods necessary to change the region into a bustling settlement and center of tourism. But railroad and steamship companies could—and did.

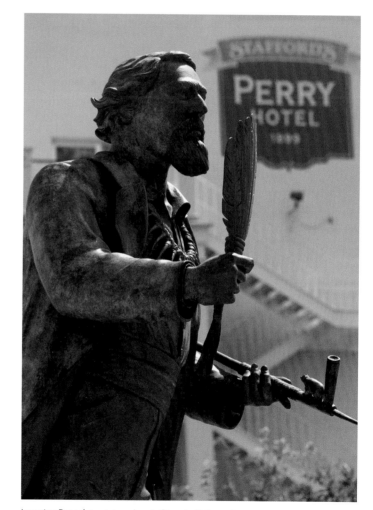

Ignatius Petoskey statue, Lewis Street. (Rebecca Zeiss)

Railroads

In 1856 the U.S. government made millions of acres of federally owned land available to states to encourage the building of railroads and to aid the settlement of previously uninhabited areas. The states receiving these grants would in turn award land to individual companies for construction of rail lines from one specific point to another. The government was accurately anticipating that between 6 and 9 million immigrants and settlers would move to the frontier between 1860 and 1890. In Michigan alone, 160,000 newcomers arrived. The states could encourage these settlers to migrate to certain areas if rail transportation was readily available for them and those goods they would need.

In 1857 the Grand Rapids and Indiana Railroad Company (GR & I) received a 823,204-acre land grant contract to build a line between Grand Rapids and Little Traverse Bay. This provided for enough land to actually lay the line (and thousands of acres left over to sell) and the potential to make significant profits transporting people and freight. Although initially work was slow because of financial difficulties and the Civil War, it began in earnest in 1869.

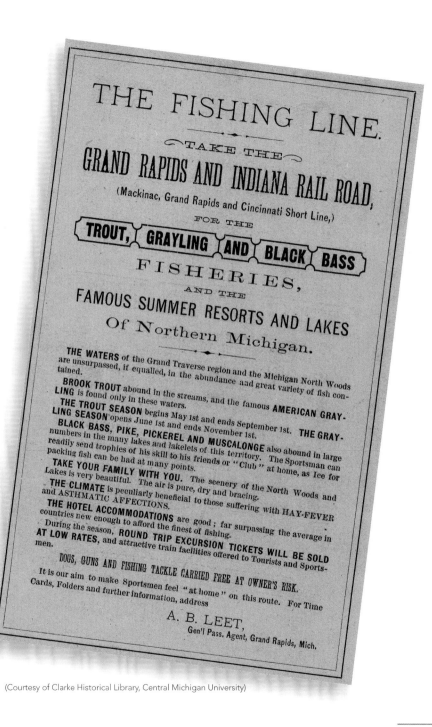

(Courtesy of Clarke Historical Library, Central Michigan University)

The line reached Cadillac by 1871, Petoskey by 1873, and the Straits of Mackinac by 1874.

While it might seem that accepting such "free" land was an easy decision, actually taking on this challenge was quite a risk for the GR & I. It gambled that it could withstand the necessary short-term capital outlay needed to construct the rail lines and eventually make money by hauling goods and people, and also, in this case, by selling

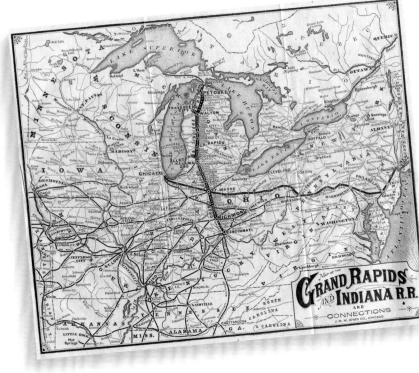

(Courtesy of Clarke Historical Library, Central Michigan University)

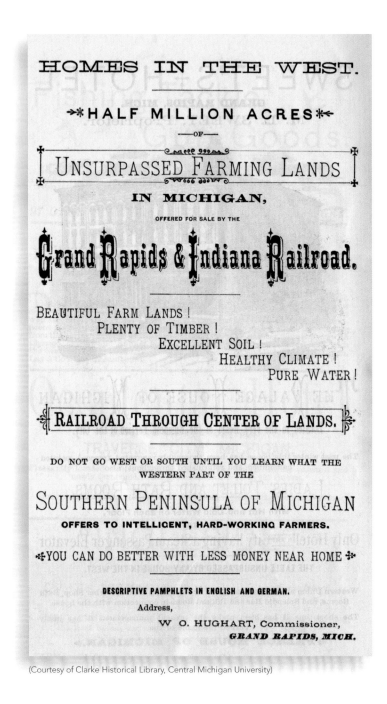

(Courtesy of Clarke Historical Library, Central Michigan University)

excess land. The railroad company knew that the more people who settle and travel, the more goods they need. However, at the beginning, there were very few people where the GR & I was laying track, and the company's directors had to hope that increased population would follow once the lines were completed. To say that the company had faith in the future is an understatement. In hindsight, the numbers suggest it was a worthy risk. In 1868 the GR & I owned only two locomotives and thirty-nine cars, valued at $43,000. By 1900 it had rolling stock worth over $1 million and its assets included sixty-six locomotives and over three thousand cars. Gross earning had grown from $22,767 in 1867 to $2.5 million in 1887.

What H. O. Rose and the Grand Rapids and Indiana Railroad had in common was a desire to increase passenger and freight volume to and from Petoskey. Rose knew his business ventures would prosper as population increased, and once the initial construction work was complete, the GR & I began an aggressive marketing campaign targeting two audiences—settlers and tourists. Traditionally railroads made huge profits selling land (and then supplying those who purchased it). With this in mind,

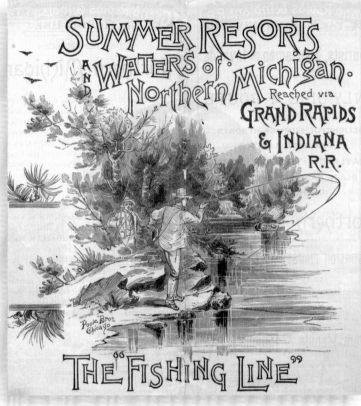

(Courtesy of Clarke Historical Library, Central Michigan University)

the GR & I proactively sought settlers by placing advertisements in national newspapers and by sending agents to Europe. While these efforts did have some success in luring people to settle, they never resulted in the bonanza the railroad desired. Promises of moderate temperatures, fertile soil, and long growing seasons simply proved false, and by the 1880s immigrant farmers largely chose the Great Plains instead.

(Courtesy of Clarke Historical Library, Central Michigan University)

edition contained pen and ink sketches (and later photographs) of northern Michigan scenes along with timetables, rates, and information on lodging and tourist attractions. These booklets were intended both to lure people to the north and, once they were there, to guide them to railroad-endorsed sites. While information for settlers was also included, increasingly the publications targeted those seeking a healthy environment, those looking for sport and recreational opportunities, and those who simply sought

(Author's collection)

This shifted the GR & I's focus away from settlers and exclusively to middle- and upper-class tourists. Newspaper advertisements appeared in major papers throughout the Midwest, and the company began referring to itself as "The Fishing Line." Between 1877 and 1895 it also published nine paperback booklets available free of charge at railroad stations, hotels, and resorts. Each

comfortable leisurely experiences. Hay fever sufferers, it was claimed, would find immediate relief in the cool summer nights, and indeed the Western (U.S.) Hay Fever Association established its headquarters in Petoskey in 1882. Sportsmen took advantage of the streams, and the State of Michigan did its part to encourage tourism by stocking waters with 14 million whitefish and four hundred thousand lake trout in 1879 alone.

Local merchants followed the railroad company's lead. Businesses focused on tourism, and even merchants who met the needs of the year-round population knew that their livelihoods depended on a constant flow of visitors—and on convincing people to make the region their home. More people meant more needs, and more needs meant more revenue.

(Courtesy of Clarke Historical Library, Central Michigan University)

(Author's collection)

Steamships

Lest one think that the railroad companies were solely responsible for encouraging and transporting these long-distance tourists, it should be remembered that Great Lakes passenger steamship companies also played an important role in bringing people to the Little Traverse Bay region. There was a long tradition of Great Lakes water commerce, beginning with the Native Americans centuries earlier. But with the post–Civil War growth of tourism and the

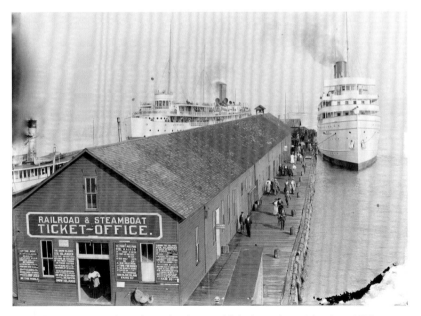

Steamships *Juniata* and *North Land* at the Arnold dock, Mackinac Island, ca. 1905.

(Courtesy of Library of Congress)

transition from sail to steam power, passenger service increased significantly: by the 1880s there were over 150 Great Lakes passenger ships. These steamship companies competed directly with railroads for the tourist trade and used similar techniques to entice passengers. Advertisements regularly appeared in midwestern

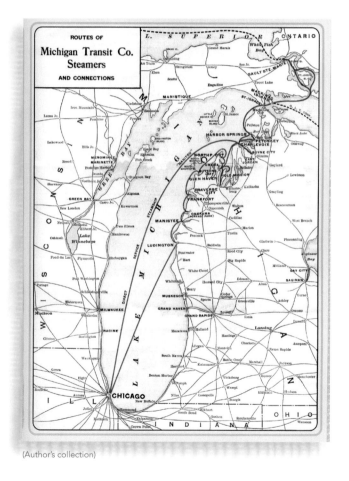

(Author's collection)

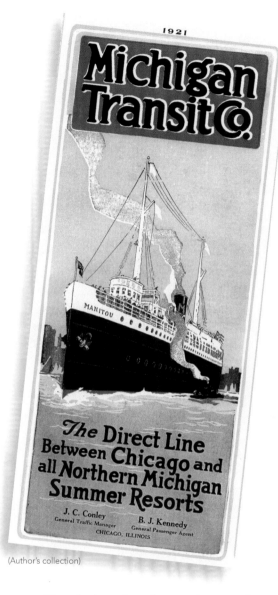

(Author's collection)

newspapers extolling the benefits of steamship travel. Travel on ships such as the *Manitou* was known for great comfort, and the Chicago to Mackinac Island run was particularly popular.

Local Excursions

Hiawatha Pageant

Railroad and steamship companies not only promoted travel but also endorsed selected local activities. To address visitors' curiosity about Native Americans, the GR & I sponsored the Hiawatha Pageant at Wa-Ya-Ga-Mug at nearby Round Lake. Trains took guests a few miles east of Petoskey to Round Lake, where the

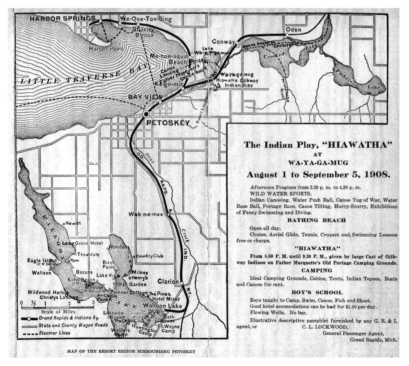

The Indian Play, "HIAWATHA"
AT
WA-YA-GA-MUG
August 1 to September 5, 1908.

Afternoon Program from 2.30 p. m. to 4.30 p.m.
WILD WATER SPORTS.
Indian Canoeing, Water Push Ball, Canoe Tug of War, Water Base Ball, Portage Race, Canoe Tilting, Hurry-Scurry, Exhibitions of Fancy Swimming and Diving.

BATHING BEACH
Open all day.
Chutes, Aerial Glide, Tennis, Croquet and, Swimming Lessons free or charge.

"HIAWATHA"
From 8.00 P. M. until 9.30 P. M., given by large Cast of Ojibway Indians on Father Marquette's Old Portage Camping Grounds.

CAMPING
Ideal Camping Grounds, Cabins, Tents, Indian Tepees, Boats and Canoes for rent.

BOY'S SCHOOL
Boys taught to Camp, Swim, Canoe, Fish and Shoot.
Good hotel accomodations can be had for $1.50 per day.
Flowing Wells. No bar.
Illustrative descriptive pamphlet furnished by any G. R. & I.
agent, or C. L. LOCKWOOD,
 General Passenger Agent,
 Grand Rapids, Mich.

MAP OF THE RESORT REGION SURROUNDING PETOSKEY

(Courtesy of Little Traverse Historical Society)

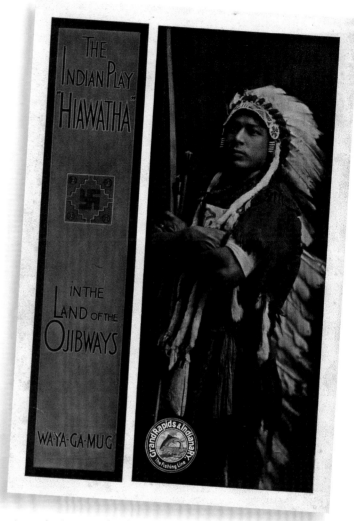

Libretto for the *Hiawatha* play, 1902. (Courtesy of Clarke Historical Library, Central Michigan University)

GR & I had constructed a cluster of buildings where visitors could watch Native American crafts being made (and then buy them), enjoy refreshments, swim, and spend time with "Indian guides"

canoeing or fishing. But the real draw was the actual pageant, where Native Americans recited and acted out Longfellow's poem *Hiawatha* to an audience of tourists seated on bleachers. Guests could even purchase a libretto containing the poem and photos of the actors taken by Grace Chandler Horn.

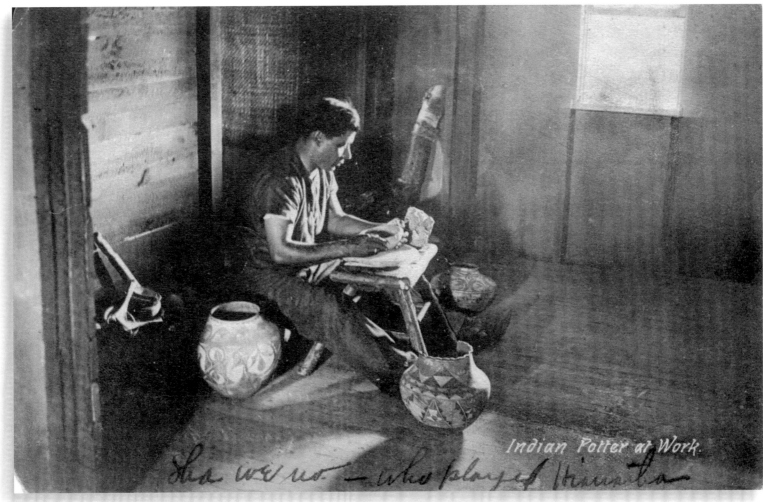

Indian Potter at Work.

(Courtesy of Little Traverse Historical Society)

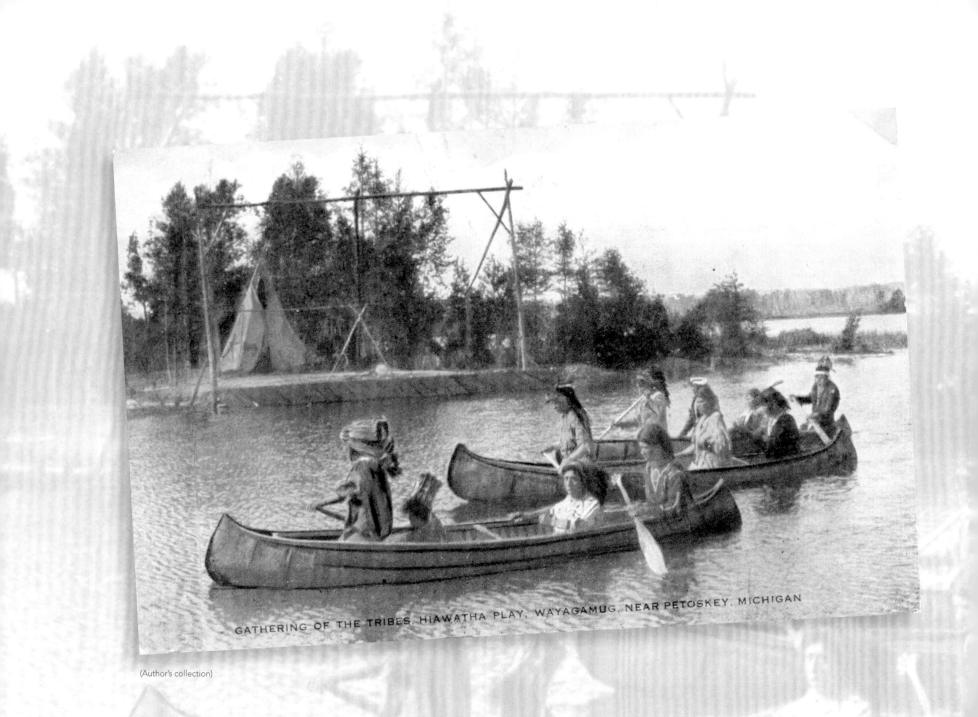

GATHERING OF THE TRIBES, HIAWATHA PLAY, WAYAGAMUG, NEAR PETOSKEY, MICHIGAN

(Author's collection)

Inland Route

The railroads also transported tourists further east, to Crooked Lake, where they could explore beyond the Little Traverse Bay region on what was known as the Inland Route. At Crooked Lake, participants boarded small steamships and could travel over forty miles north on winding rivers and across three different large inland lakes, ending up as far north as Cheboygan or Mackinac Island. Most did not go that full distance, opting instead for day trips down

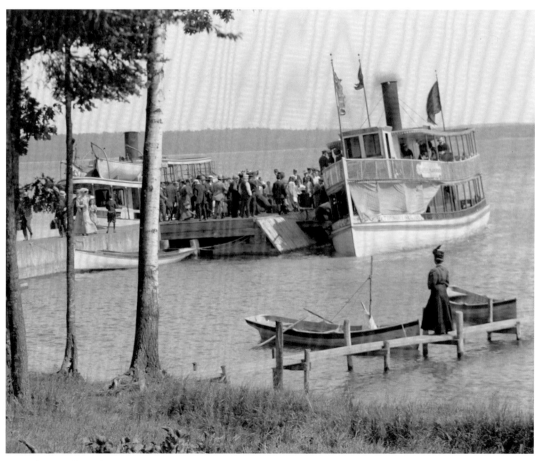

Topinabee, Mullet Lake, ca. 1905. (Courtesy of Library of Congress)

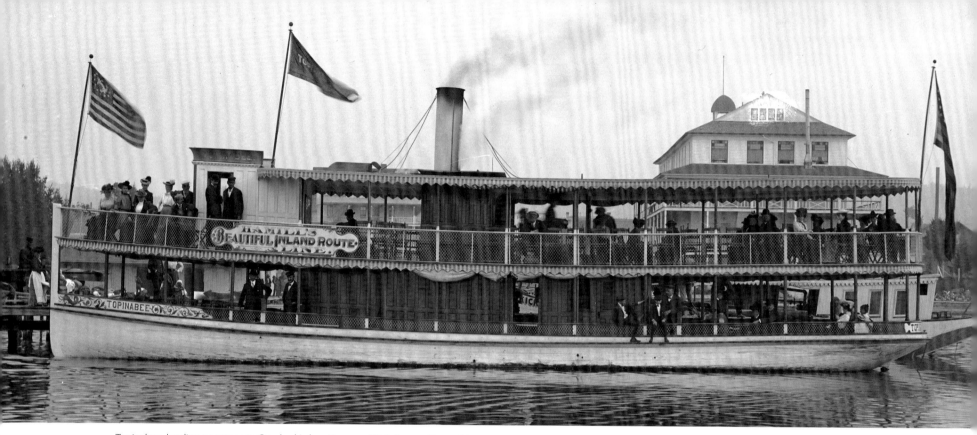

Topinabee, loading passengers, Crooked Lake. (Courtesy of Little Traverse Historical Society)

the Crooked River to Burt Lake and then down the Indian River to Mullet Lake, where they might have a meal before returning to Crooked Lake. Those wishing to extend their visits could stay at one of the resort hotels that dotted the lakes and rivers.

The combined efforts of all of these forces changed the region forever. Not only did Petoskey and Harbor Springs grow, but because of the ease of transportation and natural beauty, enclaves such as Bay View, Wequetonsing, Roaring Brook, and Harbor Point sprang up around the bay. Briefly staying "day tourists" were joined by seasonal residents, who year after year returned to cottages in one of the associations or on the shore of one of the region's many lakes and rivers. Those initial pioneers have been succeeded by new generations who continue to enjoy family traditions at the same locations.

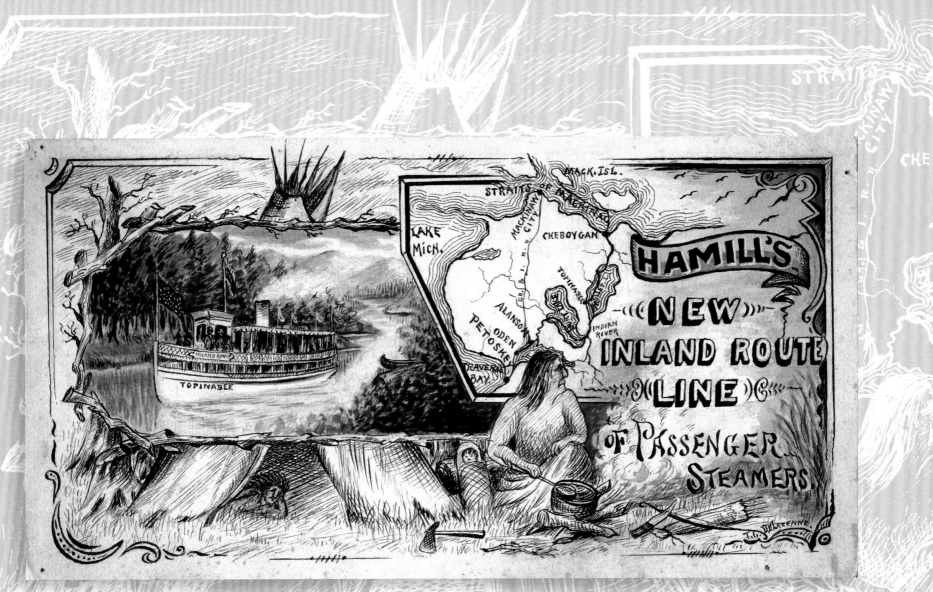

Advertisement for the Inland Route. (Courtesy of Little Traverse Historical Society)

What would Hiram Rose think about Petoskey today? While the clothing, technology, and transportation methods are all new, there is much he would still recognize. The local economy still depends on tourism, and "million-dollar sunsets" are still enjoyed (most nights) by locals and tourists alike. Rose would also recognize many buildings and street scenes from his time, though they may have been altered or repurposed. Undoubtedly he would be pleased that his vision has been realized.

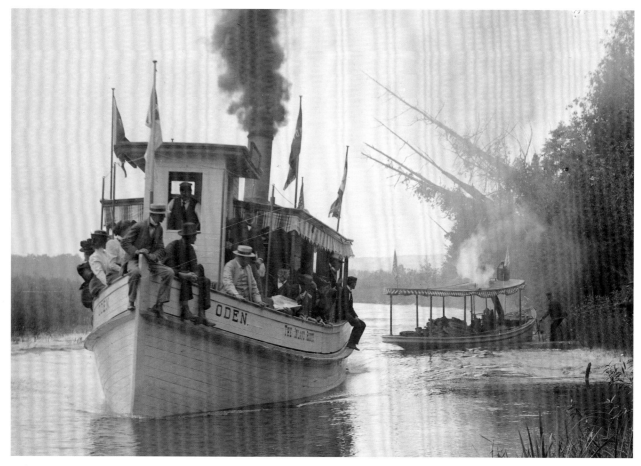

Oden entering the Crooked River from Crooked Lake. (Courtesy of Little Traverse Historical Society)

Petoskey

Petoskey, Michigan, Oct. 30, 1882

Dear Friend Della,

I believe I have not written to you since I came to my new home. It is a year now since we came and it seems very much like home. There is said to be nearly two thousand inhabitants and the place is growing all the time. We have a house and lot situated on a little rise of ground so that we have a view of the whole town and the bay and the county seat four miles across the bay. There is a natural harbor there and for that reason, the place is called "Harbor Springs." I have never lived in so sightly a place before. It is just like looking at a beautiful landscape painting only more beautiful, of course, because it is real nature. The town is full of tourists from about July until the last of September. Camp meetings are held here every year. It is nice to see the steamers on the bay. There are several that come only once a week and four or five that are here everyday. Besides there is a little ferry steamer running back and forth from the Harbor to this place. The railroad runs now through to the straits of Mackinac. . . . It is only seven years since the town was first started. It was inhabited by a tribe of Indians called the Petoskeys and it is named after them. The old chief is still alive. He is about an hundred years old. Three of his sons are near neighbors to us [and] live in good houses furnished nice and they dress well for they are all rich. One of the sons is a merchant. Land can be bought here from two to two hundred dollars an acre. The price depends on the situation and amount of clearing. We have not bought a farm yet but intend to as soon as we can.

Mary Denton, Petoskey, Mich. Box 262

Today Petoskey is a well-established community with a thriving economy, but when Mary Denton wrote this letter, it was just discovering what it would become. Prior to the railroad's arrival in 1873, the area had a significant Native American population and only a handful of white settlers. Provisions of the Treaty of 1855 promised individual Native Americans the right to property, but in April 1875 non-Natives secured the legal right to buy government holdings, and land speculators, Civil War veterans, and fortune seekers flooded the area—and all were buying. When it became possible for whites to buy government land, over 800 homestead claims were filed within the first three days. At that time, Petoskey's population was only 150, and these new arrivals overwhelmed the community's ability to provide essentials like housing and food, meaning the winters of 1875 and 1876 were filled with hardships. But as the years went by, the economy righted itself and soon the town was filled with the stores, churches, and schools that

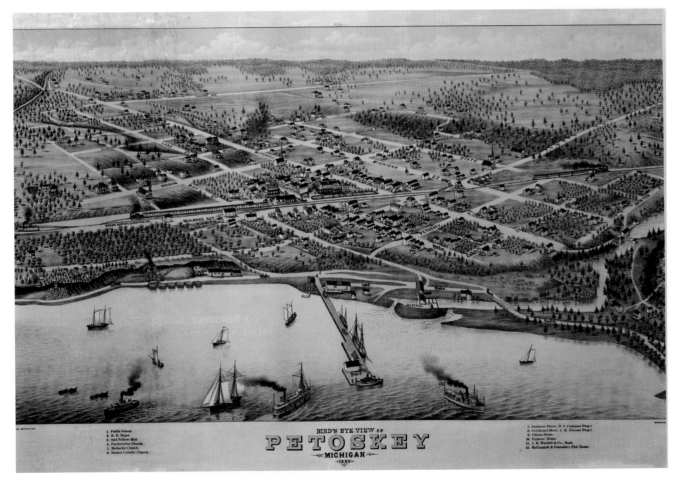

BIRD'S EYE VIEW OF
PETOSKEY
MICHIGAN
1880

(Courtesy of Clarke Historical Library, Central Michigan University)

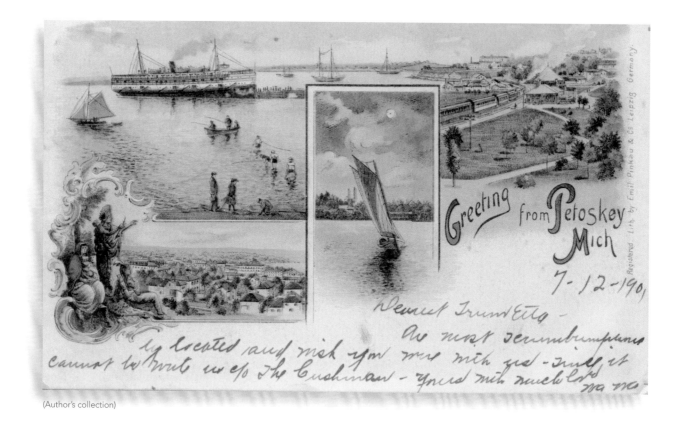

(Author's collection)

the year-round residents needed. But for most Native Americans this influx of outsiders had a devastating effect. They often lost legal rights to property promised to them and were denied access to the land and way of life their ancestors had enjoyed for centuries.

By the 1880s a largely tourist economy emerged, supplemented by limestone work and wood-related mills. By 1892 two railroad companies ran regular trains to and from Petoskey, and steamships made regular stops at the pier. Summer visitors could enjoy first-class accommodations and food, with music performed throughout the day and night by professional orchestras. Those on more modest budgets could take advantage of friendly boardinghouses, restaurants, bars, and free sunsets.

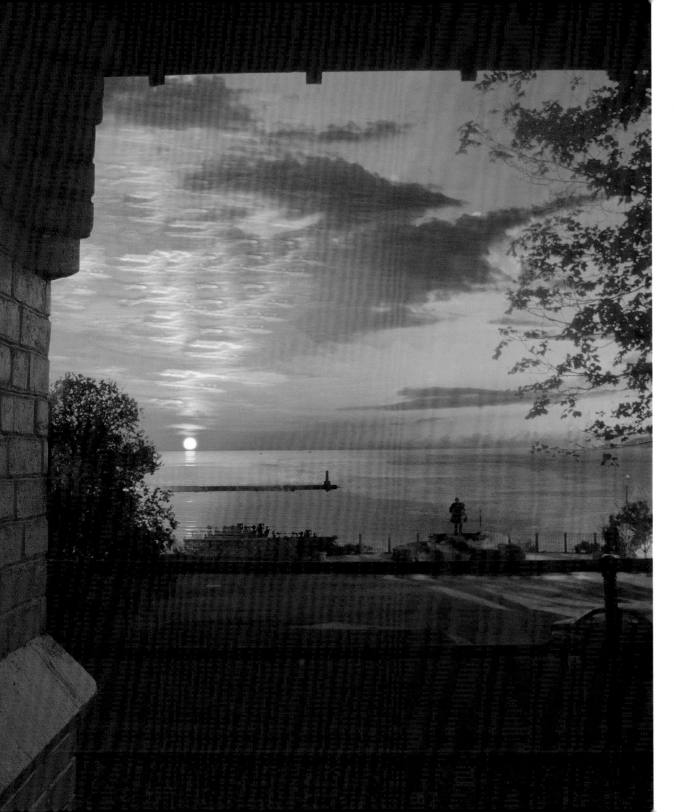

(Rebecca Zeiss)

This transition to a tourist-based economy was the result of a concerted effort on the part of large railroad and steamship companies as well as local businesses. Although visitors could still sometimes overwhelm the local population, they were increasingly the city's financial lifeblood. This relationship between town and tourist remains the same today, as that tourist-based economy continues.

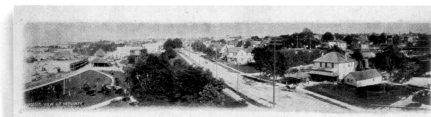

BIRD'S-EYE VIEW OF PETOSKEY, MICH.

ODE TO PETOSKEY

BATTLE HYMN OF NORTHERN MICHIGAN

My country, 'tis of thee,
Sweet land of Petoskey
 Wequetonsing;
Land where hay fever died,
Land of the tourist's pride,
From the Bay View side
 Let anthems ring.

Let warwhoops swell the breeze,
Let every person squeeze
 The timid throng;
Let vender's tongues awake,
Let all that sell partake,
Let "swells" their wallets break—
 The sound prolong.

(Author's collection)

The Petoskey Resort MARCH and Two Step

SAGINAW, MICH. E. S.
PUBLISHED BY
ROCCO PAVESE
COPIES FOR SALE AT ALL MUSIC STORES
Copyright, 1902, by Rocco Pavese.

50¢

(Author's collection)

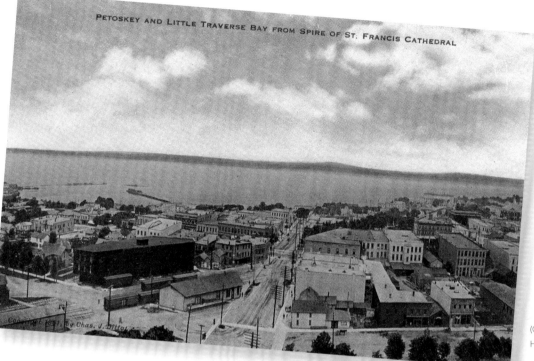

PETOSKEY AND LITTLE TRAVERSE BAY FROM SPIRE OF ST. FRANCIS CATHEDRAL

(Courtesy of Little Traverse Historical Society)

Throned on a noble amphitheatre of hills, upon the south shore of a beautiful bay five miles broad and nine deep, environed all the way around by broken ranges of lofty heights, Petoskey is unrivaled for the beauty of its outlook, each street and block having its own peculiar view, for its health-inspiring purity of atmosphere, and for its wide fame as a popular summer resort. Its streets and homes overlook the entire bay and a succession of famous summer resort villages along the water's edge clear around the bay. . . . Petoskey and these tributary resorts already attract from 100,000 to 150,000 summer visitors from all parts of the American Continent, and the number is yearly increasing. Petoskey is traversed by the Grand Rapids and Indiana and the Chicago and West Michigan railways and is touched at by all the great Northern lines of lake steamers, this giving easy and speedy communication with all parts of the continent. . . . Such is Petoskey, the most beautiful and popular summer resort in the northwest, and the Mecca of hay fever sufferers from all parts of the United States, who here find instant and absolute relief.

George Strang, *Petoskey and Little Traverse Bay*, 1895, Central Michigan

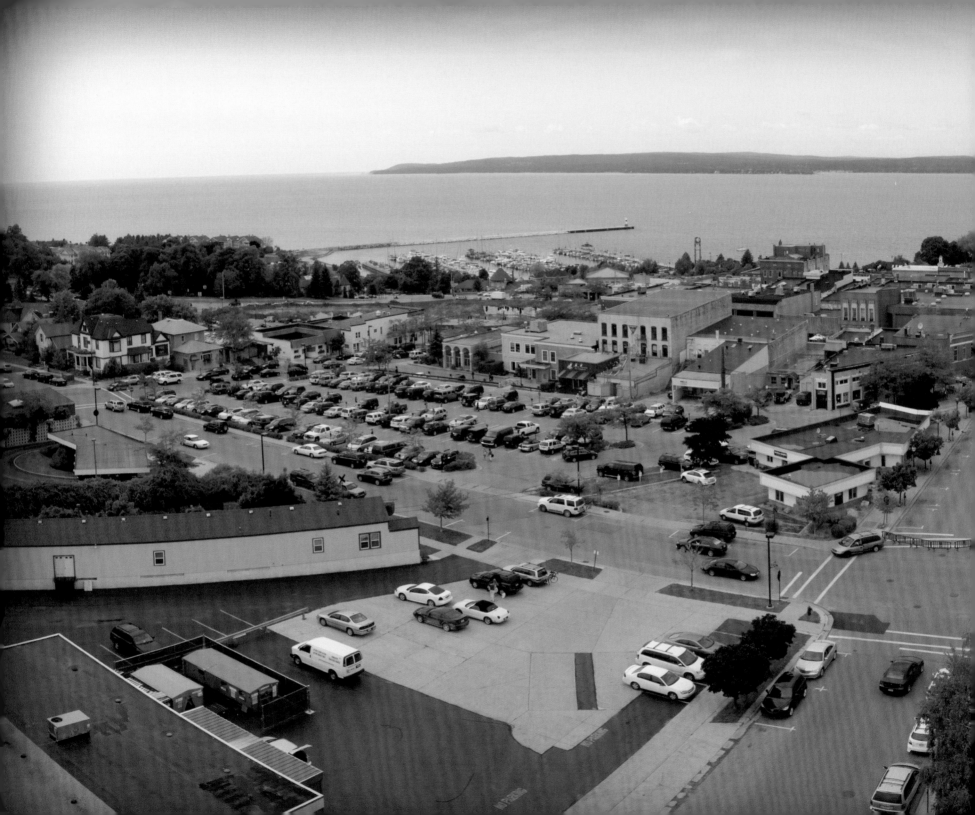

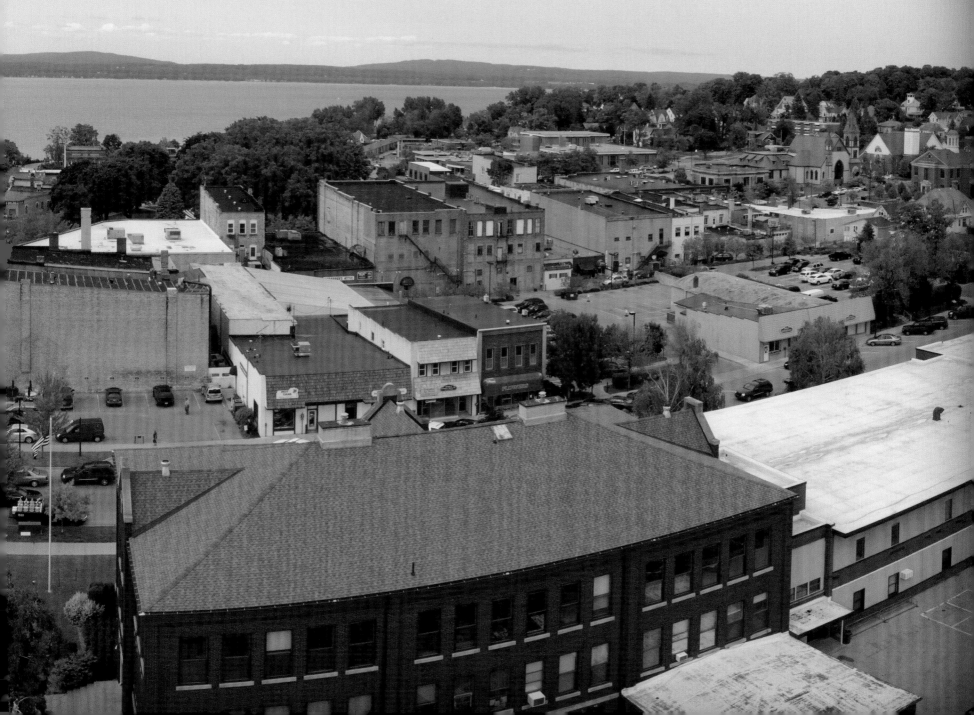

Railroads

Today, especially in the summer, cars rule the Little Traverse Bay region, bringing people from far away and then allowing them to travel locally to shop and to visit attractions and friends. But a century ago these requirements were efficiently met by the railroads. Two former rail depots remain in Petoskey to remind visitors of that transportation era long past. One is now a history museum and the other a commercial mall. While the buildings' exteriors have changed little, gone are the hissing steam engines, the billowing cinder-filled smoke, and the flurry of activity associated with arrivals and departures. But with a little imagination and information, it's easy to see and appreciate the railroads' impact here.

The Grand Rapids and Indiana

Beginning with the GR & I's first train in 1873, the railroad's influence was quickly felt in Petoskey. Connected for the first time with the rest of the state and country, with goods and people able to reach the area relatively cheaply, Petoskey soon found itself in the midst of an economic boom. The GR & I knew that if it was to recoup its investment, it needed to continue increasing both passenger and freight volumes. Grand Rapids, Michigan's second-largest city in 1880, with a population of forty thousand, was 190 miles due south and would always be significant for passengers and freight, but GR & I officials decided a larger regional approach was needed. Chicago, another 181 miles beyond Grand Rapids, was a logical target audience: many city residents must long for a convenient and comfortable escape from hot city summers. But Chicago was not the only long-distance city connected to Little Traverse Bay. By 1903 the railroad's marketing campaign extended to the entire Midwest (including Louisville, St. Louis, and Cincinnati), from which comfortable sleeper-car trains began operating.

GR& I Main Stations

Over the years GR & I passengers would use three different main stations in two different locations in Petoskey. The first of these was completed by spring 1874, and M .F. Quaintance was appointed agent. At the start, a daily passenger train pulled into that station, and three times a week freight trains arrived. Those first trains were

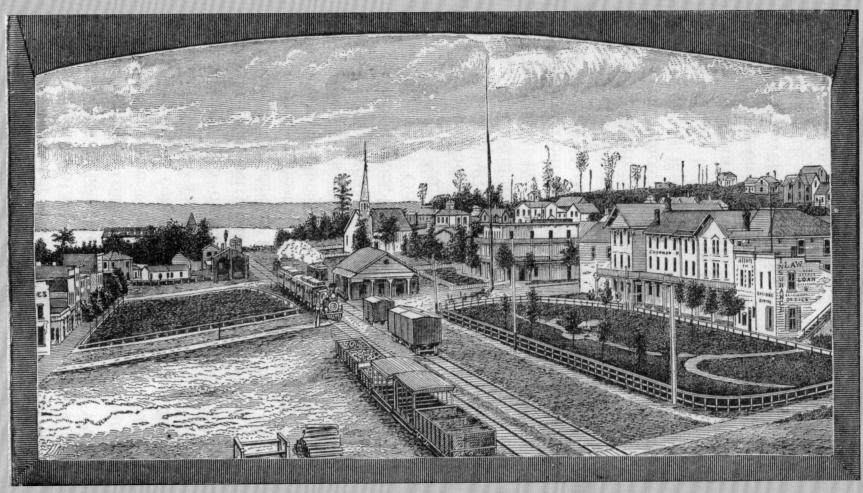

Sketch of Petoskey's first depot. (Courtesy of Clarke Historical Library, Central Michigan University)

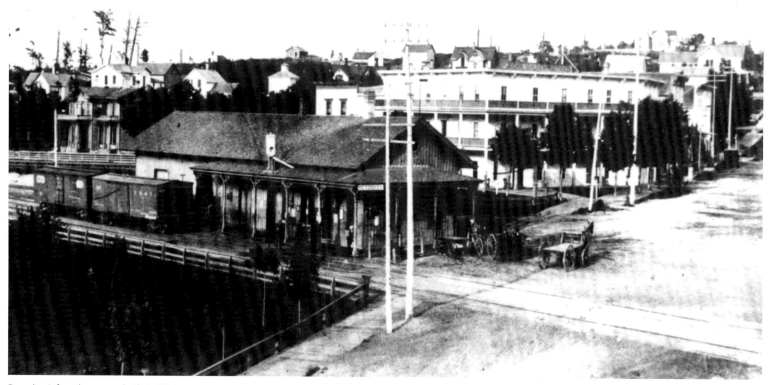

Petoskey's first depot was built in 1874. (Courtesy of Little Traverse Historical Society)

slow, though the twenty-mile-an-hour speed was not unusual for the time. In the earliest years the Cincinnati-Petoskey route took a full twenty-four hours and had fifty-three scheduled stops—not counting the numerous unscheduled ones for water and fuel—but by 1884 train speed had doubled and there were significant improvements to the lines. By 1898 passengers, who paid $14.85, traveled the full 371 miles from Chicago to Petoskey in only twelve hours.

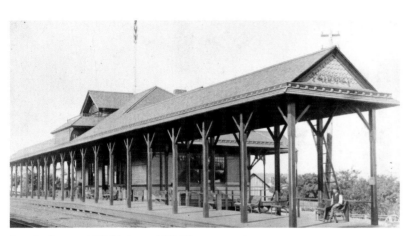

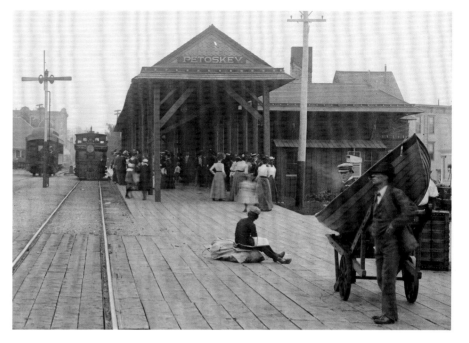

Petoskey's second GR & I depot, 1896–99. (Courtesy of Little Traverse Historical Society, Library of Congress)

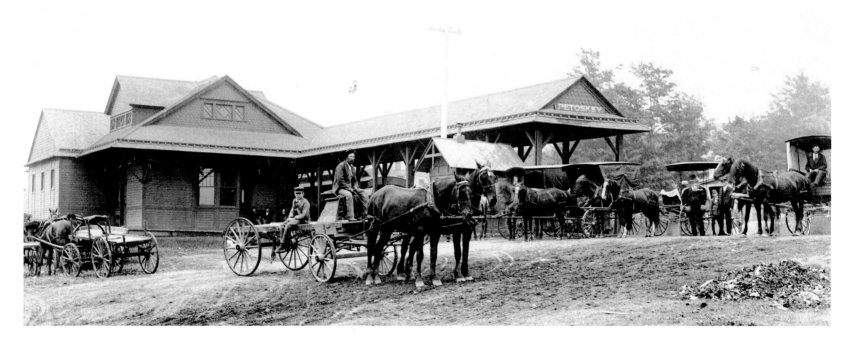

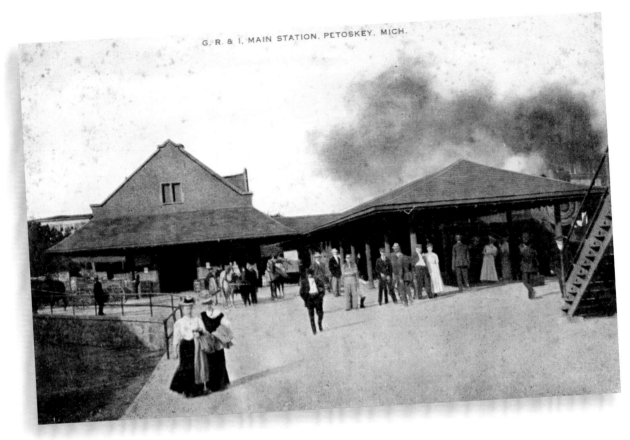

G. R. & I. MAIN STATION, PETOSKEY, MICH.

Above and right: The third and final main passenger terminal for the Grand Rapids and Indiana, later the Pennsylvania Railroad Company. (Author's collection; courtesy of Little Traverse Historical Society; courtesy of Library of Congress)

Another improvement: the GR&I Railroad, not content with the ordinary handsome sleeping coaches, now has added to these a car for sleeping purposes solely, of a most unusual and convenient pattern. It has been constructed especially for the benefit of parties who visit Petoskey and vicinity and do not wish to remain in a north woods hotel overnight. The car is a sort of miniature hotel, and in its several compartments you can sleep, cook, or visit, according to taste. Nothing could be more convenient and tourists should bear that fact in mind.

Emmet County Democrat, July 16, 1875

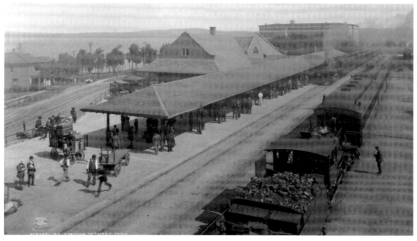

As passenger traffic increased, a larger station was needed. Built in 1896 at the corner of Bay and Lewis streets, the new building had a spacious lobby, room for freight and baggage, and a wide covered platform to protect passengers from the elements. This station remained active until it burned in 1899 and was replaced with the building that still stands today. That one-story station, designed by D. H. Burnham of Chicago, cost $22,000 and was 33 feet by 105 feet. In addition to regular runs, special excursion trains were organized and publicized. Arriving from all over the Midwest, these were very popular with city residents looking to escape north for a short respite, and the trains' arrival at the station typically caused quite a scene.

THROUGH TRAINS
AUGUST, 1908.
SOUTH-BOUND

	No. 6 Except Sunday	No. 4 "Northland Limited" Daily	No. 18 Daily	No. 2 Except Saturday
Lv Mackinac Island	6.45 am	12.00 noon	3.35 pm	8.45 pm
Lv Mackinaw City	7.40 am	12.55 pm	4.35 pm	10.10 pm
Lv Harbor Springs	8.30 am	2.25 pm	5.30 pm	10.30 pm
Lv. Bay View	9.03 am	2.46 pm	5.48 pm	11.27 pm
Lv. Walloon Lake	7.20 am	1.55 pm	4.50 pm	8.00 pm
Lv Petoskey	9.15 am	2.55 pm	6.00 pm	11.35 pm
Ar. Traverse City	1.10 pm	v7.30 pm	------	------
Ar. Cadillac	12.55 pm	6.10 pm	9.20 pm	†2.50 am
Ar. Reed City	2.17 pm	7.02 pm	10.14 pm	4.00 am
Ar. Detroit ____ P.M.	9.30 pm			
Ar Big Rapids	2.45 pm	7.27 pm	10.37 pm	4.30 am
Ar. Grand Rapids	4.55 pm	9.10 pm	12.20 am	6.35 am
Ar Muskegon	7.20 pm			
Ar Detroit ____ G.T.				8.55 am
Ar. Detroit ____ M.C.	10.30 pm	7.15 am		11.30 am
Ar. Detroit ____ P.M.	10.05 pm			12.25 pm
Ar. Kalamazoo			6.00 am	11.55 am
Ar. Chicago ____ M.C.	7.20 pm	10.40 pm	2.00 am	8.45 am
Ar. Ft. Wayne			7 15 am	12.35 pm
Ar. Richmond	10.50 pm	1.35 am		12.01 nn
Ar. Cincinnati Penna.		4.40 am		3.35 pm
Ar. Indianapolis "		7.20 am		5.55 pm
Ar. Louisville "		6.55 am		
Ar St. Louis ____ Van.		10.30 am		
Ar St. Louis ____ I.C.		1.53 pm		
Ar Pittsburgh Penna.			6.02 pm	
	8.15 am	5.05 pm		8 10 pm

v On Sundays at 6.25 p.m. † Except Sunday.

No. 4. "The Northland Limited"—Parlor car to Grand Rapids except Saturday. Sleeping cars to Cincianati, Indianapolis, Louisville, St. Louis. Dining car to Grand Rapids daily.

No. 2—Sleeping cars to Grand Rapids and Cincinnati. Buffet parlor car Grand Rapids to Chicago.

No. 6—Parlor car to Grand Rapids and Grand Rapids to Fort Wayne.

No. 18—Sleeping cars to Chicago daily, to St. Louis via Chicago and Illinois Central R. R. Except Satuday. Dining car to Cadillac.

Train schedule showing connections, 1908.
(Courtesy of Little Traverse Historical Society)

etoskey had a full thousand added to her floating population yesterday by the arrival of the excursion of the GR&I railroad. The regular 5:50 morning train brought about 300 from Cincinnati, Indianapolis, Piqua, and Dayton . . . but the real crowd came last night on the special train from Detroit . . . there were 12 coaches, all filled with tired excursionists . . . about 600 in number. . . . The GR&I depot and platforms were a surging mass of humanity for an hour, there being hundreds of Petoskey citizens there, either to meet friends or to gratify their desire to see the site. The hundreds of excursionists soon were distributed among various hotels and restaurants were kept busy until midnight caring for the hungry.

Petoskey Record, August 29, 1895

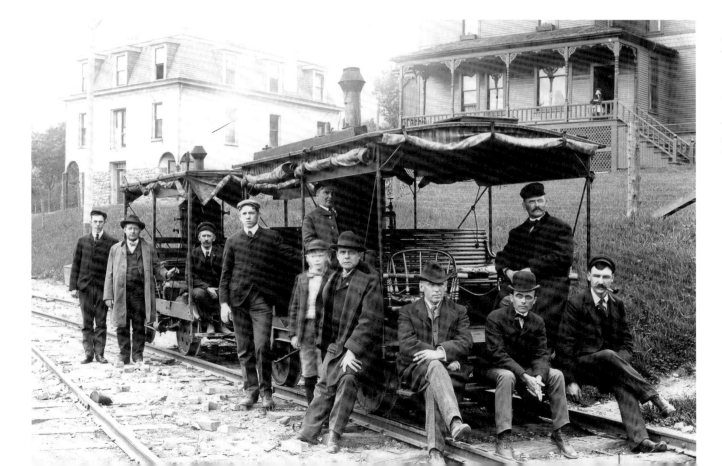

Road service and inspection crew, 1905. Picture taken from the GR & I station facing Division Street. Included are M. F. Quaintance (Petoskey agent, seated front, far left) and Ben Hudson (superintendent of the Northern GR & I Division, seated, front center).
(Courtesy of Little Traverse Historical Society)

(*Above and right:* Rebecca Zeiss)

The handsome new passenger station that has been completed at Petoskey is commensurate with the business passing through it each year. The new station building is one of the most complete and artistic of any of the railway stations in the country. The main portion is 105 feet long, and the platform, which is covered, extends 312 feet along the track. The building is made of brown vitrified bricks with sandstone trimmings, and the interior is finished in white enamel brick with English oak woodwork.

Grand Rapids & Indiana Railway Company, *Michigan in Summer*, 1904

Suburban "Dummy" Station

Initially, bringing guests from far away was the GR & I's single focus, but soon the need for a regional transportation network was obvious. This began when the founders of Bay View were promised a rail connection between their campground and Petoskey. This was accomplished by 1875, when H. O. Rose purchased a trolley from New York City and had wooden rails installed. The trolley coasted downhill to Bay View and then a horse or mule pulled it back to

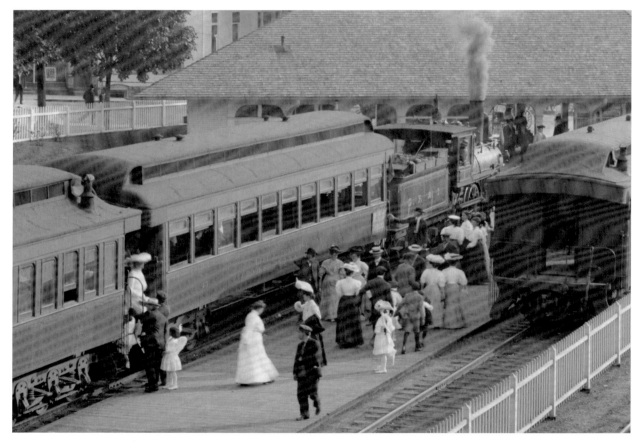

Passengers disembarking from a train at the suburban station. The Cushman Hotel is in the background.
(Courtesy of Library of Congress)

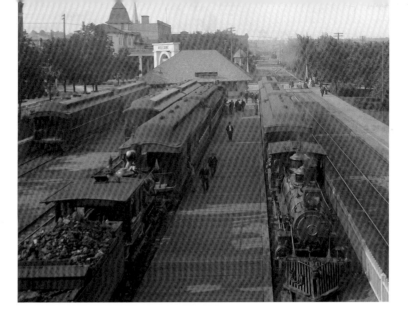

The suburban train platforms were once a site of great activity.
Today there is little evidence of that.
(Courtesy of Library of Congress; Rebecca Zeiss)

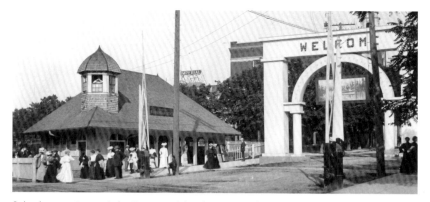

Suburban station on Lake Street and that location today. (Courtesy of Little Traverse Historical Society; Rebecca Zeiss)

Petoskey. This service was a great convenience, and as other resorts and associations sprang up around the bay and on nearby inland lakes, the GR & I began what became an extensive local service to complement its long-haul trains. By 1882 rails were in place between Petoskey and Little Traverse (Harbor Springs), and four trains a day ran between them. This service expanded and served those staying at Walloon Lake to the south and Crooked Lake to the north.

These regional trains were smaller than the trains that arrived from far away and were locally referred to as suburban or "dummy" trains. Both comfortable and convenient, they typically consisted of a locomotive and two or three coaches (one of which was often a baggage car). In her memoir *In the Wake of the Topinabee*, Arline Browne describes the back-to-back gray-painted wooden benches with metal frames attached to the red floor and a conductor whose responsibility it was to keep the cars clean. He would also check tickets, which were typically bound into booklets rather than printed

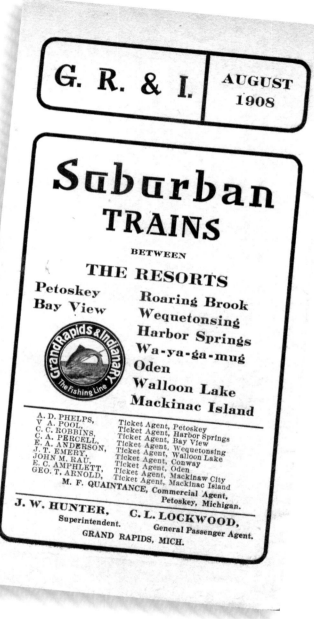

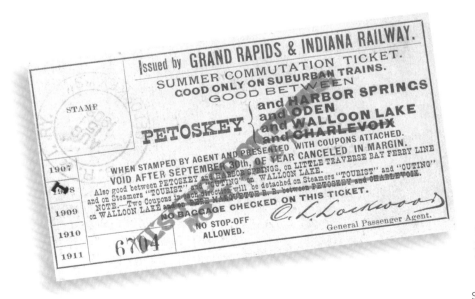

Suburban train schedule and ticket, 1908. (Courtesy of Little Traverse Historical Society)

The first trolley between Bay View and Petoskey. (Courtesy of Little Traverse Historical Society)

individually. It's easy to imagine groups of people taking the train to Petoskey and returning with overstuffed bags from their shopping expeditions, making walking down the aisle difficult. The dummy trains (allegedly so named because they didn't really go anywhere— just back and forth) were very popular and enabled the unification of the distant locales of the region. To gain an idea of how popular these were, one has only to look at statistics from 1909. That year, at peak times, it was common for six thousand people per day to travel on these local trains. During summer, trains ran between Petoskey and Harbor Springs every fifteen minutes and almost as

frequently out to the lakes. Indeed, by the turn of the twentieth century, Michigan's second-largest local transportation network—second only to Detroit in number of passengers—was the one around Little Traverse Bay.

In 1900 a seasonal suburban depot was constructed on the original GR & I station's site on Lake Street and it became a summer social and transportation hub. Often people arriving at the main station needed to transfer to the suburban depot, and porters with

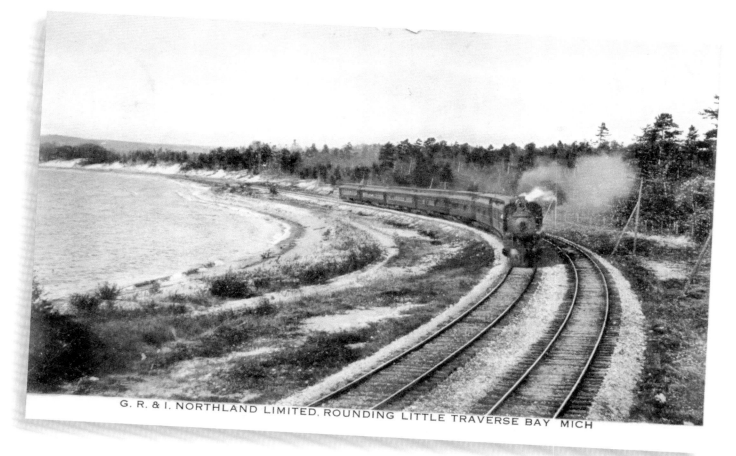

G. R. & I. NORTHLAND LIMITED, ROUNDING LITTLE TRAVERSE BAY MICH

Trains around Little Traverse Bay made travel quick and cheap. (Author's collection)

carts stood ready to assist them with their luggage. Given the high volume of train traffic, a steel crosswalk was constructed across Bay Street in front of what today is the Perry Hotel, making it safe and quick for people to cross from one side of the tracks to the other.

It is difficult today to comprehend the sheer volume of rail traffic in Petoskey between the long-haul and local trains. A local source claimed 13,000 trains passed by the Petoskey rail station between June 25 and September 30, 1906. That means an average

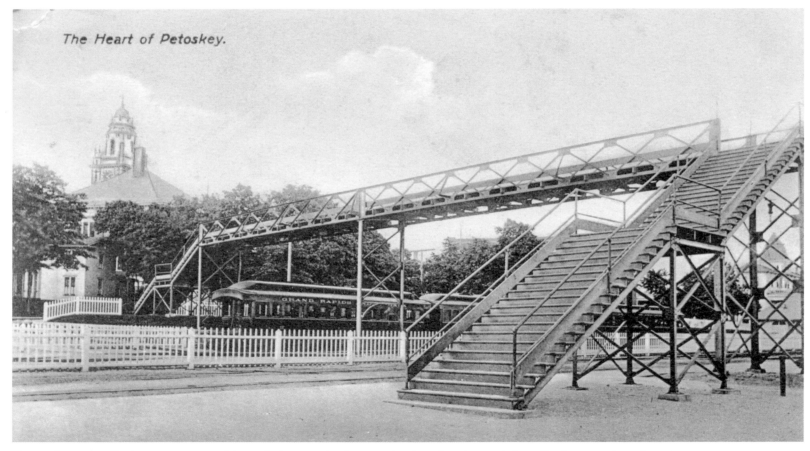

The Heart of Petoskey.

The metal crossover allowing passengers to safely transfer between the dummy and main stations. It extended over Bay Street. (Author's collection)

of 134 trains per day and suggests that during peak daylight hours, a train passed every five minutes. These are staggering numbers that reflect how popular this area had become.

It is interesting to note that the demise of these trains happened very rapidly with the introduction of automobiles and improved roads. The need for the dummy trains collapsed first. By 1921 only a single train per day was running and by 1925 none at all. Also in 1921 the GR & I was succeeded by the Pennsylvania Railroad Company, which would continue regular passenger runs to northern Michigan until December 1950. After that, service was reduced to four months in the summer, when the Northern Arrow was in service. Using diesel-powered engines, these trains boasted dining cars decorated with photomurals of the resort area, making them northern Michigan advertisements all on their own. But after Labor Day in 1960 the Northern Arrow was discontinued, and passenger service to the old Grand Rapids and Indiana Station (renamed Pennsylvania Station) would cease.

Chicago and West Michigan / Pere Marquette

In 1892 the Chicago and West Michigan Railroad arrived in Petoskey. The railroad spent $6,000 on a large, attractive waterfront station and began direct competition with the established GR & I. While focusing more on Charlevoix than Petoskey as its primary regional resort destination, it did actively market itself as an attractive alternative to the GR & I. With tracks running along Lake Michigan's shoreline, the trains went through Charlevoix and passengers then had easy connections to Detroit and Chicago. In 1899 the company merged with the Pere Marquette Railroad and began operating under that name. While it relied primarily on

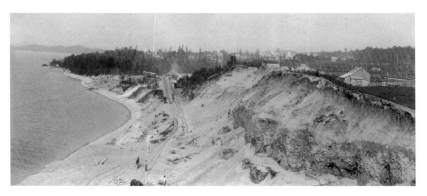

Rail lines were completed into Petoskey from Charlevoix in 1892.
(Courtesy of Little Traverse Historical Society)

long-haul trains for revenue, the Pere Marquette also had its own version of the "dummy" trains. They ran between Charlevoix and Bay View and used smaller engines, with a limited number of cars for passengers and their belongings. In 1920 the Pere Marquette proudly announced the beginning of a "Gas-Electric Motor Car Service" in addition to its regular steam-powered trains. It hoped that those who did not like the dust, heat, and noise of steam engines would make use of this service. To encourage people to use the station, the company developed a landscaped park around it featuring flowers and a wide and inviting stairway up the hill behind the station to Lake Street. At the top of the stairs was the open-air Summer House with benches where people could linger while taking

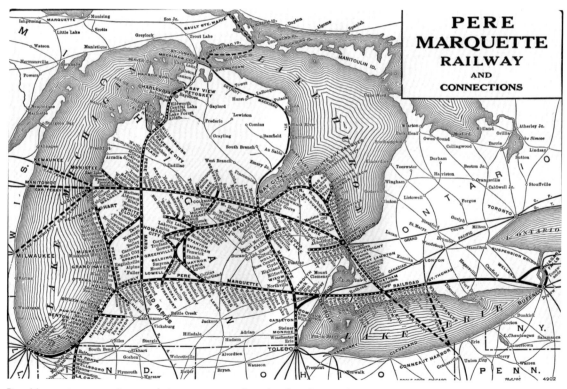

in the view of the station and bay beyond. The park and station were also occasionally used for public events, as when presidential candidate William Jennings Bryan came to Petoskey in 1896.

The Pere Marquette continued to operate until 1951, when it became part of the Chesapeake and Ohio (C & O) system. Like the GR & I, it tried to compete with automobiles, but it was a losing battle. Eventually it discontinued regular passenger runs and focused on weekend sleeper trains. Early on Friday evenings trains departing

Pere Marquette connections made it easy to get to Petoskey from larger urban areas. (Author's collection)

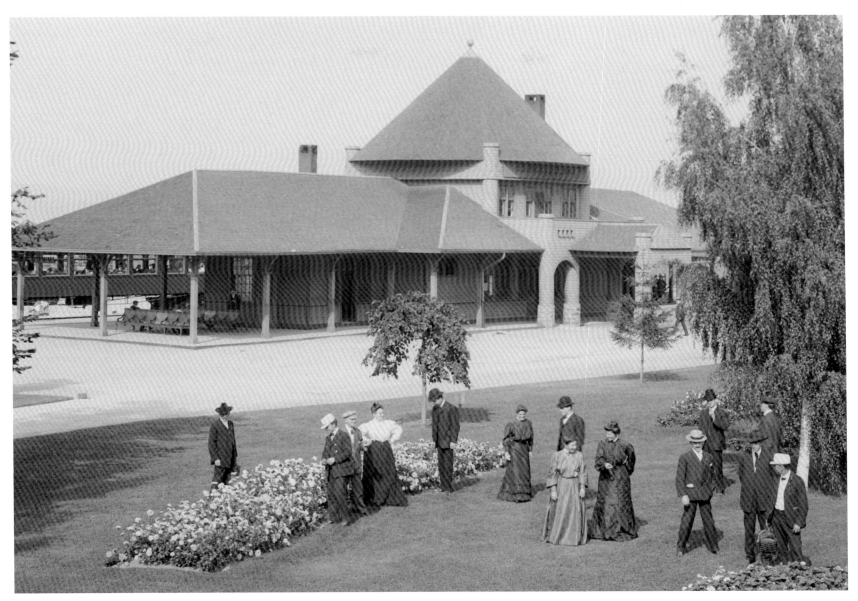

In 1899 the Pere Marquette Railroad took over ownership of the station and lines. (Courtesy of Library of Congress)

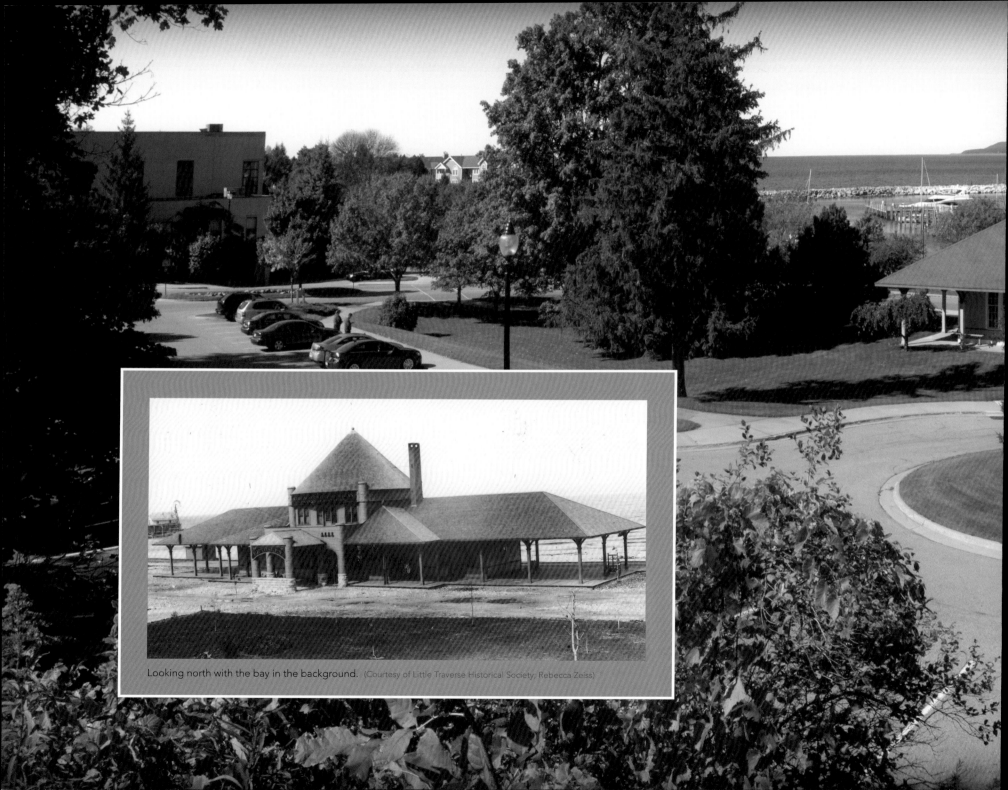

Looking north with the bay in the background. (Courtesy of Little Traverse Historical Society; Rebecca Zeiss)

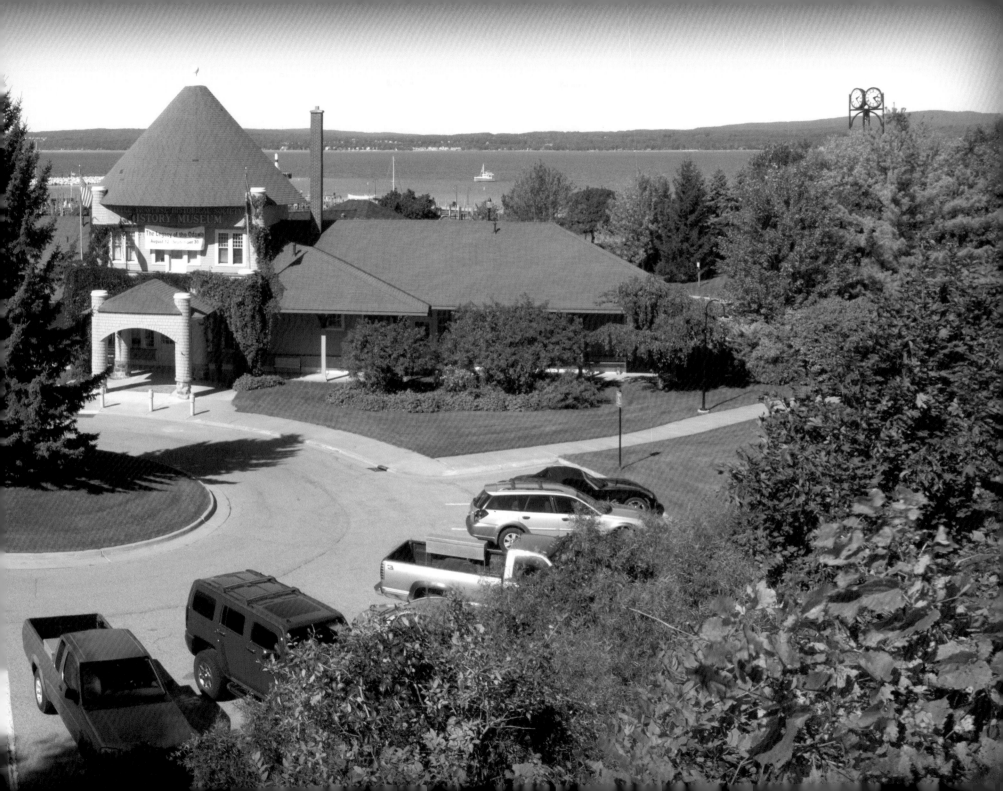

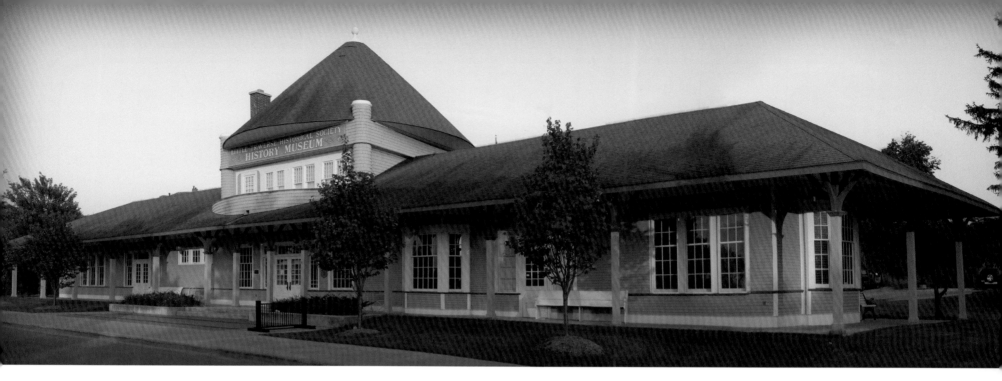

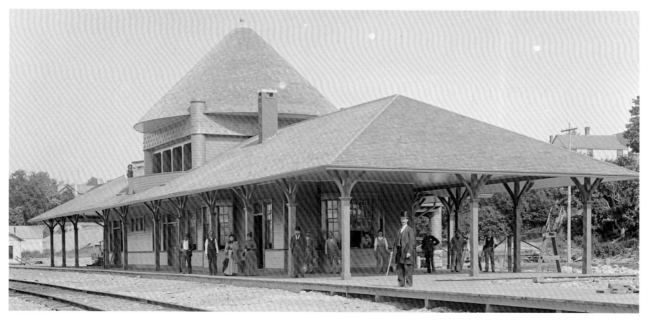

Little has changed in the building's appearance. (Courtesy of Little Traverse Historical Society; Rebecca Zeiss)

from Toledo, Chicago, and Detroit would merge at Grand Rapids and head north to deliver passengers to Charlevoix and Petoskey early on Saturday morning. Then on Sunday evening, they would head south, arriving at their destination early Monday morning. The "Resort Special" featured luxurious Pullman sleeping cars, drawing room, and club cars and made it possible for workers to easily commute north for weekends, but it did not supply enough revenue

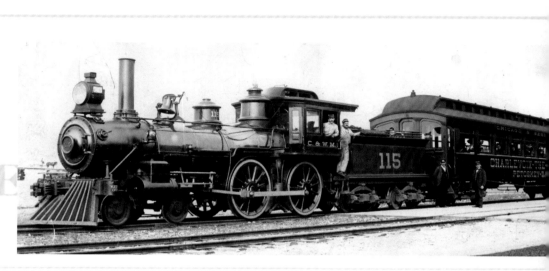

PERE MARQUETTE TRAINS
BETWEEN
BAY VIEW AND CHARLEVOIX
(SUBJECT TO CHANGE)

	AM	AM	PM	PM	PM	PM	PM	PM	PM	
Lv. Bay View	7.00	†8 30	12 10	1 50	†2 35	4 00	5.30	‡6 00	10.10	-----
Lv. Petoskey	7 10	8.40	12.25	2.05	2 40	4.05	5.45	6.10	10.15	
Ar. Charlevoix	7 40	9 05	12.53	2 33	3.13	4.33	6.13	6.40	10.43	
Ar. Belvedere	7 43	9.10	12 56	2.36	3.16	4 36	6 19	6.45	10.46	
	AM	AM	PM	PM	PM	PM	PM	PM	PM	

† Daily except Sunday. ‡ Daily except Saturday. Other trains daily.

	AM	AM	PM	PM	PM	PM	PM	PM	PM	
Lv. Belvedere	⸸8.52	10 34	1.08	2 48	†3 41	4 48	6 55	†9.15	11.10	-----
Lv Charlevoix	9.05	10 37	1 11	2 52	3 45	4 52	7.00	9 18	11.15	
Ar. Petoskey	9.30	11.05	1.40	3 21	4 15	5.20	7 30	9.45	11.45	
Ar. Bay View	9.40	11 10	1.45	3 25	4 25	5.25	7 35	9.55	11.50	
	AM	AM	PM	PM	PM	PM	PM	PM	PM	

† Daily except Sunday. ⸸ Daily except Monday. Other trains daily.

Local train and schedule. (Courtesy of Little Traverse Historical Society)

to make continuing passenger service viable, and it ended in 1966. By 1981 the C & O discontinued freight service as well.

After the passenger trains went away, the depot building stood empty and there was talk of tearing it down. Fortunately, the Little Traverse Historical Society stepped in and purchased it and the land surrounding it with the express purpose of establishing a regional history museum and archive. By 1971 the museum was opened and an agreement was reached with the City of Petoskey that transferred ownership to the city in exchange for the perpetual right to operate the museum and archive there. This has resulted in the building being very well preserved and available to the public.

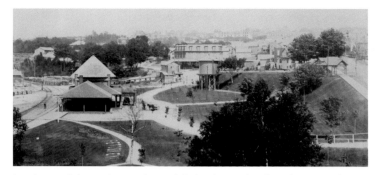

Land around the station was beautifully landscaped and was known as the Pere Marquette Park. At the far right (on Lake Street) were the open-air Summer House and a wide stairway leading down to the station. (Courtesy of Little Traverse Historical Society)

Above and at right: The current steps up to Lake Street are not as elegant as those in the past were. (Courtesy of Little Traverse Historical Society; Rebecca Zeiss)

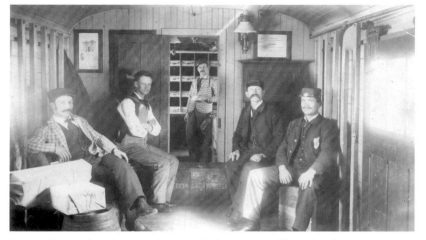

Interior photos of an elegant parlor car and a baggage car. The railroads were among the region's leading employers. (Courtesy of Little Traverse Historical Society)

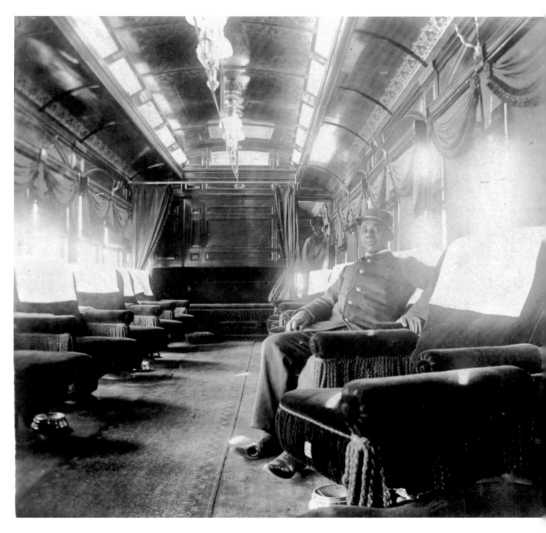

Hotels

Motorists traveling on U.S. 131 or U.S. 31 encounter many hotels and motels as they enter Petoskey. All offer guests clean rooms, attractive views and, often, breakfast. A hundred years ago (when those highways were fields and forests) the same amenities—and more—were available at Petoskey's downtown hotels. The Little Traverse community—particularly Petoskey—provided a wide range of guest housing options. These ranged from simple boardinghouses where a room could be procured to extravagant hotels that could compete with any luxury resort hotel on the East Coast. By 1900 a room at one of Petoskey's fourteen hotels could be secured for $1 to $5 per day. Additionally, there were eighteen boardinghouses where those on tighter budgets could stay. The higher-end hotels provided concerts, dress balls, and dances (with music provided by house orchestras); costume, tea, and cocktail parties; elegant dining; and sightseeing excursions. These hotels offered a summer society that rivaled what the wealthier city dwellers experienced at home.

Original Arlington

The premiere hotel was the Arlington. Located a short walk east of the GR & I main station, it cost $60,000 to build in 1882. Four stories high, it had 115 rooms and offered its guests luxurious comfort and entertainment options.

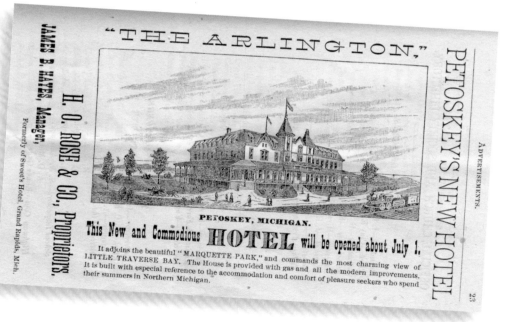

The original Arlington Hotel was opened in 1883. (Courtesy of Clarke Historical Library, Central Michigan University; courtesy of Little Traverse Historical Society)

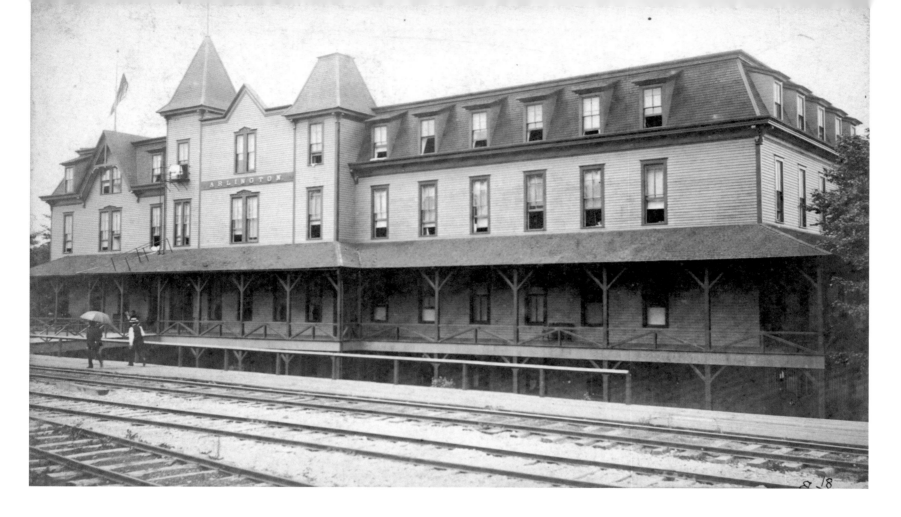

The liveliest hotel scene on my trip thus far I witnessed as the train draws up in front of the Arrington Hotel in Petoskey, Michigan. A throng of people were on the platform and verandas. A band is playing and everybody seems to be supremely happy. Many of those people are from heated Cincinnati, Louisville, and southern cities. We arrived just in time to see one of the most beautiful sunsets I have ever seen. But it is not alone the sunsets, both as to time and poetic inspiration. During my stay I have heard nothing but praise from the guests about the superior service and cuisine.

Hotel World of Chicago, July 1885

Northern travel is to be the great "go" of the season. . . . The Arlington will be informally opened for the reception of guests July 3. It is a grand structure, the grounds and floor plans being models of perfection for convenience and comfort. There are 115 large and finely furnished sleeping rooms, all well lighted and ventilated. . . . The ground or basement floor has a dance hall 40 x 70 feet; two billiard rooms—one for the gentlemen containing three tables and the other a private hall for the ladies with two tables of superior make and pattern; the bar and barber shop; a thoroughly equipped steam laundry; room for the help, and the kitchen, which is fitted with a twelve-foot range, pastry oven and every appurtenance that will add to the convenience of the chefs. On the first floor is the office for the reception of guests; reading rooms; ladies parlor and reception room beautifully furnished with velvet carpet, massive pier-glass, piano, etc. The dining room, which is on this floor, is 40 x 70 feet with 16 foot ceiling; there is also a small private dining apartment off the main room; 160 guests can be comfortably seated at one time The first floor contained the office, reading rooms, ladies parlor, and reception room beautifully furnished with velvet carpet, massive pier glass, piano and public private dining rooms to seat 160 guests at a time. The remaining floors are given over to sleeping, bath and linen rooms, arranged each side of spacious hallways. All are nicely carpeted and furnished with black walnut, cherry, or ash suites with marble tops, purchased from the Phoenix Furniture Company of Grand Rapids. The house has electric bells to every room, and will be lighted with gasoline, a tank with capacity of 15 barrels having been set from eight or ten feet in the solid rock in the rear of the hotel. A twelve-foot veranda extends entirely around the hotel proper, making a delightful promenade. No better location can be found in the state than the site occupied by the Arlington. The view is magnificent and the breeze invigorating.

Grand Rapids Eagle, June 19, 1883

New Arlington

By the 1890s other, newer hotels began to rival the Arlington, so the owners decided to reinvent it. The New Arlington Hotel opened in July 1898 after extensive remodeling during the winters of 1897 and 1898. It now had three hundred guest rooms and could accommodate seven hundred guests per night—twice as many as any other local hotel and, for a time, even more than Mackinac Island's Grand Hotel. It was open seasonally (typically from late June through early October). Guests enjoyed four bowling allies, separate billiard rooms for gentlemen and ladies, card and grill rooms, a casino and dancing hall, and an orchestra of ten musicians for daily concerts

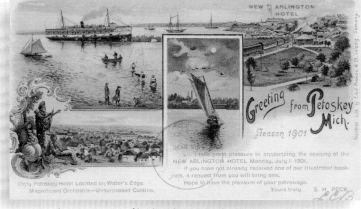

A tremendous promoter of his hotel, S. H. Peck sent postcards announcing the Arlington's 1901 season. (Author's collection)

Arlington guests received daily printed music programs identifying musical selections and performance times. (Courtesy of Little Traverse Historical Society)

and dancing. The building's exterior was painted a warm straw color trimmed with seal brown, the sash in olive and the roof in red.

Clearly the Arlington was the social center of the summer season. It promoted itself as such and its owner, Samuel H. Peck, enjoyed his place in the community. Its opening each season was one of the biggest events of the summer. A local newspaper account from 1901 gives an idea of what the Arlington's guests enjoyed.

Sadly, all of this elegance came to an abrupt end in 1915. On June 19, while staff was preparing the hotel for its summer opening,

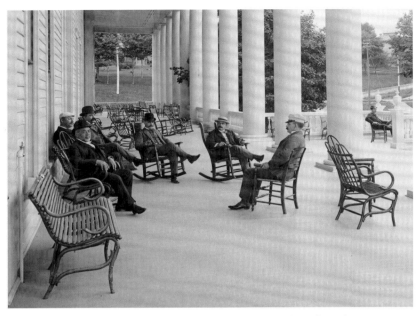

Above and opposite: Arlington guests enjoyed fine dining and watching the sunsets from the wide bay-facing balcony. (Courtesy of Library of Congress)

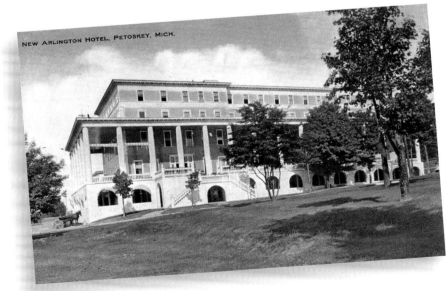

The Arlington's white paint was replaced with yellow in an attempt to make it more attractive. (Courtesy of Little Traverse Historical Society)

a fire started in an elevator shaft and soon the entire structure was engulfed in flames. People flocked to watch it burn, some taking photos that later were turned into colorized glass lantern slides and shown at the local theater. Fortunately, no lives were lost, but the fire danger of wooden buildings was so high that in 1899 a local safety ordinance was passed requiring future large hotels to be built of block or brick. The Arlington's owners thought the cost to re-create the hotel using these materials would be too high and elected not to rebuild. The site was abandoned and has become parkland.

In response to Mr. and Mrs. Peck's invitations, three hundred of Petoskey's fairest ladies and gentlemen spent four most delightful hours in the lobbies and ballroom of the New Arlington. By 8:00 the carriages began to arrive bringing the first guests. The stream of people kept up incessantly until nearly 9:00 with Mr. and Mrs. Peck receiving each guest. . . . Mrs. Peck, charmingly gowned in a beautiful creation of white lace over pink was a most gracious hostess. About 10:00 Mr. and Mrs. Peck leading, all marched through the long broad corridor to the dining room, which had been cleared of tables, and the grand march began. Never in Petoskey's history has a ball had such a grand opening. The ladies all in beautiful evening gowns and the men of all ages, were representatives of Petoskey's best. . . . The figure of the march was perfectly carried out while the music, furnished by the Elgin Military Orchestra, was perfect in execution. Prof. Jewel de Commerce, a French dance master who has been engaged as master of ceremonies for the season, managed the sequence of dances. The great supporting pillars in both the large parlor and the spacious dining room were wound with bunting appropriate to the day and the

snowy whiteness of the walls was relieved by flags. Palms and ferns contributed to the decoration. Not a thing was left undone which could in any way add to the pleasure of those present. In the ballroom punch was served between dances and in the pretty private dining room, on the right side of the corridor, a delightful three course buffet lunch was served to everyone present. The menu and the idea were modeled after one recently given in the Waldorf Astoria in New York City. To Mr. Peck belongs the credit of introducing this sort of entertainment into northern Michigan. The dancing ended at 12:00 although the lobby did not empty until much later. Not an unpleasant thing occurred to mar the success of the evening. Mr. and Mrs. Peck have forever established for themselves an enviable reputation as host and hostess.

Daily Resorter, July 5, 1901

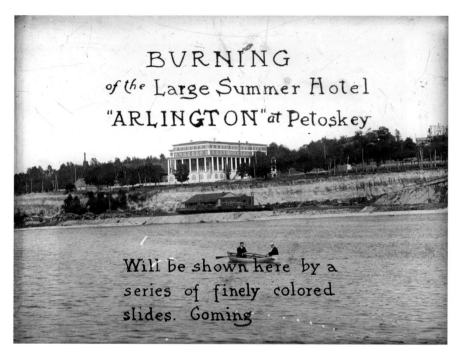

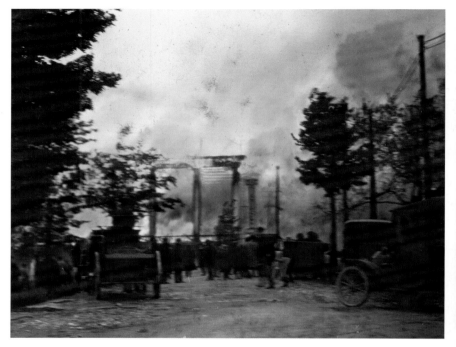

After the hotel burned in 1915, the local theater created a popular glass lantern slide show illustrating the event. (Courtesy of Little Traverse Historical Society)

S. H. Peck managed the Arlington in summer and the Plaza Hotel in Florida in winter. This is one of the correspondence envelopes he made available for guests at either hotel.

(Author's collection)

Opposite: The view toward the station and Perry Hotel from the Arlington site. (Rebecca Zeiss)

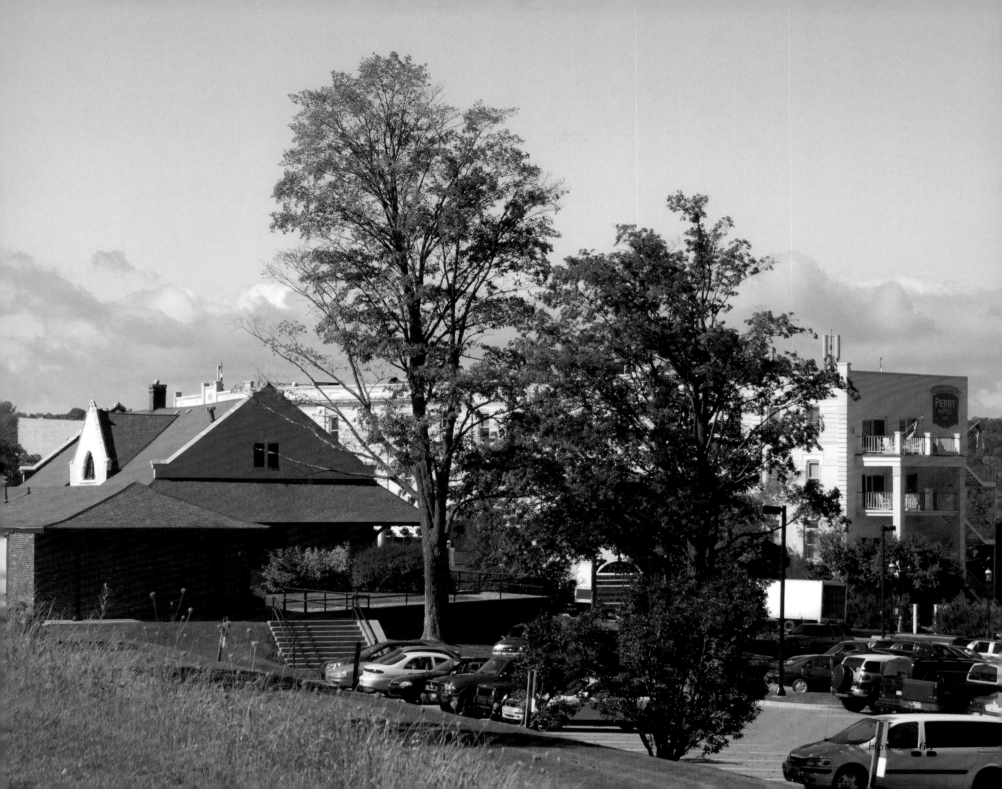

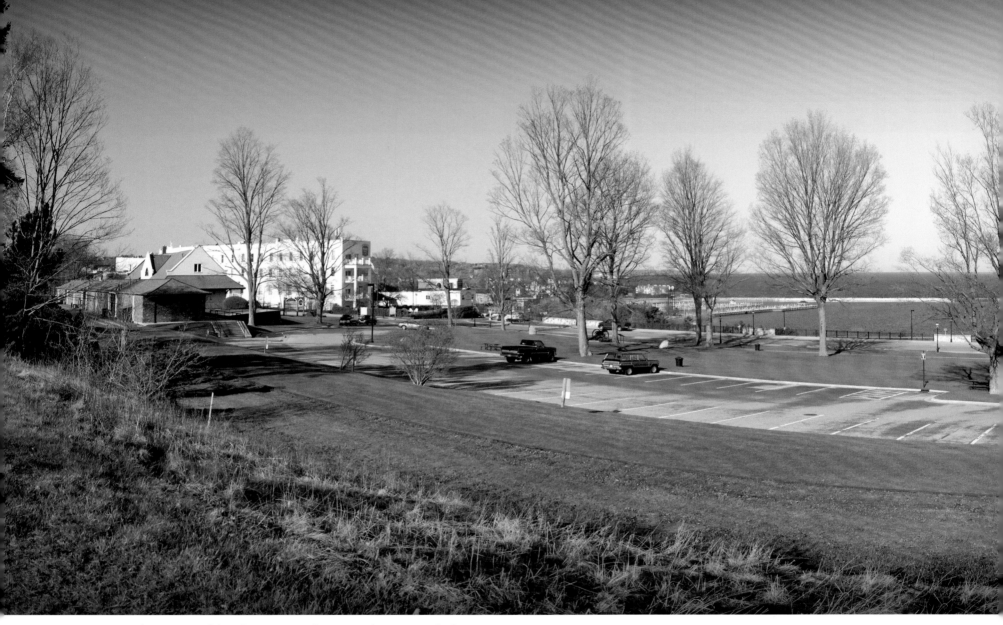

Nothing remains of the Arlington except the views and proximity to the former train station. (Rebecca Zeiss)

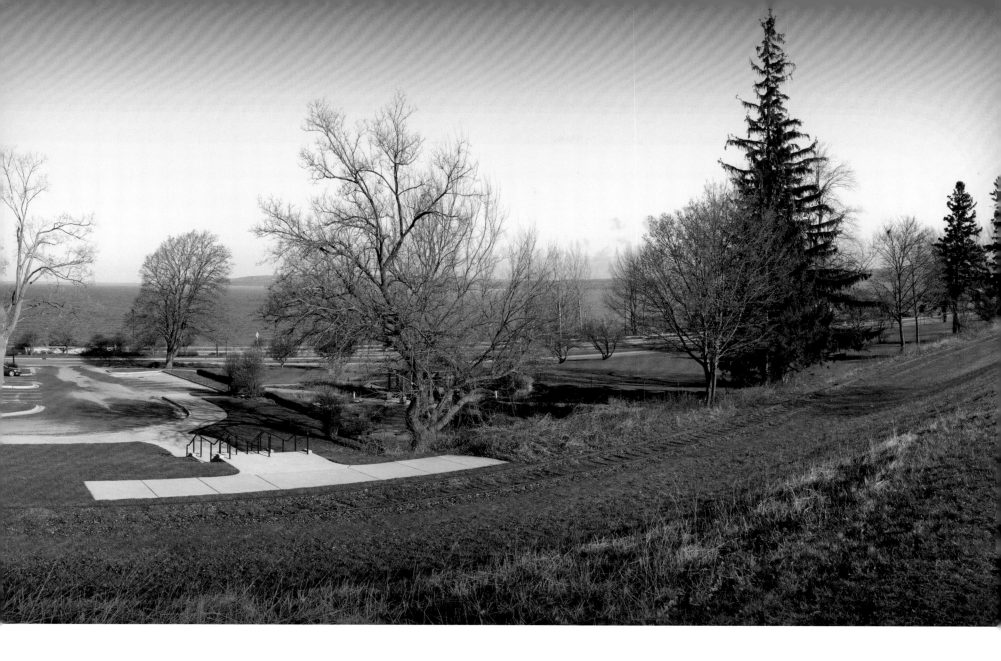

Cushman Hotel

Before the Arlington, there was the Cushman. In 1874 David Cushman built his hotel and opened it the following year. Located on Lake Street across the street from the original GR & I railroad depot, it was a convenient place for travelers to stay, and because it was open all year round it was also popular with locals. A twenty-four by fifty–foot addition later in 1875 increased its capacity to 150 guests; the gold and white dining hall could seat all of them at the same time. Private suites were finished in white, and polished oak was found throughout the hotel. The office and lobby area was seventy-five feet long, with art tile flooring. An elegantly furnished parlor adjoined the lobby, and its doors could be thrown open when both office and parlor were used for the social hops given for guests and friends.

Over time David Cushman continued to expand and improve the hotel. During the winter of 1876 a veranda was added to the north and west sides of the second story, and in 1890 the building was extended north, directly up to the Lake Street sidewalk. In 1899 the veranda was replaced with a 254-foot-long porch that was 12 feet wide on the first and third stories. Grand ionic columns and a rounded porch made this a premiere place to see and be seen. Also in 1899, a four-story brick annex was added to the wooden structure, allowing the hotel

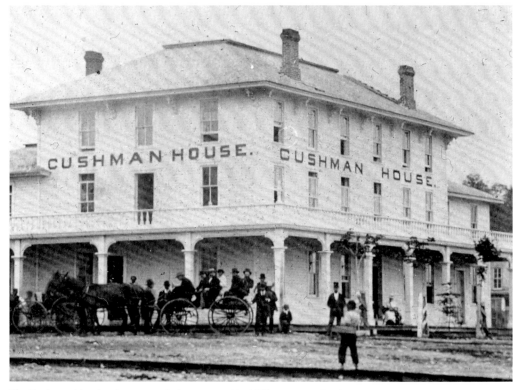

The Cushman Hotel as it appeared when opened in 1874. (Courtesy of Little Traverse Historical Society)

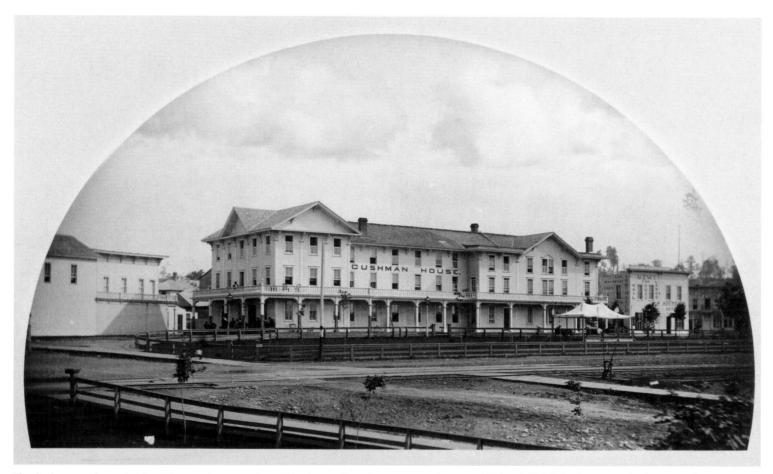

The Cushman underwent at least three major renovations. This photo reflects its appearance between 1876 and 1899. Lake Street is in the foreground.
(Courtesy of Little Traverse Historical Society)

to stretch the full distance from Lake Street to Mitchell Street. This addition encompassed fifty additional guest rooms. In 1907 William McManus purchased the hotel and made additional improvements. In October 1919 a young Ernest Hemingway would stay there. And in 1933 McManus sold the hotel and it was eventually torn down.

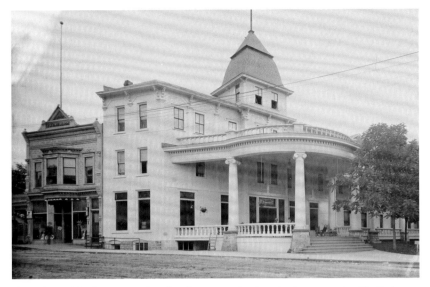

The enlarged Cushman was directly adjacent to what is today known as the City Park Grill. (Courtesy of Library of Congress)

Ground broken for addition to the Cushman House—to be extended to the north to the line of Lake Street and all northern end altered so that the façade will present a uniform and complete architectural whole. In the new part will be the office with tiled floor, present parlor will be thrown into the dining room and the room now used for the office, somewhat enlarged, will be converted into general parlor or drawing room. The improvement will increase dining room and office capacity and add scores of fine private rooms.

Petoskey Record, October 8, 1890

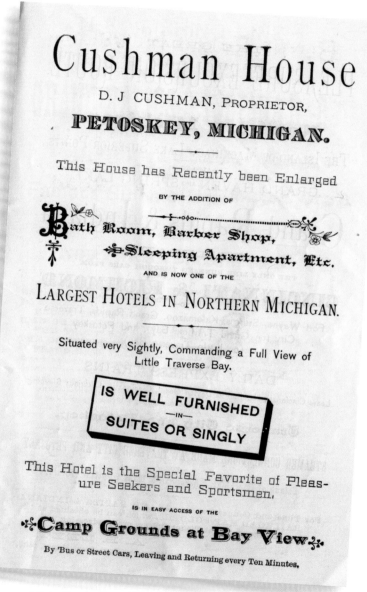

Cushman House

D. J CUSHMAN, PROPRIETOR,

PETOSKEY, MICHIGAN.

This House has Recently been Enlarged

BY THE ADDITION OF

Bath Room, Barber Shop, Sleeping Apartment, Etc.

AND IS NOW ONE OF THE

LARGEST HOTELS IN NORTHERN MICHIGAN.

Situated very Sightly, Commanding a Full View of Little Traverse Bay.

IS WELL FURNISHED
—IN—
SUITES OR SINGLY

This Hotel is the Special Favorite of Pleasure Seekers and Sportsmen.

IS IN EASY ACCESS OF THE

Camp Grounds at Bay View

By 'Bus or Street Cars, Leaving and Returning every Ten Minutes.

(Courtesy of Clarke Historical Library, Central Michigan University)

The Cushman House annex is the first fireproof brick building in Petoskey. Its solid walls are built of red brick with red sandstone trimmings and the elevations facing Mitchell Street and the park are very pleasing. The first floor is occupied by stores and the post office, with the exception of a lobby which serves as an office for the building. Passenger elevator to top floors. All above the first floor is used as lodging rooms.

Daily Resorter, July 12, 1900

THE CUSHMAN HOUSE, PETOSKEY, MICH.

The Cushman's 1899 renovation added a brick annex and allowed the hotel to stretch the whole distance between Lake and Mitchell streets. (Courtesy of Clarke Historical Library, Central Michigan University)

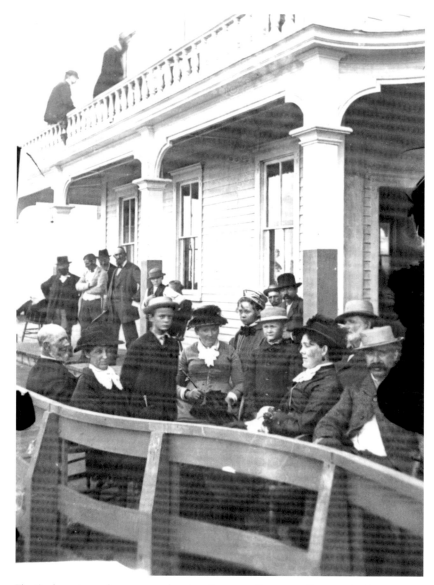

The Cushman's porch was a popular place to see and be seen. (Courtesy of Little Traverse Historical Society)

The whole premise has been refinished, redecorated, and to a large part refurbished. The halls in the first two floors in the Cushman and all four floors of the annex are being finished in a distinctive color scheme which does away with the sameness that pervades so many hotels. At the front entrance the massive portico with its huge columns (the colonnade a block long) and the entire exterior of the building have received a fresh coat of paint, and all lights have been replaced with tungstens and the effect is magnificent. The lobby is finished with yellow walls and white and gold ceiling and cornice. The ladies parlor, first floor, has been entirely changed, a beautiful sight with its green walls and cream ceiling and drop. The new carpet is an "even" color with the walls with black designs at intervals. The writing room is finished in red walls, white ceiling, and extends up the main staircase to the second floor

Petoskey Record, July 7, 1909

Music in the park has a long tradition in Petoskey. The Cushman's orchestra played there, and today musicians often perform there on summer nights. (Courtesy of Little Traverse Historical Society; Rebecca Zeiss)

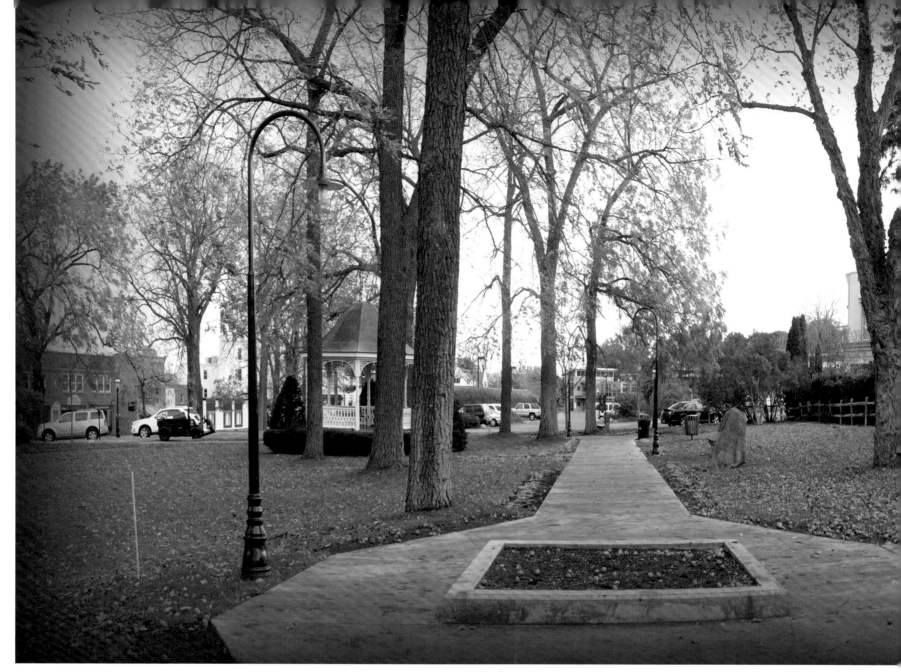

On Pennsylvania Park's east edge are a driveway and parking lot where the Cushman stood. It is completely gone except for the lower floors of its brick annex, which now house Meyer Ace Hardware. (Rebecca Zeiss)

Perry Hotel

The Perry Hotel was a midsize hotel built in 1899 by Norman J. Perry. It was made of brick rather than wood; management promoted it as fireproof and safe for the 150 guests it could accommodate. In 1919 new owners Drs. John and George Reycraft proposed turning it into a hospital but were persuaded instead to

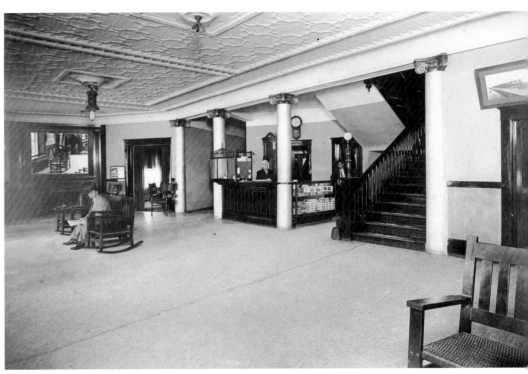

The hotel's reception lobby was originally on the first floor rather than the lower level, where it is today. (Courtesy of Little Traverse Historical Society)

convert the Grand Hotel on Lake Street rather than the Perry. Later the doctors' nephew, Herbert Reycraft, took over operations of the hotel, and in 1926 a four-story, forty-six-room addition was added. The Perry is the only one of Petoskey's classic turn-of-the-century downtown hotels still in existence. It is wonderfully maintained and allows visitors a true glimpse into the past.

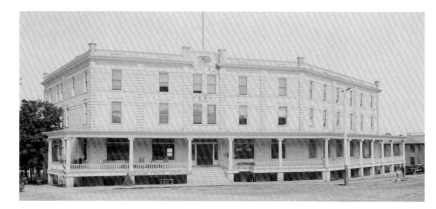

The Perry's guests of one hundred years ago would recognize its façade today. (Courtesy of Library of Congress; Rebecca Zeiss)

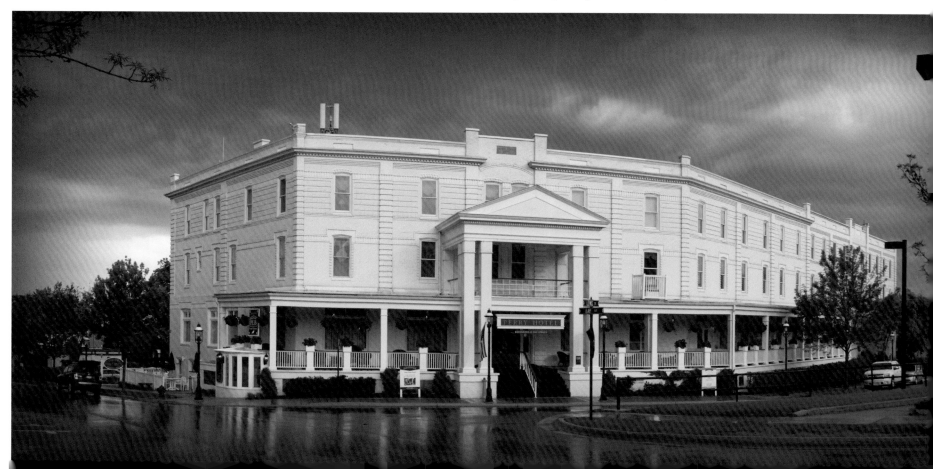

(Rebecca Zeiss)

New Perry Hotel has been improved with a $5000 addition which will accommodate all the help. The addition is fireproof. Some of Mgr. Perry's innovations are a fine open fireplace with a French plate mirror in the office; a new range and steam cooker in the kitchen; a four chair barbershop in the basement; a cigar and news stand; and a buffet. A 60 foot bowling alley will be built in the corridor under the front porch of the hotel.

Daily Resorter, July 7, 1900

The hotel's proximity to the train station made it a popular destination for travelers.
(Courtesy of Little Traverse Historical Society; Rebecca Zeiss. *Opposite:* Rebecca Zeiss)

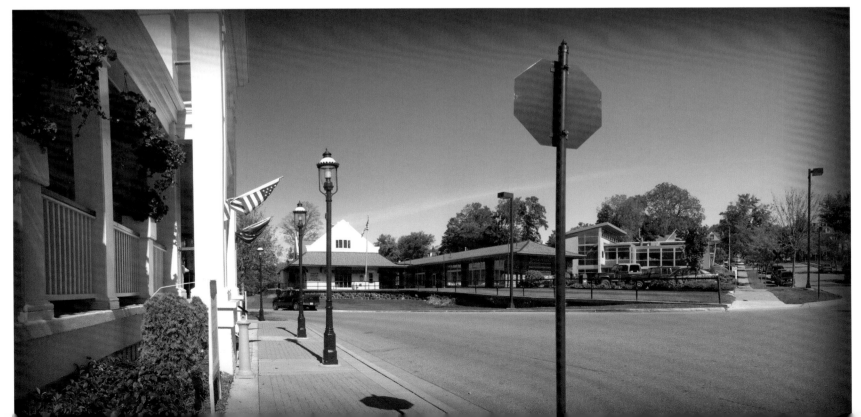

Waterfront

Petoskey's waterfront naturally draws visitors. Its ever-changing blue water and those famous million-dollar sunsets pull people to the shore. The green parkland, picnic tables, playground, docks, and walkways make it a perfect place to spend a leisurely day. While its value now is recreational, that is a far cry from its commercial past.

Limestone

For centuries, Native Americans used Lake Michigan for transportation and food. Traveling along its shore, they moved people and goods the length of Michigan's west coast. They also fished the waters to supply themselves with needed food. But when Hiram Rose first saw Petoskey's limestone cliffs, geologically

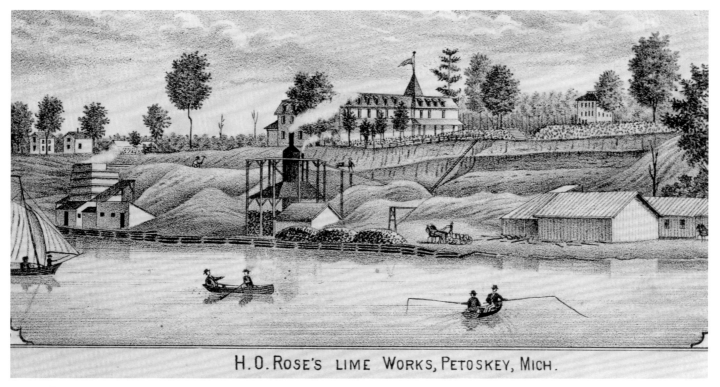

Sketch of the H. O. Rose and Company Lime Works. The Arlington Hotel is in the distance. (Courtesy of Little Traverse Historical Society)

One of Rose's lime kilns at the waterfront. (Courtesy of Little Traverse Historical Society)

formed from fossilized remains, he focused on the land's potential rather than the water's. Purchasing two hundred waterfront acres, Rose constructed in 1874 the first commercial dock and opened his limestone operation. The limestone was extracted, crushed, and heated, producing lime that was used primarily in plaster and mortar. By 1876 the H. O. Rose and Company Lime Works used three full-time kilns and produced ten thousand barrels of lime annually. Having the quarry and kiln at the same site allowed Rose to reduce transportation costs, as the processed lime weighed far less than the stone. In 1900 Rose sold his interest to the Michigan Lime Company, and in 1917 the Petoskey Portland Cement Company was formed, with operations shifting from Petoskey's waterfront

west to Resort Township, where it eventually expanded to four hundred acres. But in Rose's time, the limestone business employed over thirty individuals, whose efforts ate away at the limestone façade, pushing it back from the water's edge to where it now stands a significant distance away.

Workers extracted limestone, moving the face back significantly from the water's edge. The photo with the wagon was taken April 20, 1901. (Courtesy of Little Traverse Historical Society)

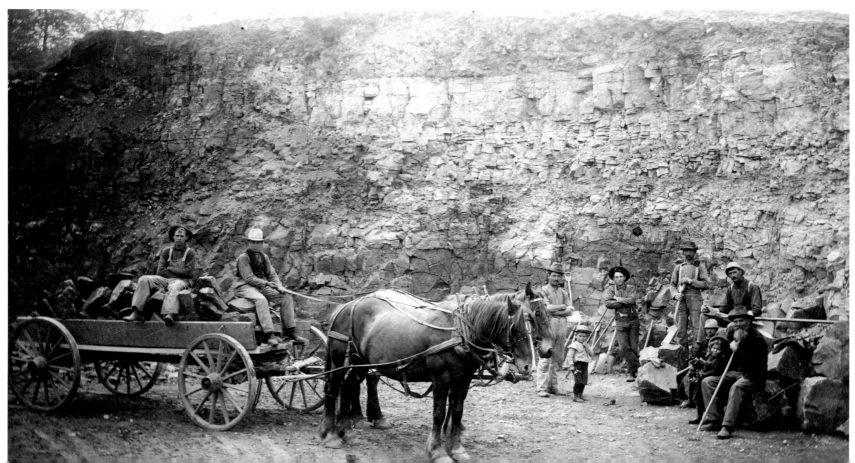

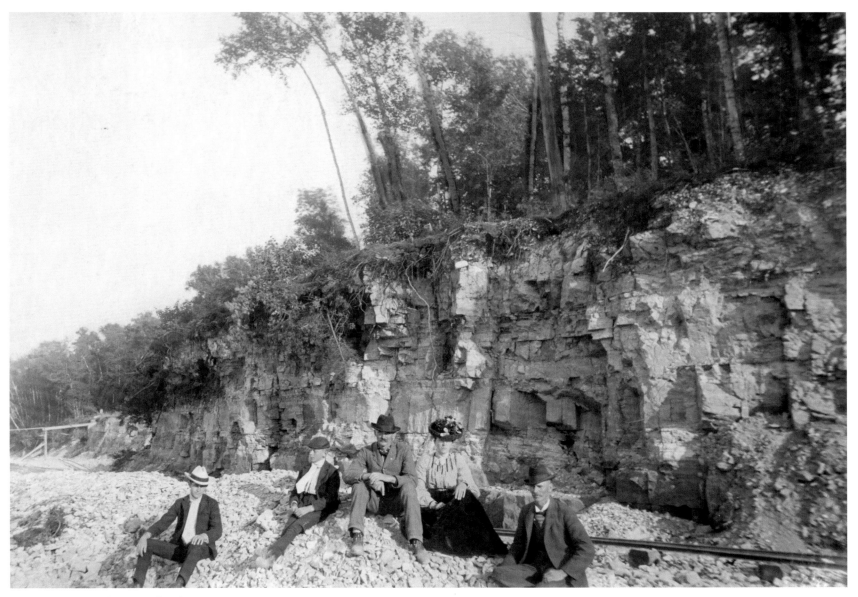

Visitors posing at the limestone façade. (Courtesy of Little Traverse Historical Society)

The limestone cliff remains but is now largely hidden by greenery. (Rebecca Zeiss)

Boats

Boats have always been a part of Petoskey's waterfront. The Native Americans used them to travel the coastline, and when Europeans arrived, not only did they initially arrive by boat, they soon began to find commercial uses for them. As the limestone business grew, alongside it so did boat manufacturing and rentals. The Banner Boat House, located on the rugged shore, was the first of several companies to build boats there. But Petoskey's location was something of an obstacle to pleasure and commercial boats.

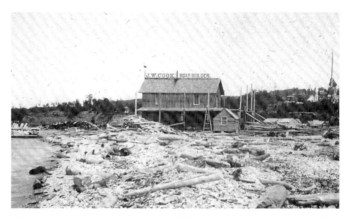

While tourists found boating delightful, the shore was not the beautiful picnic area it is today. (Courtesy of Little Traverse Historical Society)

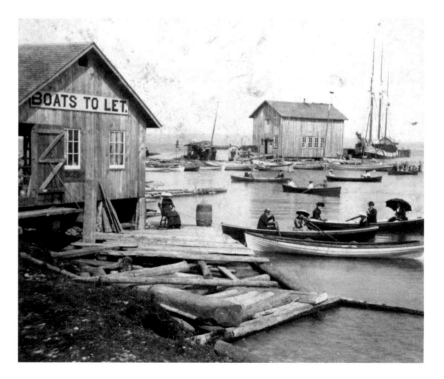

Advertisement for the Banner Boat House. (Courtesy of Little Traverse Historical Society)

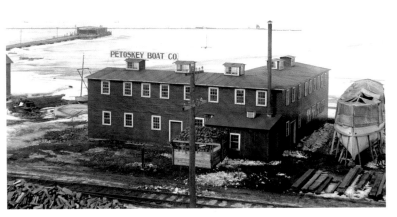

The building that housed the Petoskey Boat Works would eventually be used for manufacturing rugs and later producing toys before it was torn down. (Courtesy of Little Traverse Historical Society)

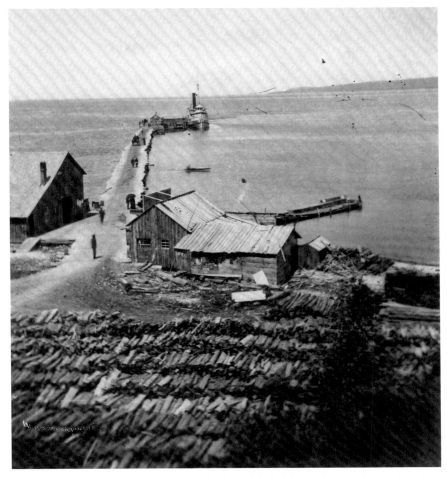

An early dock constructed by H. O. Rose. The Connable Fish House is to the left, and cords of firewood for ships are in the foreground. (Courtesy of Little Traverse Historical Society)

Unlike Harbor Springs, there was no natural harbor, and the shoreline was exposed to fierce westerly winds and storms. Still, locals (led by Rose) knew the commercial importance of a dock and from 1874 kept building them, only to see each one destroyed. The need to protect the dock was evident, and in 1894 the first of several breakwaters was built. The initial one had two sections and did offer some protection (until it too was washed away). Over the years the existing breakwaters (including the current one) have battled Mother Nature to

provide Petoskey with sheltered dockage. For navigational purposes, the breakwater has almost always had a light at its end. The most architecturally significant of these was the pagoda-style one that shone there between 1912 and 1924. As has always been the case, the breakwater is a popular place for sunset watching, fishing, and swimming.

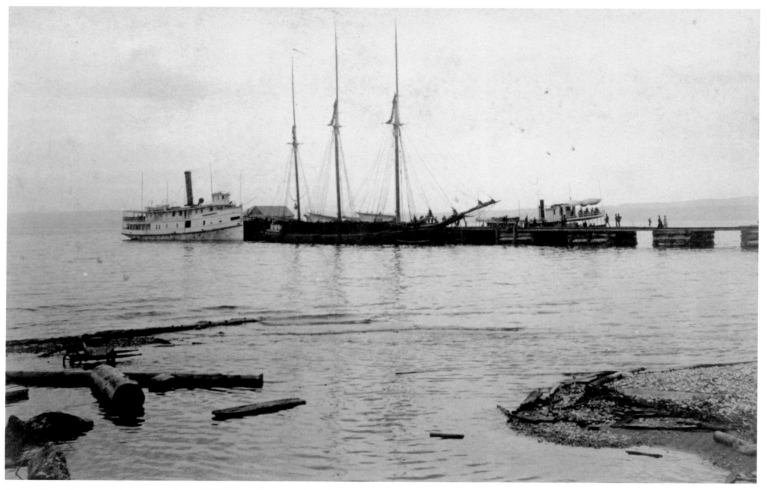

Dock with a schooner and steam bay ferry, 1888. Taken from mouth of the Bear River. (Courtesy of Little Traverse Historical Society)

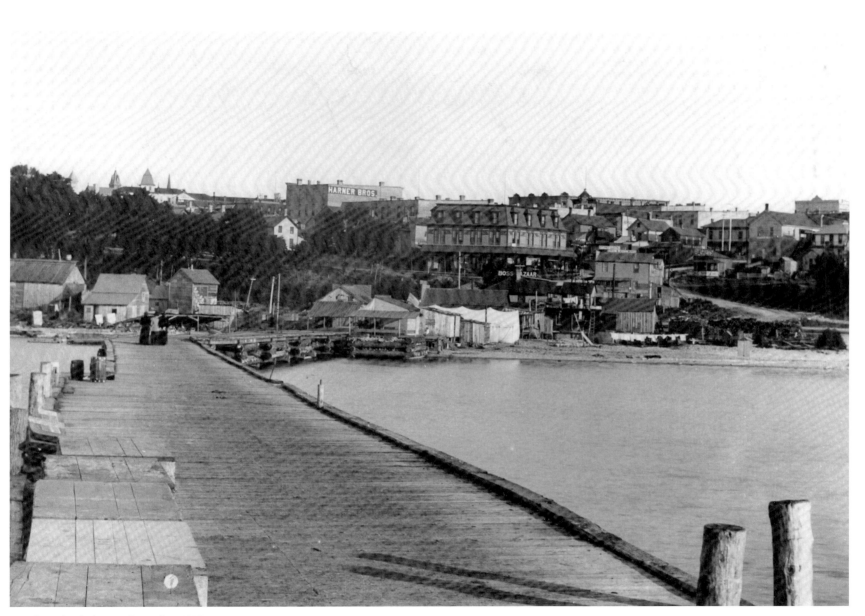

View from the dock toward Petoskey, 1894. (Courtesy of Little Traverse Historical Society)

In the early years Petoskey's dock was used exclusively for commercial purposes. Cargo could be loaded and unloaded there, but soon what was being transported shifted from goods to people. While the water tended to be too shallow for many deep-hulled large Great Lakes steamships, it worked well for smaller ones. This was especially true of the bay ferries that regularly stopped there

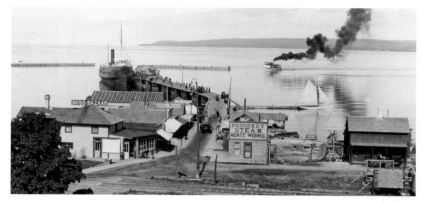

Early dock scene. Tourist shops are at the dock, and in the distance can be seen an early breakwater and two bay steam ferries. The presence of rail tracks indicates this was taken after 1892. (Courtesy of Little Traverse Historical Society)

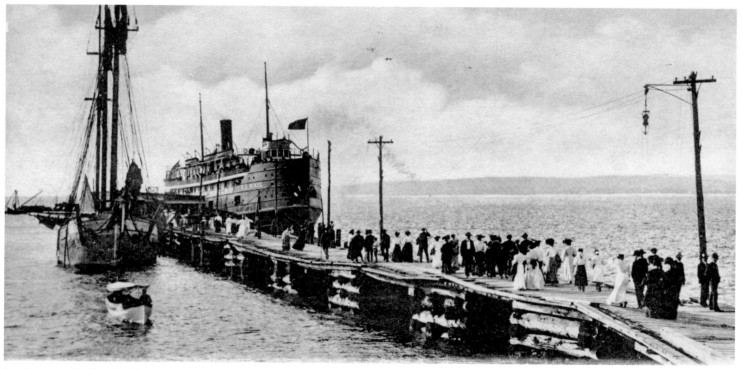

Smaller steamships like the *Illinois* provided passenger service at Petoskey. (Author's collection)

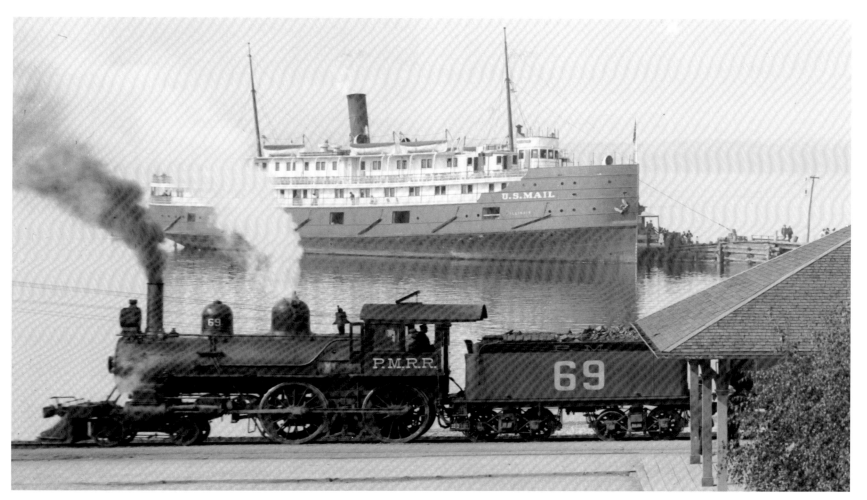

Having both a rail station and passenger steamships dock meant that the Petoskey waterfront had a constant flow of tourists. (Courtesy of Library of Congress)

to take passengers to and from Charlevoix, Harbor Springs, and all points in between. Long gone now are those steam-powered ships. In their place are rows of sailboats and powerboats waiting for clear skies and warm days to edge out past the breakwater and into the deep waters of Little Traverse Bay and Lake Michigan.

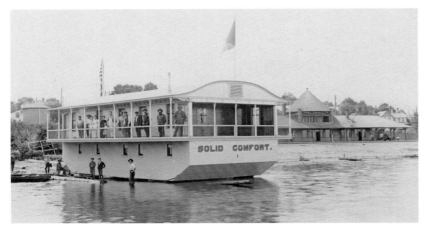

The *Solid Comfort* at Petoskey's waterfront. The Pere Marquette station is in the background. (Courtesy of Little Traverse Historical Society)

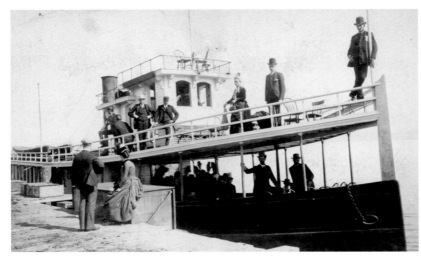

Petoskey dock scene, 1887. (Courtesy of Little Traverse Historical Society)

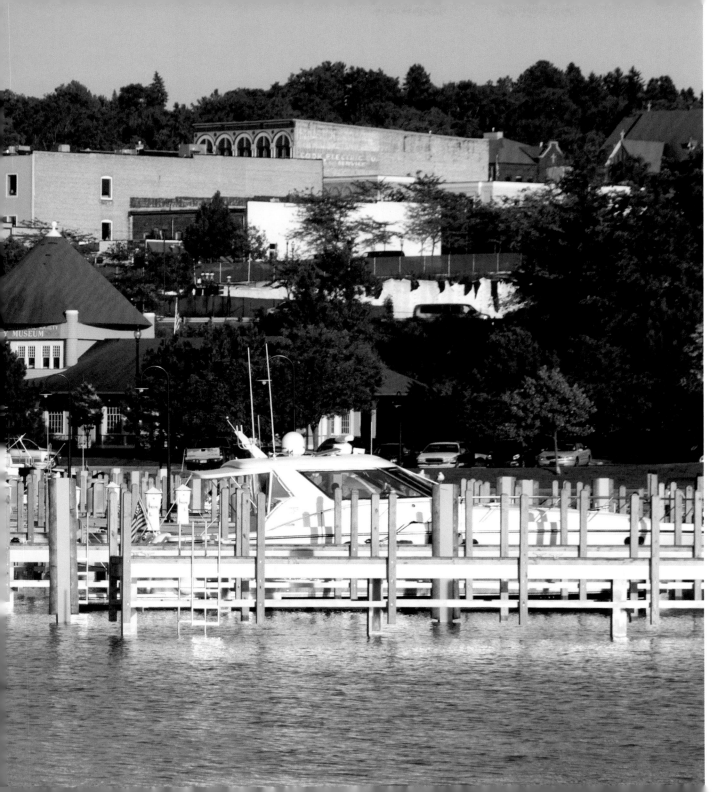

(Rebecca Zeiss)

(Rebecca Zeiss)

(Rebecca Zeiss)

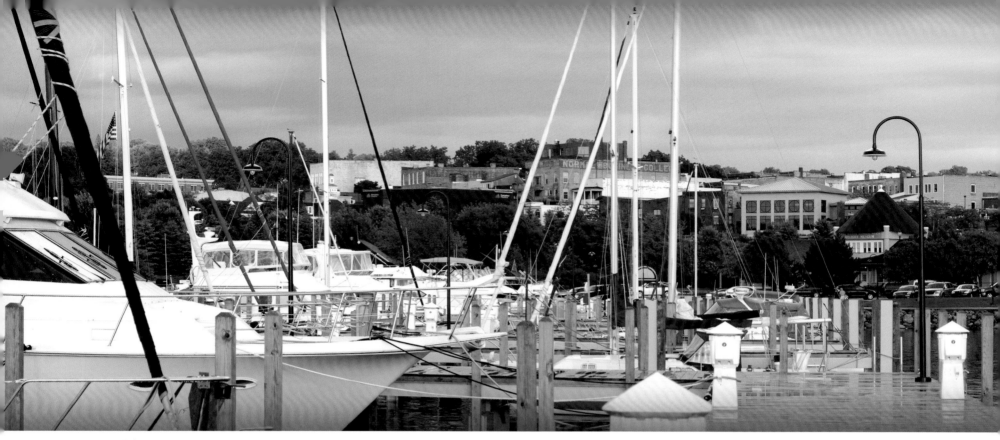

(Rebecca Zeiss)

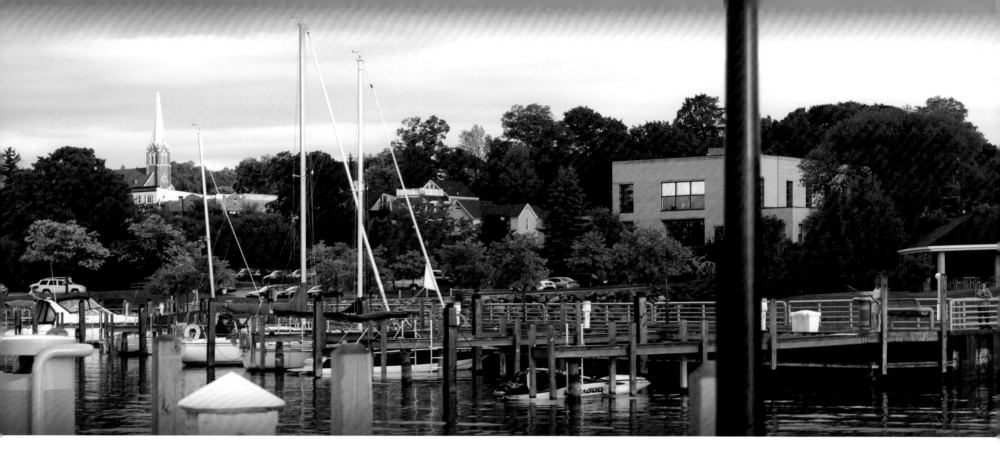

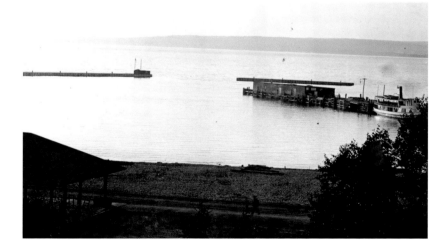

Photo showing the two-section breakwater built in 1894.
(Courtesy of Little Traverse Historical Society)

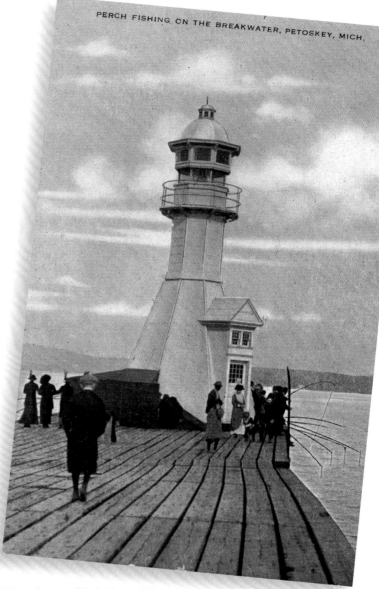

PERCH FISHING ON THE BREAKWATER, PETOSKEY, MICH.

(*Above*: Courtesy of Clarke Historical Library, Central Michigan University
Left: Rebecca Zeiss)

Tourists

Over the years the Petoskey waterfront has undergone a significant transformation. It retained its original commercial and transportation importance for a number of decades, but as that diminished with the end of rail and passenger ship service, it was largely abandoned. Current Petoskey residents remember it primarily as a place where youths played baseball on city-sponsored fields. But by the 1980s the City of Petoskey began transforming it into

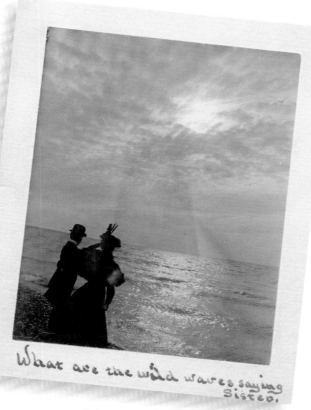

For generations people have enjoyed sunsets over Lake Michigan. This photo captures a spectacular one on May 29, 1898. (Courtesy of Little Traverse Historical Society)

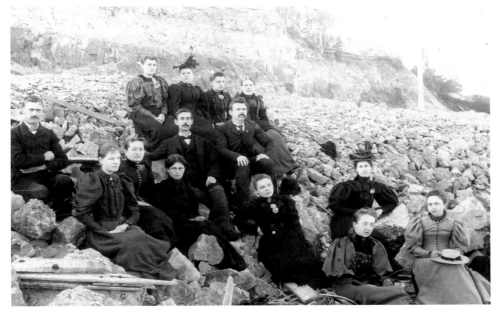

Despite the lack of green grass and picnic tables, these early visitors enjoy the waterfront. (Courtesy of Little Traverse Historical Society)

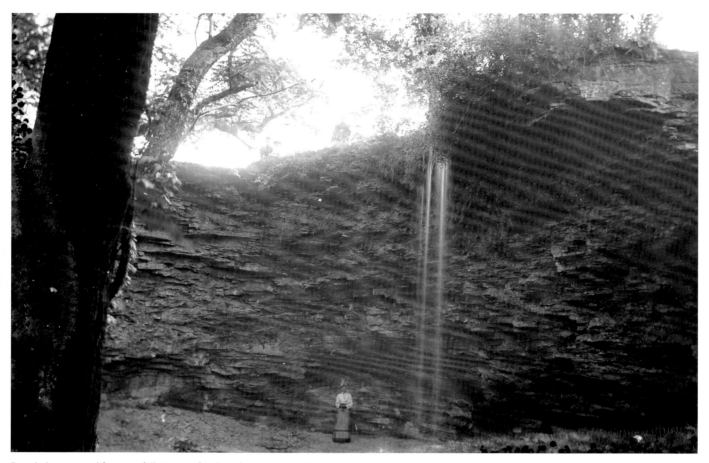

People have posed for waterfall pictures for decades. (Courtesy of Little Traverse Historical Society)

a beautiful waterfront park complex. Rail lines were removed and replaced with the Little Traverse Wheelway—a paved biking and walking trail that largely follows the rail bed's route around Little Traverse Bay to Harbor Springs and, to the south, Charlevoix. While remnants of the past exist—Rose's kiln pond, the limestone façade, the rail station, the pier, and the breakwater—most people know it only as a beautiful place to enjoy the water, picnic, and to view sunsets.

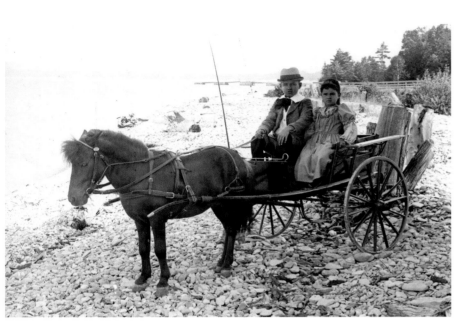

These children were photographed with their pony and cart just east of Bay View.
(Courtesy of Little Traverse Historical Society)

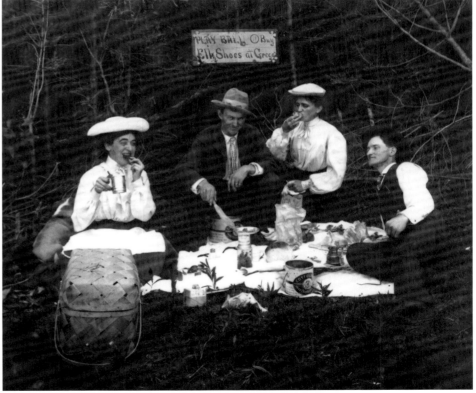

(Courtesy of Little Traverse Historical Society)

When the county courthouse was demolished in the 1960s, its clock was saved and for a while was relocated to the Little Traverse Historical Society's museum. With the waterfront's redevelopment, a replica of the original clock was created and now stands atop the waterfront tower. (Author's collection; Rebecca Zeiss)

(Rebecca Zeiss)

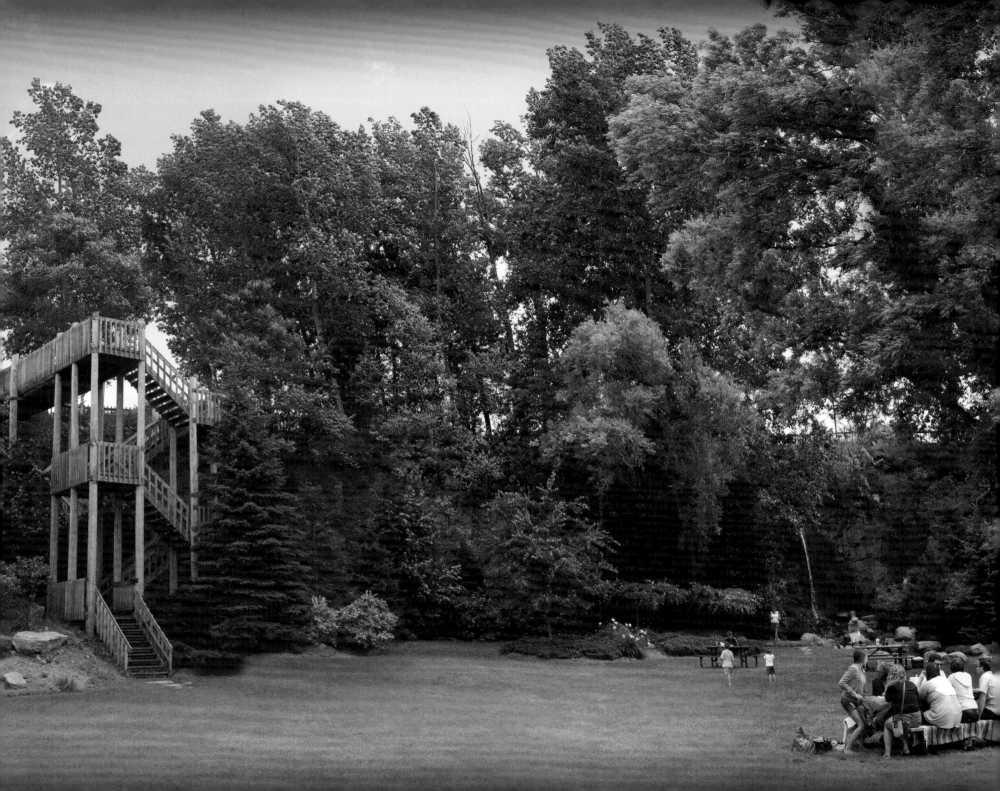

(Rebecca Zeiss)

Lake Street

East Lake Street

East Lake Street is at the center of today's "Gaslight District" and since Petoskey's creation, it and Mitchell and Howard streets have formed Petoskey's commercial heart. Lake Street's early advantage began when the Grand Rapids and Indiana railroad decided to build its first depot on it. This meant that both freight and passengers would unload at that location, and the closer a hotel or business was to the depot, the easier and less expensive it was for customers to reach it. Two hotels sprang up immediately: the Occidental

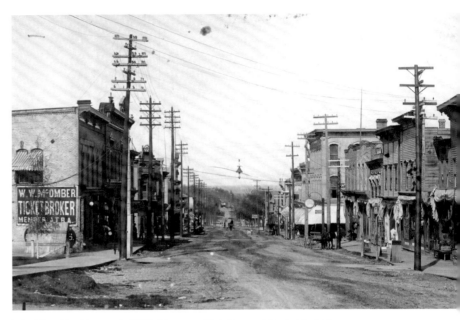

Lake Street looking west, 1889. (Courtesy of Little Traverse Historical Society)

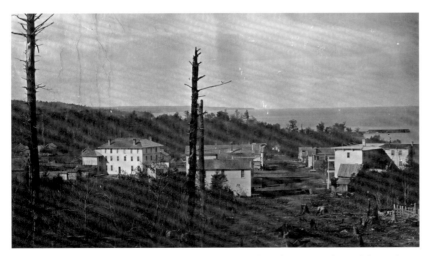

View down Lake Street, 1877. The recently constructed Cushman Hotel is visible on the left. (Courtesy of Little Traverse Historical Society)

(immediately east of the depot on the same side of the street) and the Cushman, across the street. Saloons, dry goods establishments, hardware stores, drugstores, jewelers, bazaars, and specialty shops followed. Always a bit more oriented to catering to the summer visitors than Mitchell Street, Lake Street was the natural pathway for those coming up into town from the waterfront or heading back to catch a ship or Pere Marquette train. This heightened foot-traffic pattern remains in place today.

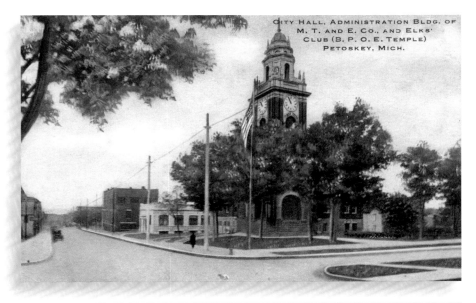

When the former Emmet County courthouse was demolished in the 1960s, its replacement was built at the same site—the corner of Division and Lake streets. (Courtesy of Little Traverse Historical Society)

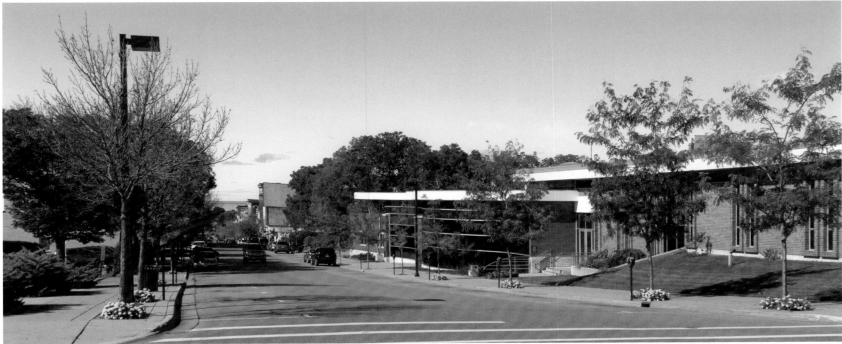

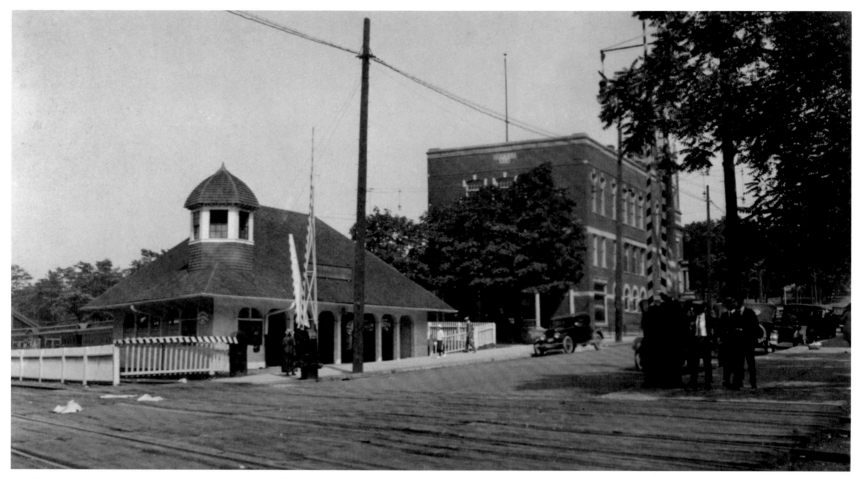

The GR & I suburban station was located next door to the Elks Hall. Neither structure survives; the site is part of the county's government complex.
(Courtesy of Little Traverse Historical Society; Rebecca Zeiss)

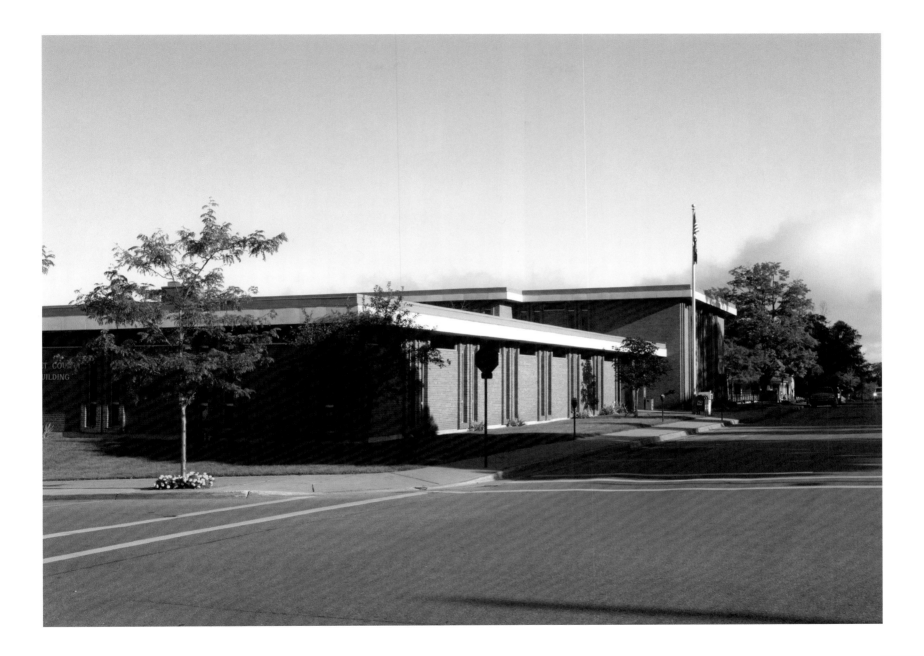

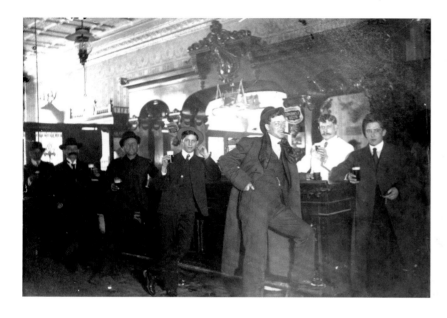

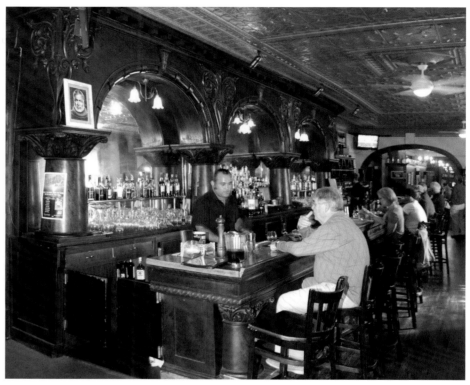

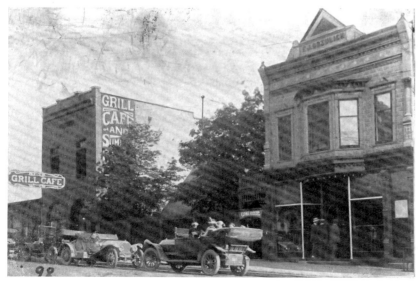

Since 1875 food and drink have been served at 432 East Lake Street. The original McCarthy's Hall was followed by establishments of various names; over time the business grew to include an open-air "Palm Garden" to the east and later, in 1910, the Grill Café building was constructed and guests there enjoyed fine-dining experiences. Patrons at the City Park Grill still sit at the thirty-two-foot-long Brunswick mahogany bar where generations of locals and visitors have lifted glasses. (Courtesy of Clarke Historical Library, Central Michigan University; courtesy of Little Traverse Historical Society; Rebecca Zeiss)

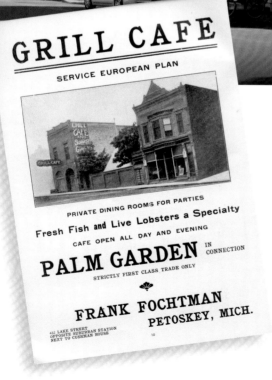

GRILL CAFE

SERVICE EUROPEAN PLAN

PRIVATE DINING ROOMS FOR PARTIES

Fresh Fish and Live Lobsters a Specialty

CAFE OPEN ALL DAY AND EVENING

PALM GARDEN IN CONNECTION

STRICTLY FIRST CLASS TRADE ONLY

FRANK FOCHTMAN PETOSKEY, MICH.

432 LAKE STREET
OPPOSITE SUBURBAN STATION
NEXT TO CUSHMAN HOUSE
10

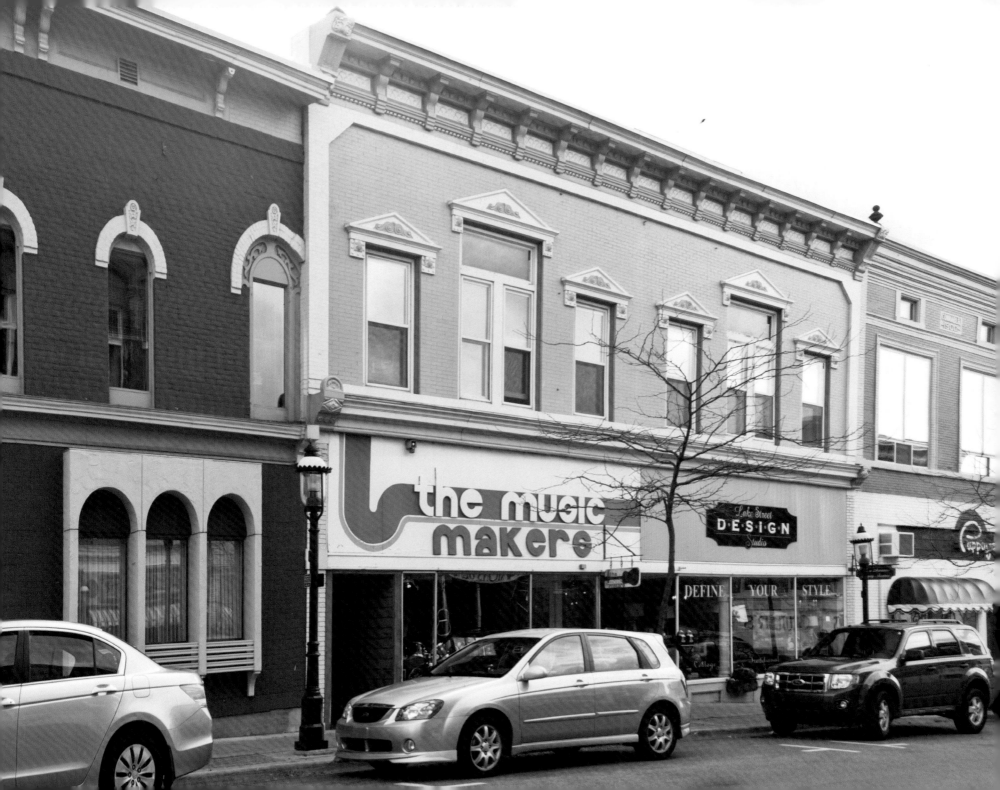

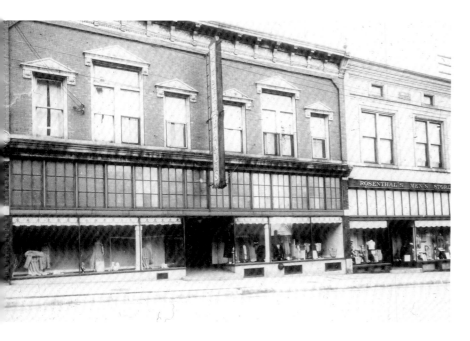

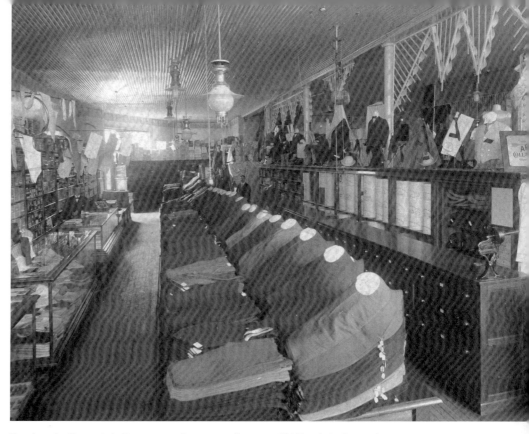

For decades Rosenthals Department Store was a fixture at 406 East Lake Street. Its stock included fine clothes and a whole floor dedicated to carpets. Annual buying trips to major cities ensured that the stock was of high quality and in fashion. (Courtesy of Little Traverse Historical Society; Rebecca Zeiss)

The cluster of buildings at the intersection of Park and Lake streets has hosted a number of businesses over the years and currently is the home of the American Spoon Café.
(Author's collection; Rebecca Zeiss)

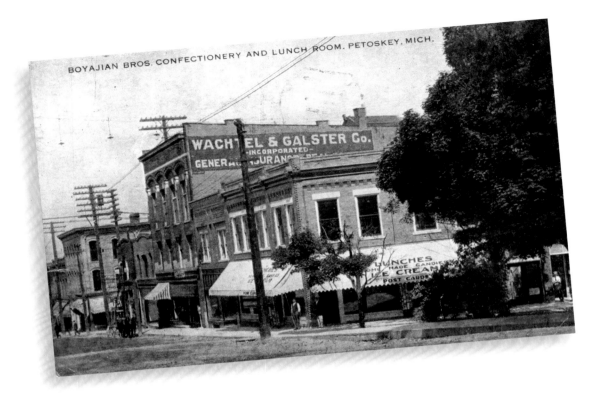

BOYAJIAN BROS. CONFECTIONERY AND LUNCH ROOM, PETOSKEY, MICH.

WACHTEL & GALSTER Co.
INCORPORATED
GENERAL INSURANCE

LUNCHES
HOME MADE CANDIES
ICE CREAM
POST CARDS

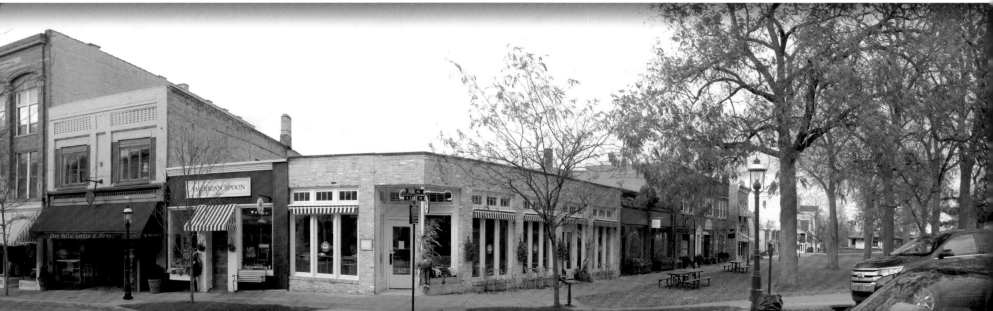

AMERICAN SPOON

Built in 1879, this is said to be the first brick building in Petoskey. Originally the Central Drug Store, it is one of Petoskey's most picturesque storefronts. The site has been Symon's General Store since 1960 and shares a façade with Dave's Boot Shop. (Courtesy of Clarke Historical Library, Central Michigan University; courtesy of Little Traverse Historical Society; Rebecca Zeiss)

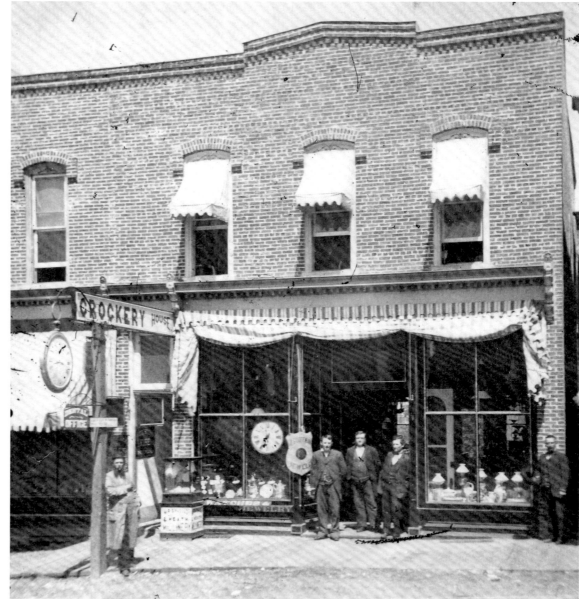

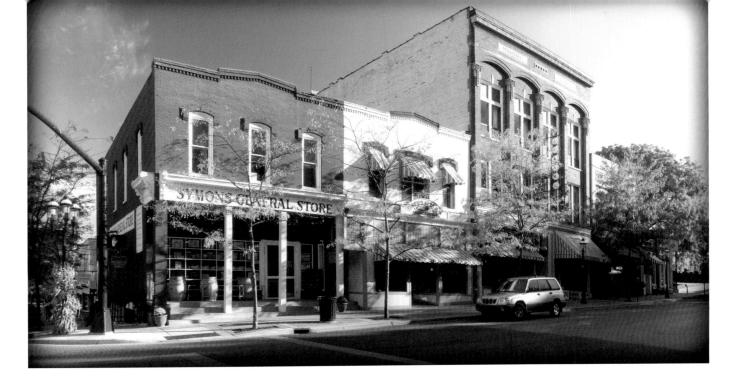

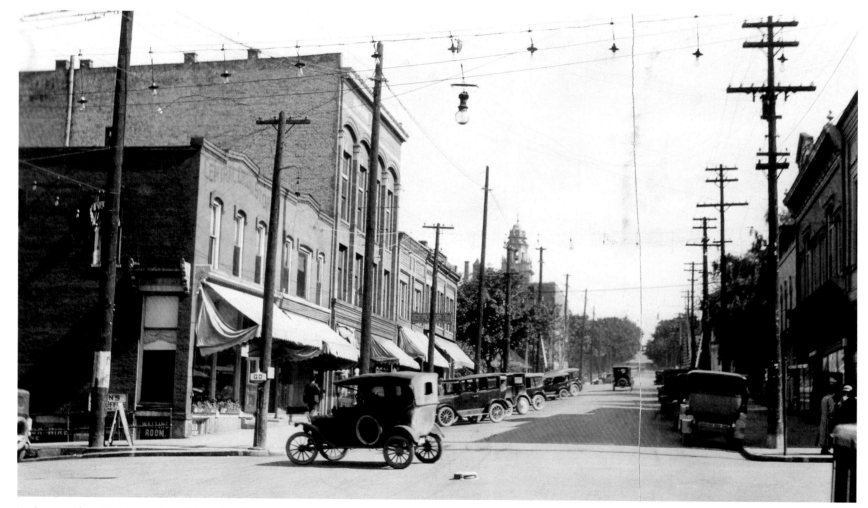

Looking east from the intersection of Howard and Lake streets. (Courtesy of Little Traverse Historical Society)

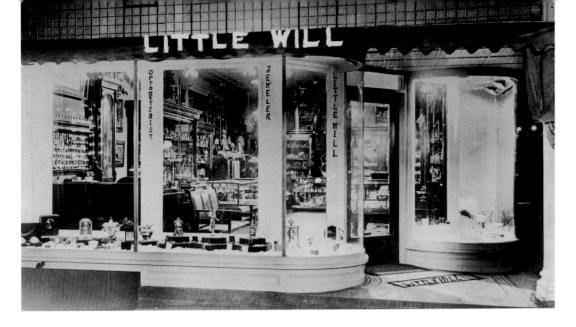

The storefront known today as Cutlers was formerly the home of "Little Will" Searle, who operated a seven-employee jewelry and eyeglass shop there. Arriving in Petoskey in 1882, he spent time traveling between lumber camps selling goods before establishing his business in town. (Courtesy of Little Traverse Historical Society; Rebecca Zeiss)

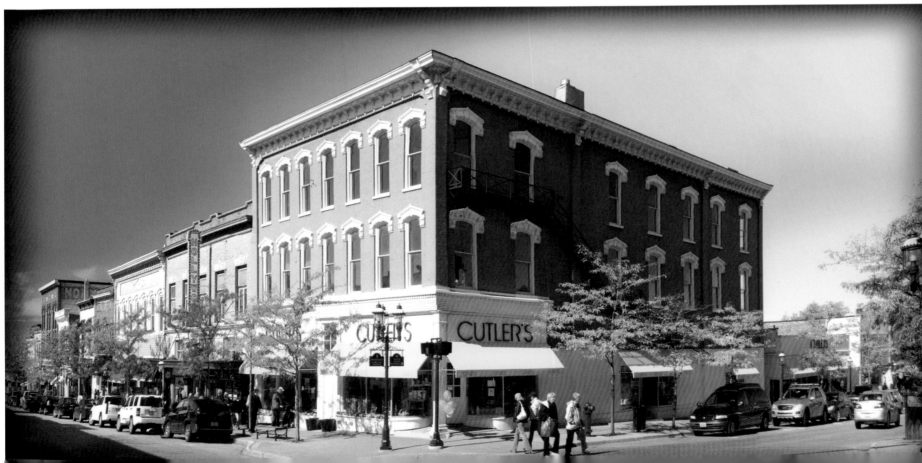

Formerly Levinson's Department Store, this site operated as a theater between 1925 and 1972. The interior was altered by removing most of the second floor to allow for a four-hundred-seat movie house. (Courtesy of Clarke Historical Library, Central Michigan University; courtesy of Little Traverse Historical Society; Rebecca Zeiss)

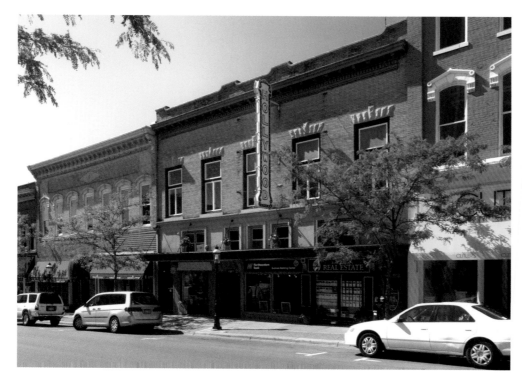

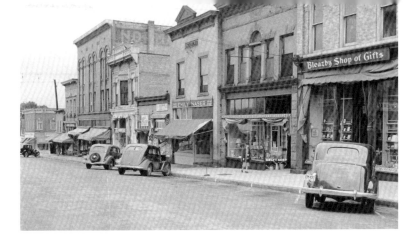

The north side of Lake Street's 300 block looks much the same today as it did decades ago. (Author's collection; Rebecca Zeiss)

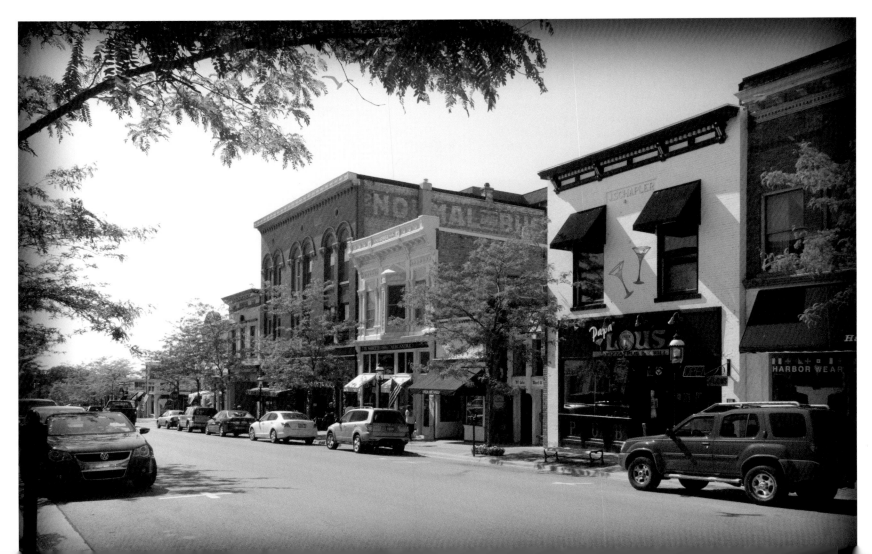

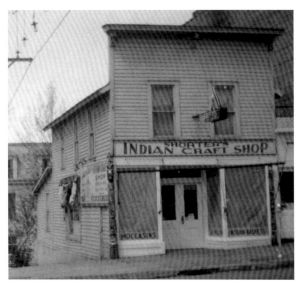

In 1946 Carl and Ruth Shorter opened Shorter's Indian Craft Shop and began selling souvenirs to visitors. Still owned and operated by the Shorter family, the store retains much of its original appearance. (Courtesy of Little Traverse Historical Society; Rebecca Zeiss)

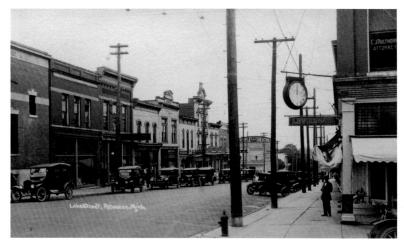

View of the south side of Lake Street's 300 block. The Temple Theater is visible on Petoskey Street, as is the National Hotel in the middle of the block. (Courtesy of Little Traverse Historical Society)

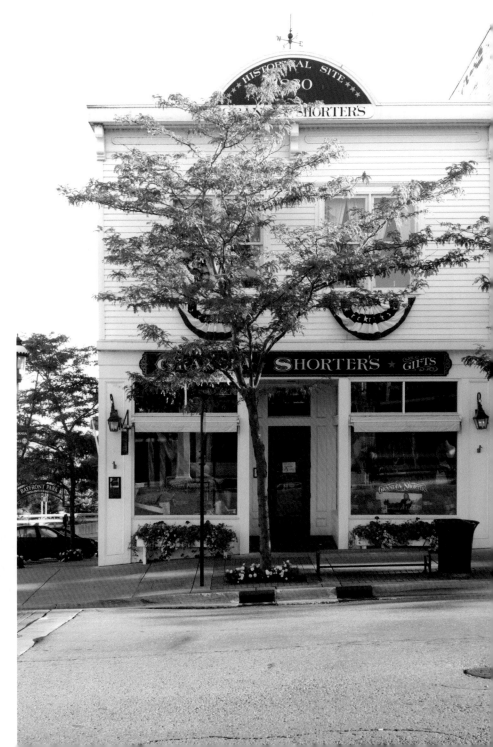

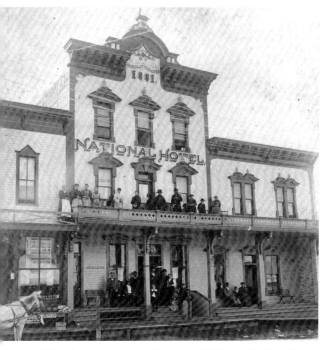

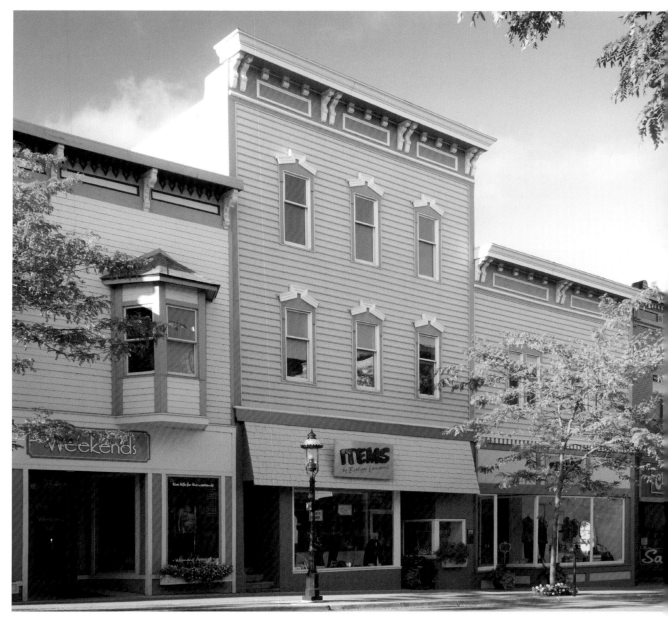

Hiding behind a modern façade at 316 East Lake Street is Petoskey's oldest hotel. Built in 1876 as the Farmers' Home Hotel, it was renamed the National Hotel in 1881. In 1901 a fire destroyed much of the upper floors and the hotel was not reopened, though remnants of the original hotel remain closed off on the upper floors. (Courtesy of Little Traverse Historical Society; Rebecca Zeiss)

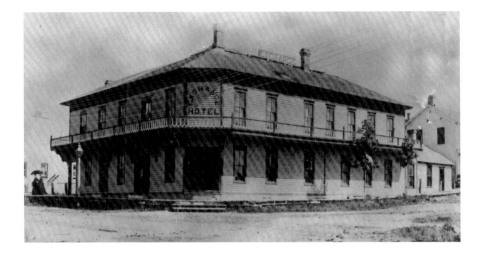

While the National Hotel lies hidden on Lake Street, the Exchange Hotel simply is no more. Formerly located on the southeast corner of Petoskey and Lake streets, the original structure was replaced with modern buildings. (Courtesy of Little Traverse Historical Society; Rebecca Zeiss)

Looking east from the intersection of Petoskey and Lake streets.

(Author's collection; Rebecca Zeiss)

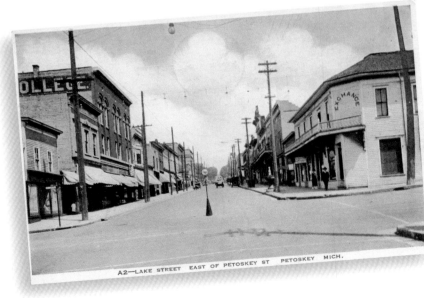

A2—LAKE STREET EAST OF PETOSKEY ST PETOSKEY MICH.

West Lake Street

Mission Church

West Lake Street, the portion west of today's U.S. 31, had a very different personality. Not on the tourist path, it was put to various other uses. In 1859 a Catholic mission church was built there that initially served both white settlers and Native Americans. The St. Francis Solanus Indian Mission Church is thought to be the oldest building standing in the region and is on both the Michigan and National Register of Historic Places. When a new Catholic church,

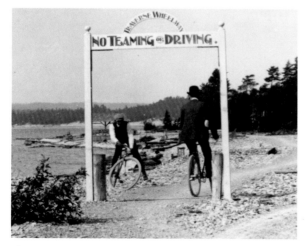

The original Traverse Wheelway signs have been replicated and now stand at various places along the current wheelway.
(Courtesy of Little Traverse Historical Society; Rebecca Zeiss)

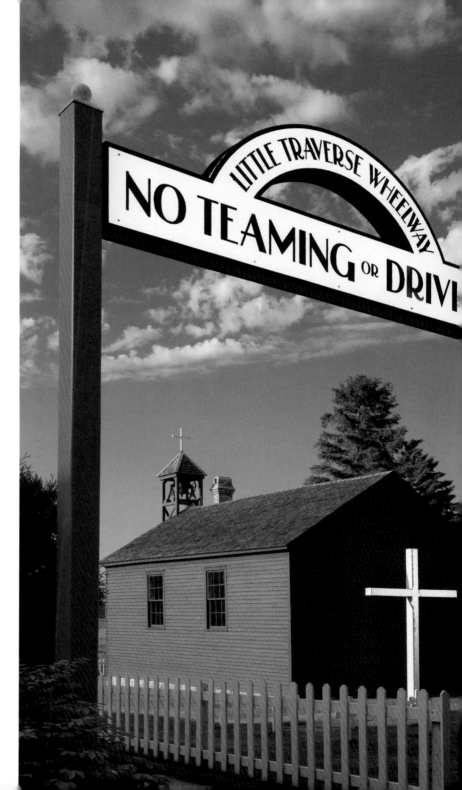

St. Francis Xavier, was built on Howard Street in 1879, the mission church remained in use by Native Americans. Over the years regular services were discontinued and the building fell into disrepair. In 1931 and again in 1959 and 2005 the building was renovated. Currently the church remains an important historical and cultural building where Mass is offered once a year on the feast day of St. Francis Solanus.

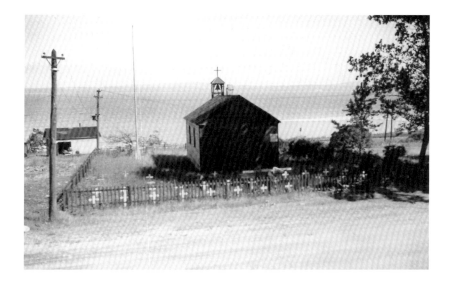

(Courtesy of Little Traverse Historical Society; Rebecca Zeiss)

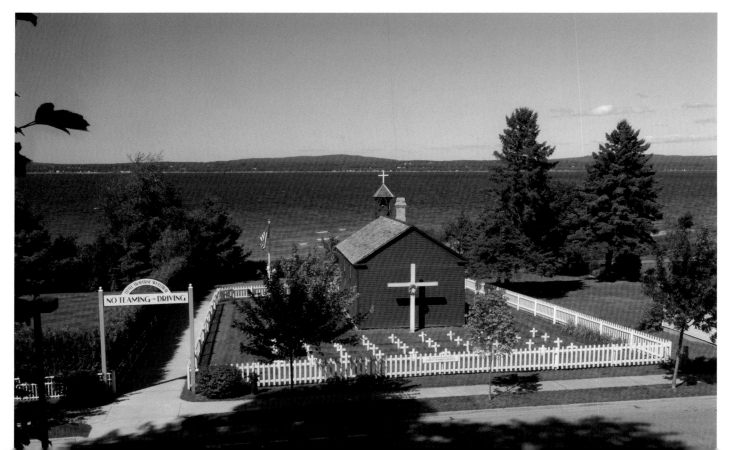

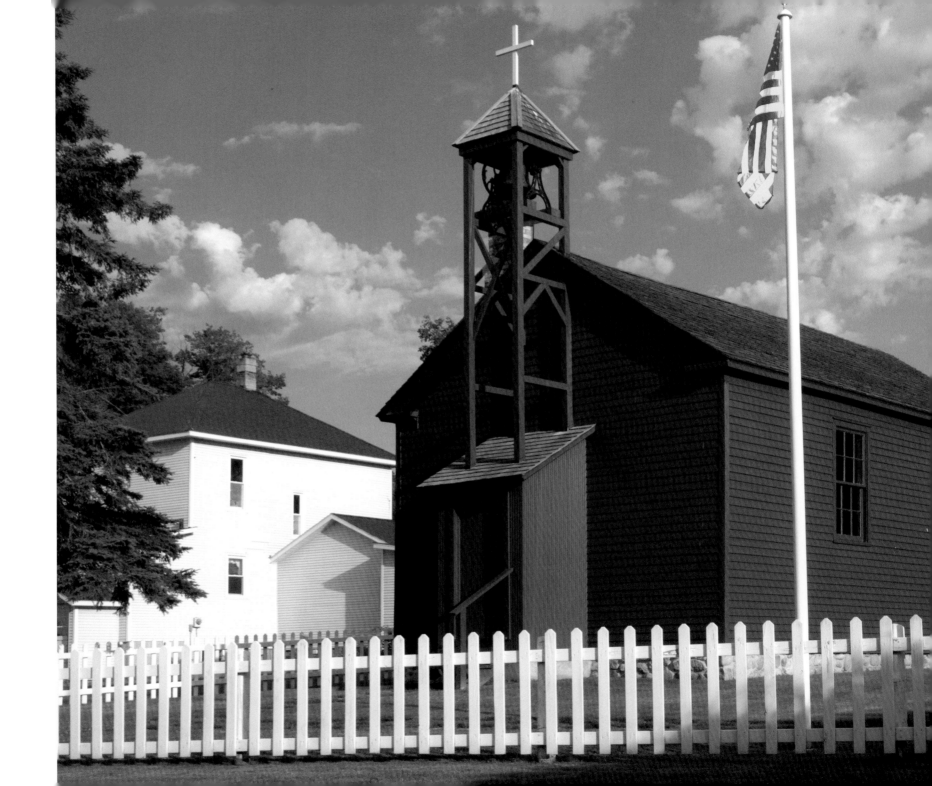

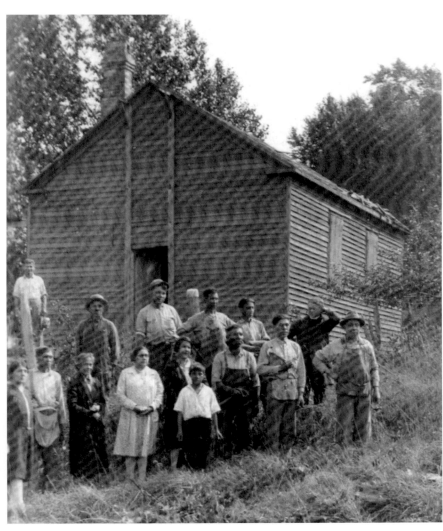

St. Francis Solanus Indian Mission Church. Local Ottawas repaired the church in 1931. (Courtesy of Little Traverse Historical Society; Rebecca Zeiss)

(Rebecca Zeiss)

Mineral Spring

Another historically and currently interesting location is what is known today as Mineral Well Park. In 1878 an oil well was drilled near the Bear River on Lake Street. When a steady flow of mineral water was discovered (rather than oil), entrepreneurs like David Cushman decided to market the water to tourists. Petoskey was already promoting itself as a healthful escape for those suffering from respiratory or other ailments. It was thought the fresh northern air had curative powers, and people by the thousands came to be cured of their asthma or hay fever. In addition to fresh

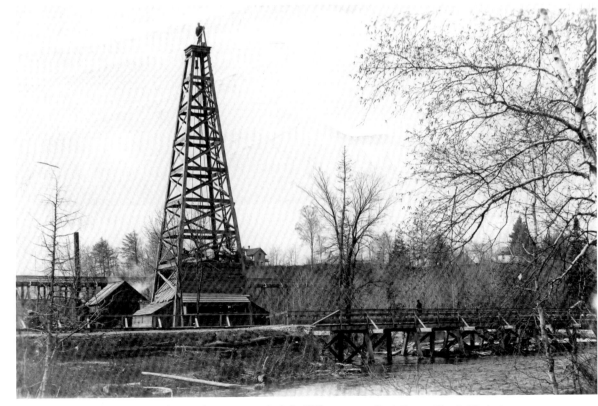

Rigging for a well that discovered mineral water instead of oil, 1878. (Courtesy of Little Traverse Historical Society)

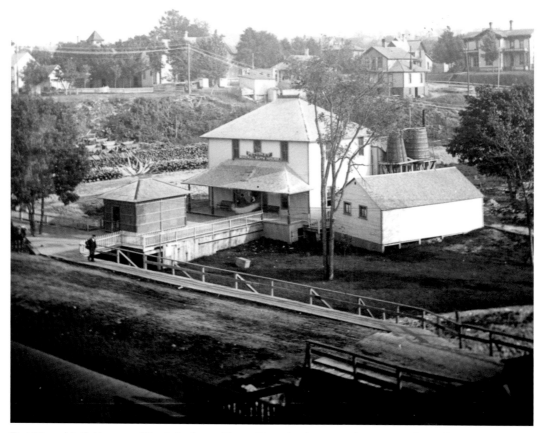

First Mineral Bath House on West Lake Street. The well is under the covered structure in front of the house. Notice the water tanks holding surplus water for the bathers. (Courtesy of Little Traverse Historical Society)

air, mineral baths were promoted across the country for their restorative value. A Mineral Bath House built at the failed oil well site offered guests a leisurely soak in waters that, it was said, would provide health benefits. Drinking the water was also supposed to be healthful, and it was common for people to fill jugs and bottles to take home with them. As the mineral water fad passed, this area was transformed into parkland along the Bear River. The original wooden structure over the spring was replaced by the current concrete one, and over the years generations of visitors and residents have enjoyed picnics here.

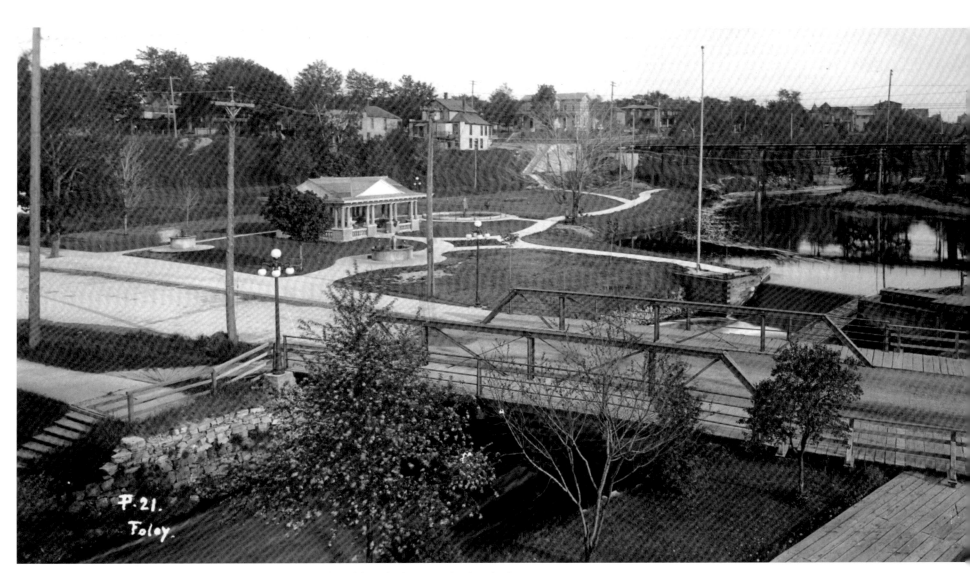

By the 1920s the bathhouse was gone and the area turned into a park. Visible in the foreground is the Lake Street bridge over the Bear River. (Courtesy of Little Traverse Historical Society)

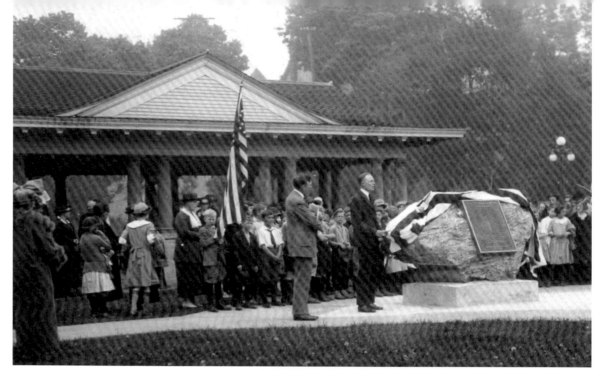

In the early 1920s World War I veterans erected a monument in front of the pavilion. This has since been moved to Pennsylvania Park (Courtesy of Little Traverse Historical Society; Rebecca Zeiss)

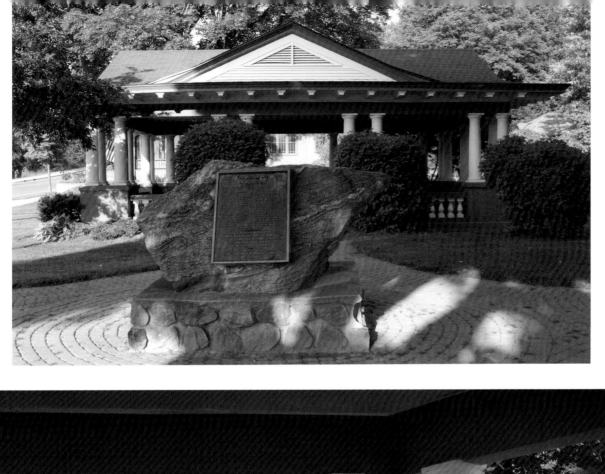

Mitchell Street

Mitchell Street began as a place primarily for local residents to do business, and it has to some extent retained that purpose over the decades. In general, Lake Street was more likely to have seasonal shops catering to summer visitors and residents, but Mitchell covered the basics for year-round residents; it was the home of department stores (J. C. Penney, Montgomery Ward, Woolworth's, Fochtman's), hardware stores, and grocery stores (A&P, Kroger), the library, and churches. Initially development happened only east of the rail tracks, but the commercial area would eventually spread west over the Bear River Bridge.

Mitchell Street, 300 Block

Mitchell Street's 300 block has a mix of old and new structures. At 318 East Mitchell is a three-story building originally named the Coburn Building. Over the years this structure has housed the Palace Meat Market, hardware stores (Bump and Waldron and then Easton and Co.), and Cook Electric. On either side of Coburn Building there have been significant changes both in structures and uses. To the east (at 320 and 322 East Mitchell)

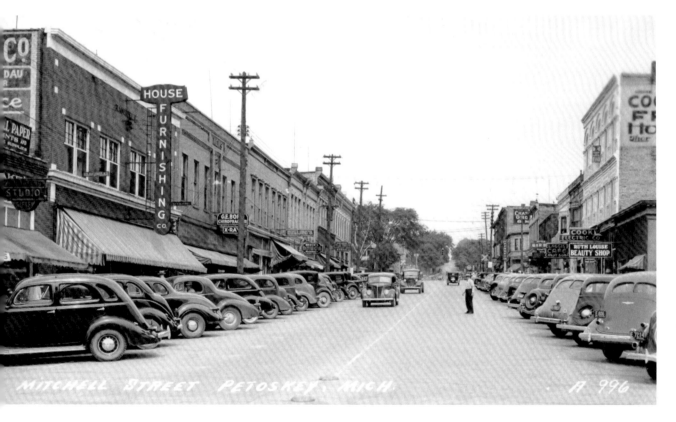

Looking east from the intersection of Petoskey and Mitchell streets. (Author's collection)

Despite the changing façades, the buildings at the northeast corner of Petoskey and Mitchell streets are recognizable (Courtesy of Little Traverse Historical Society; author's collection; Rebecca Zeiss)

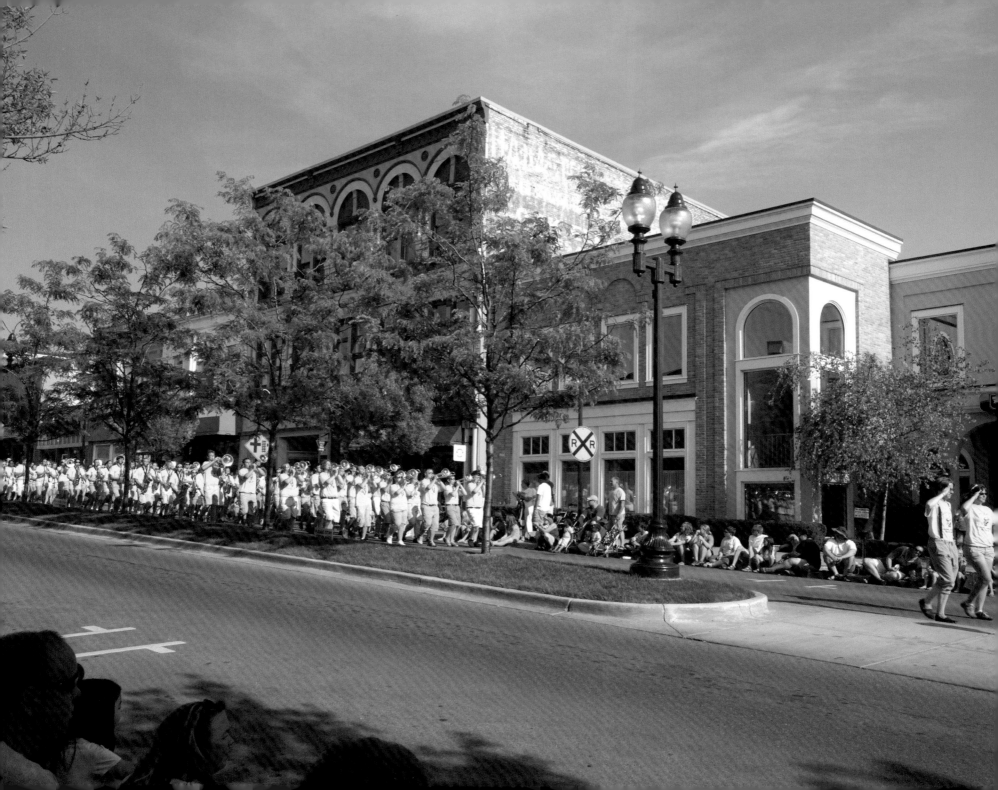

is an 1893 building used as a drugstore. To the west of it—where the Fifth Third Bank is now located—stood an ornate post office building that was demolished when the current one was built at a different location. On the north side of the street are longtime home furnishings and children's apparel stores.

It's interesting to see how buildings often change physically, though the type of business conducted at the site does not. An example is the northwest corner of Mitchell and Howard streets, where Watchel and Quinlan opened Petoskey's first bank. Start-up banks needed to instill confidence in potential clients and what

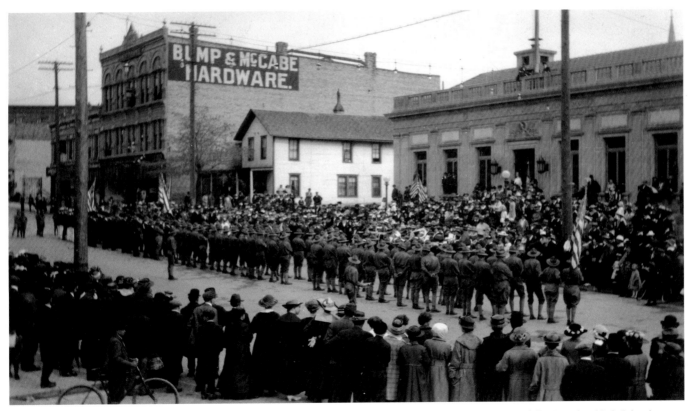

There is a long tradition of parades passing by this block. Shown here are ones honoring World War I veterans and the Petoskey High School band on the Fourth of July. (Courtesy of Little Traverse Historical Society; Rebecca Zeiss)

better way to do that than to build a substantial building that (on the inside and out) would assure people that their money was safe. Over the years that original bank was succeeded by others, including the First State and (currently) Chase Bank. While Petoskey's pioneers might not recognize the current building (the original structure was torn down—as was a subsequent one—and the façade has had frequent adjustments), they certainly would remember that corner as being one where there was a bank.

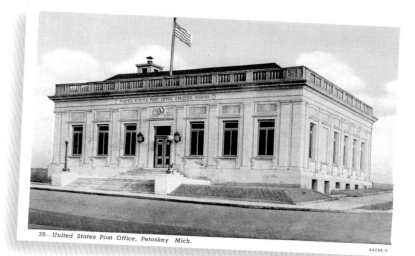

For decades the Petoskey post office was located at the southeast corner of Petoskey and Mitchell streets. That site is now occupied by 53 Bank. (Author's collection; Rebecca Zeiss)

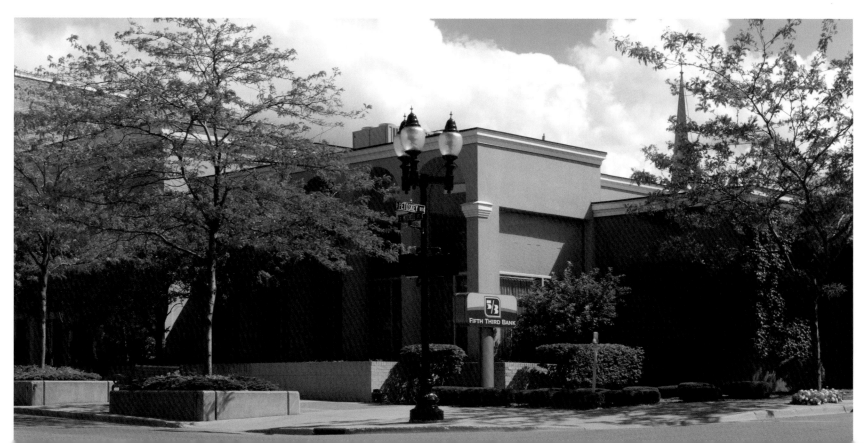

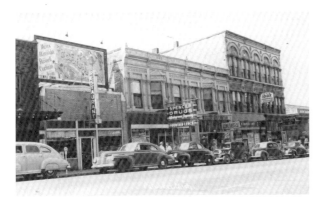

The south side of the 300 block of Mitchell Street looking from the east. The Coburn Building is on the far right. (Courtesy of Little Traverse Historical Society; Rebecca Zeiss)

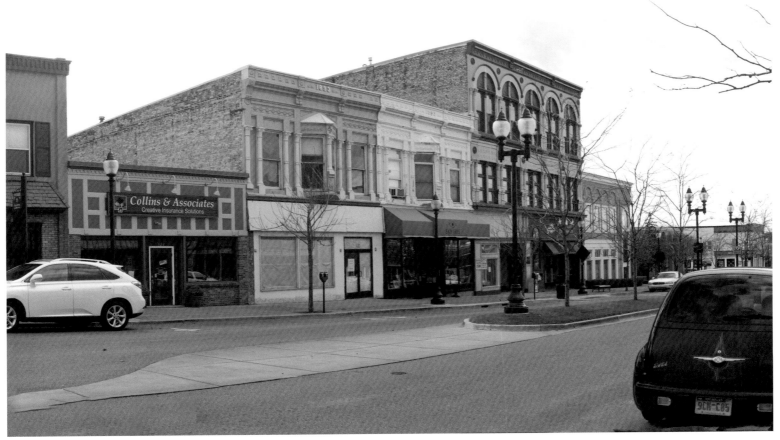

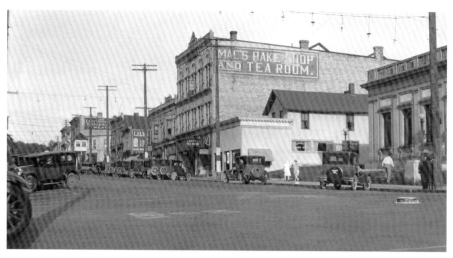

The south side of the 300 block of Mitchell Street looking from the west. (Courtesy of Little Traverse Historical Society; Rebecca Zeiss)

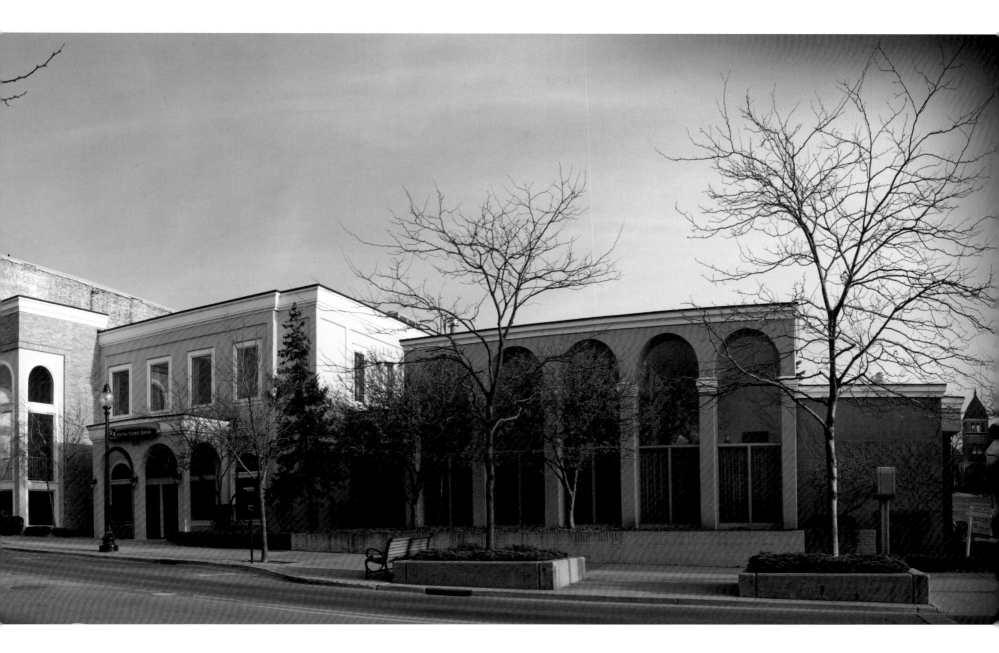

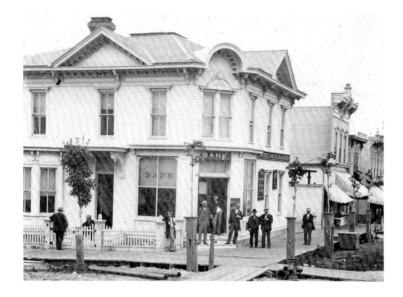

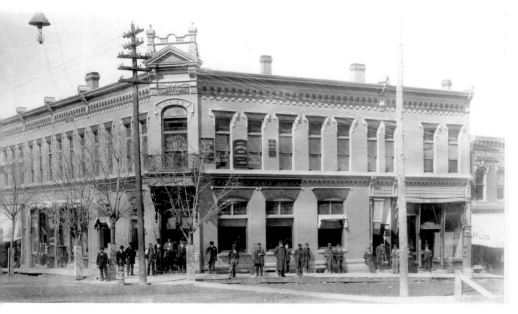

The evolution of the banks at the corner of Howard and Mitchell streets. (Courtesy of Little Traverse Historical Society)

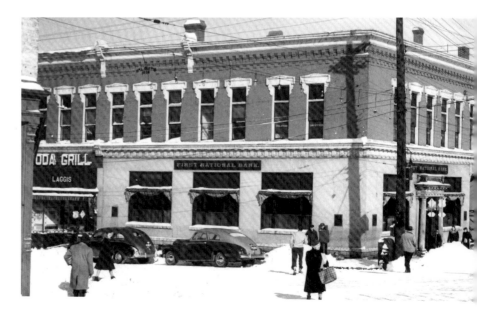

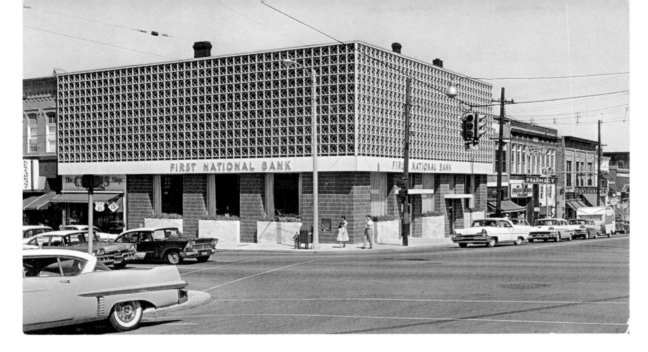

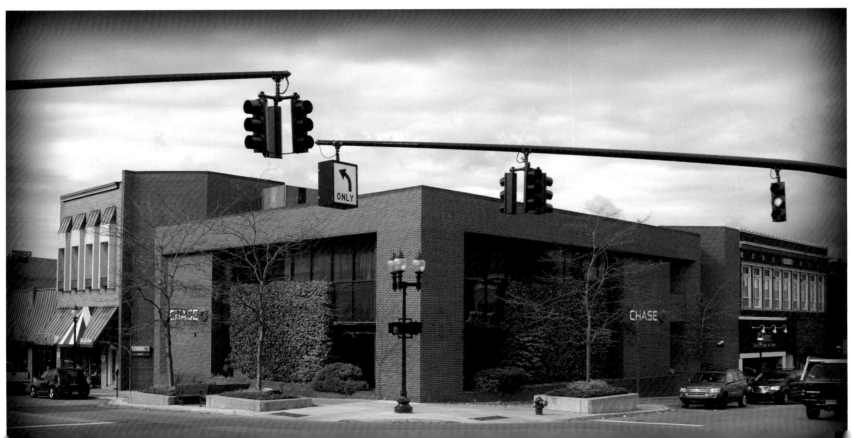

(*Left:* Author's collection; *below:* Rebecca Zeiss)

Mitchell Street, 400 Block

Mitchell Street (east of Howard Street) is the site of some of Petoskey's oldest commercial history. When the first hotels were erected on Lake Street in the 1870s, buildings also began to go up on Mitchell. The Clifton and Central hotels anchored the block, with the Rose and Butters store supplying early settlers with necessary dry goods. Over time, meat markets, department stores, auto dealerships, cigar shops, and liveries would meet commercial needs, while churches and the library addressed spiritual and intellectual ones. Today Mitchell Street retains this eclectic mix of businesses.

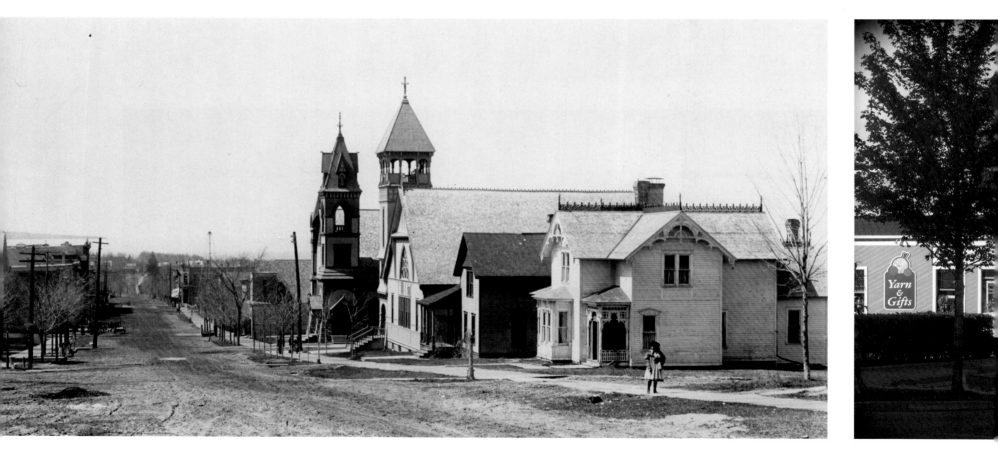

Looking west toward the 400 block of East Mitchell Street. (Courtesy of Little Traverse
Historical Society; Rebecca Zeiss)

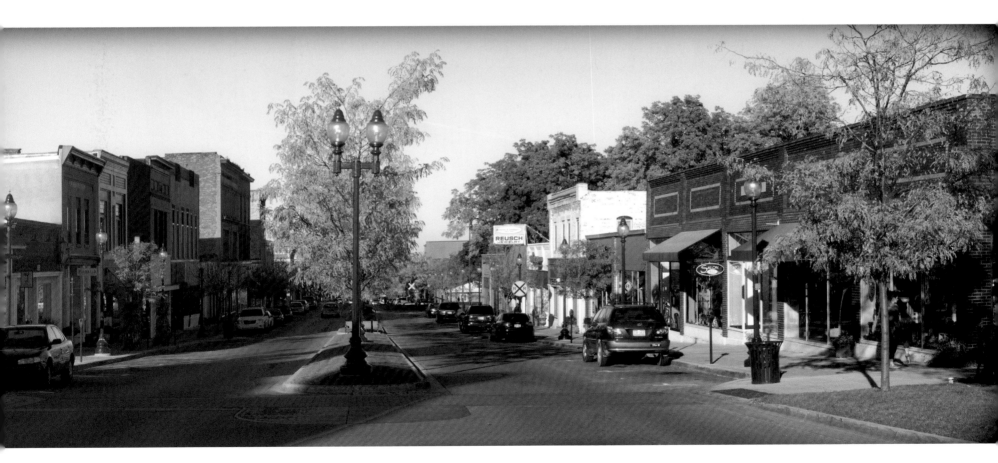

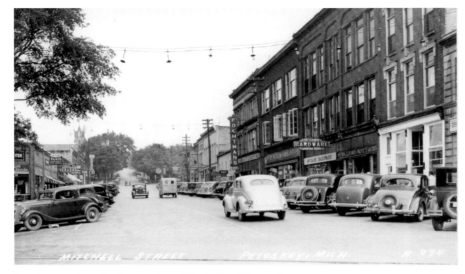

Looking east from the intersection of Mitchell and Howard streets. (Author's collection; Rebecca Zeiss)

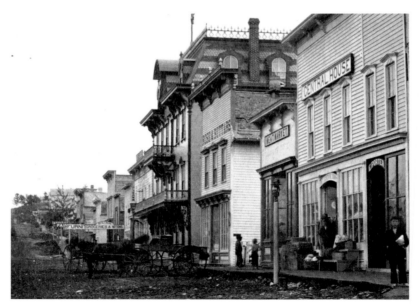

This 1870s image showing both the Clifton and Central hotels. Between them is the Rose and Butter store. The Central was located where J .C. Penney is now. (Courtesy of Little Traverse Historical Society)

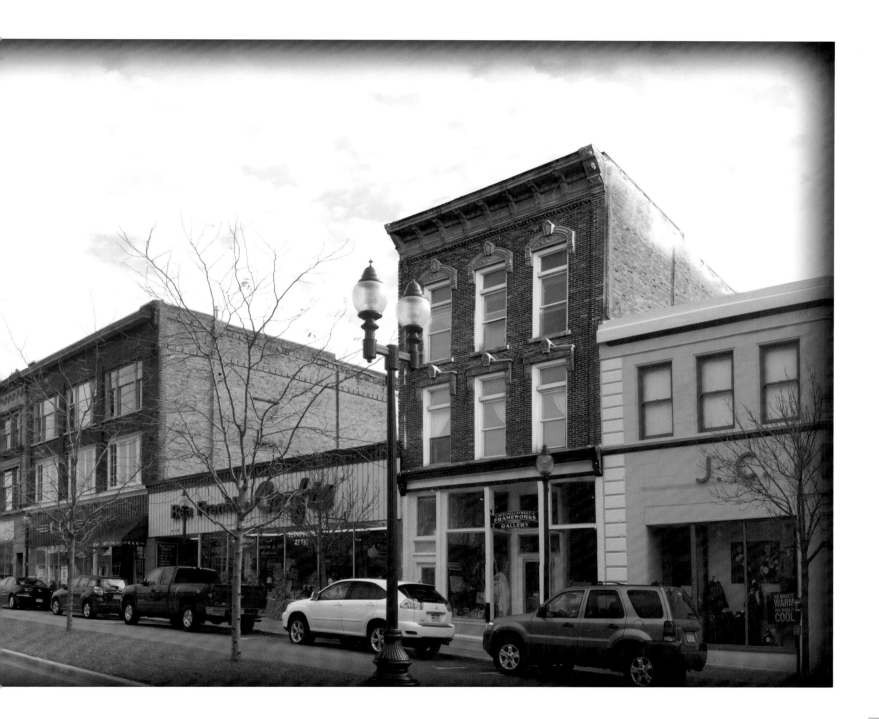

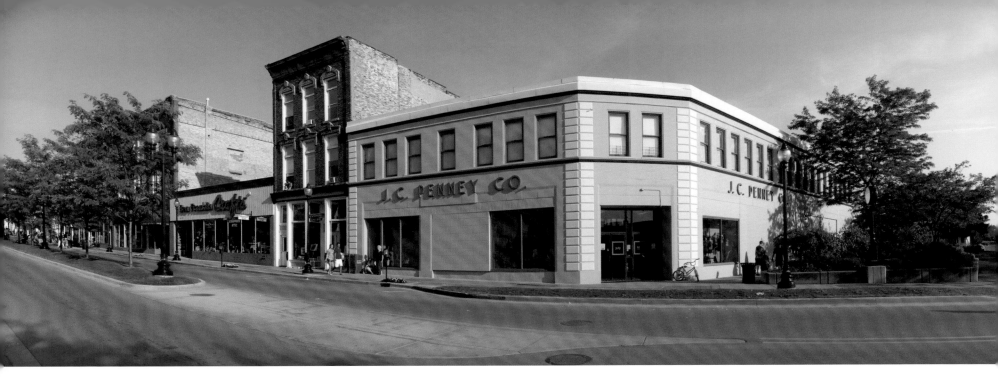

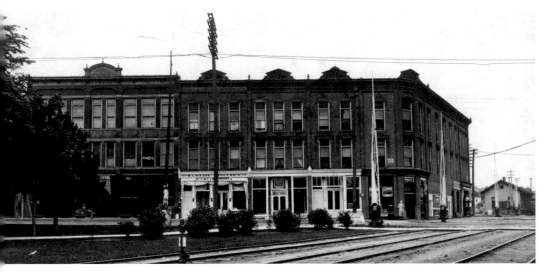

Generations of people recognize the J. C. Penney store, but few realize the structure was built in 1926 at the site of what was previously known as the Fochtman Block. (Courtesy of Little Traverse Historical Society; Rebecca Zeiss)

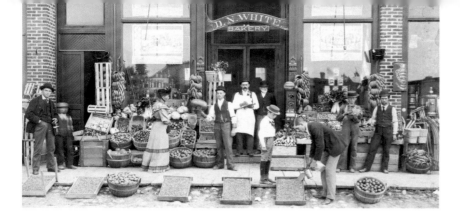

This page and page 156: When the Fochtman Block buildings were torn down, the building at 416 East Mitchell remained. Over the years it commonly served as a grocery store and now houses Mitchell Street Frameworks. The façade is one of the best preserved on Mitchell Street. (Courtesy of Little Traverse Historical Society; courtesy of Clarke Historical Library, Central Michigan University; Rebecca Zeiss)

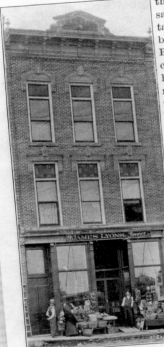

James Lyons, Grocer.

James Lyons, of 12 E. Mitchell St., came to this city in 1889, and has made a success of the wholesale and retail grocery business Previous to coming here he had been manager in the same business in Manistique He employs several men, and his business extends through the northern part of Michigan, besides an excellent retail business in and about Petoskey He also furnishes supplies for many boats.

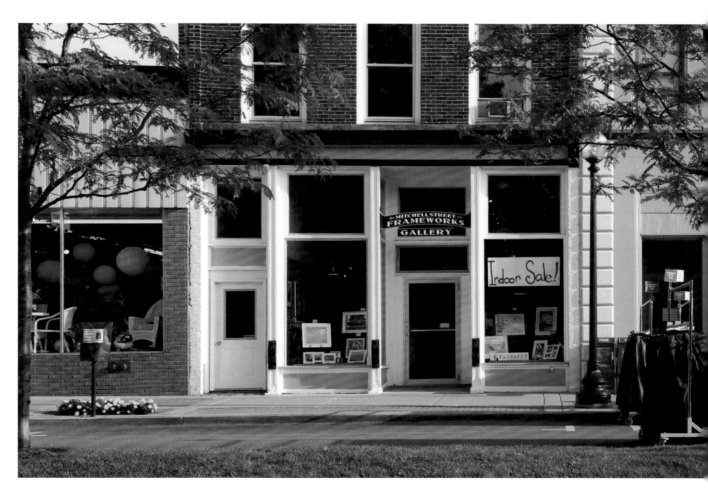

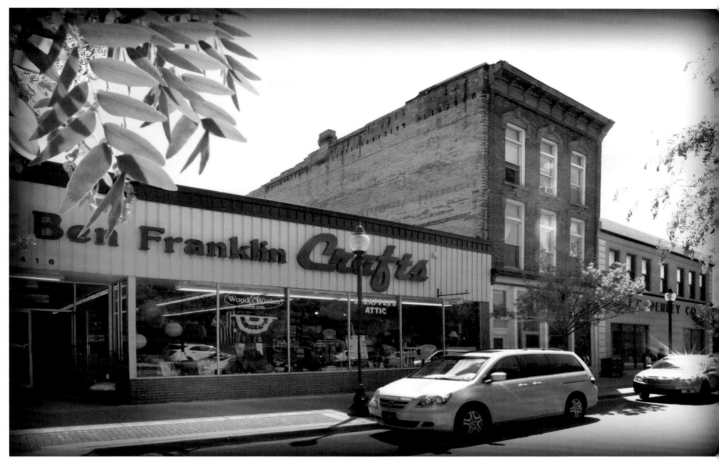

Built in 1893, the Gates Building stood until it burned in 1963. The site is now the current Ben Franklin store. (Courtesy of Little Traverse Historical Society; Rebecca Zeiss)

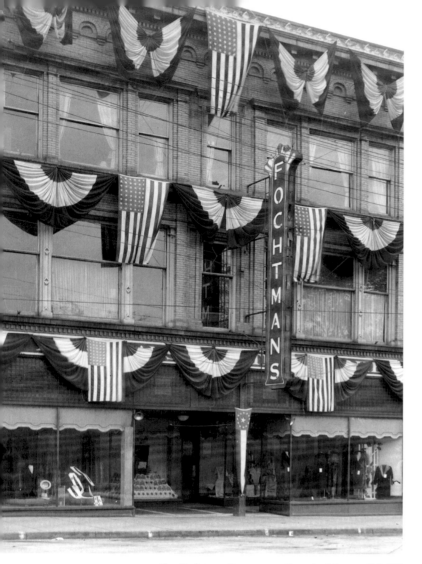

The Fochtman Department Store building at 418–420 East Mitchell Street is a Petoskey landmark. Built in 1904 immediately adjacent to the Clifton Hotel, this store was Adolphus (A. D.) Fochtman's second on Mitchell Street and featured the first elevator in northern Michigan. Surviving a 1914 fire, the business prospered until the Great Depression led to closure in 1935. "AD Fochtman" is still visible on the façade. (Courtesy of Little Traverse Historical Society; Rebecca Zeiss)

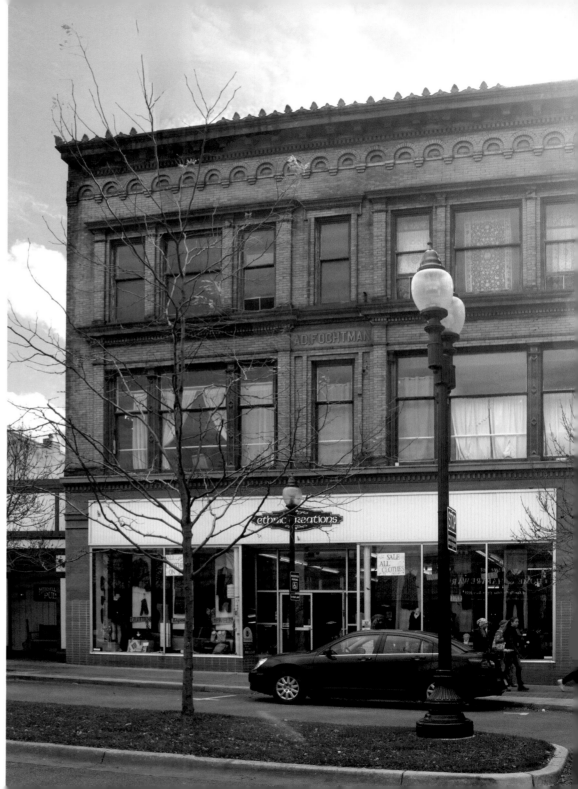

The view from the park showing the Fochtman building. The Fochtmans bought the adjacent Clifton Hotel in 1911 and then discontinued its use as a hotel. (Courtesy of Little Traverse Historical Society; Rebecca Zeiss)

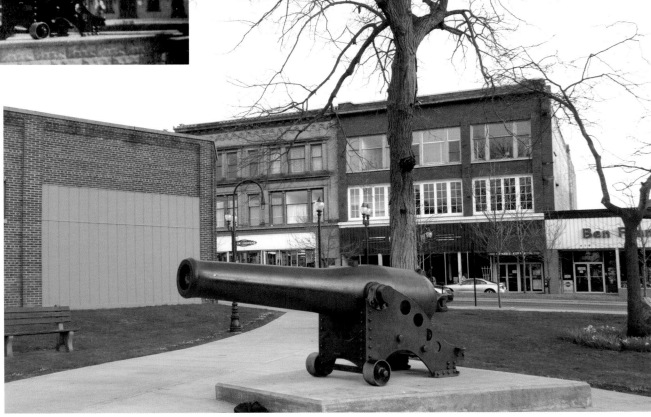

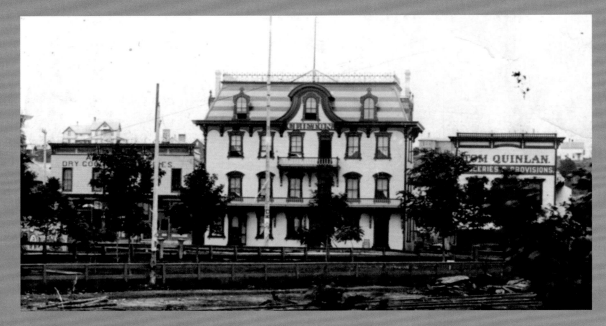

Built as the City Hotel in 1875, the Clifton was one of Petoskey's earliest hotels. J. A. C. Rowan took over ownership in 1879, and in 1882 it was enlarged to stand three stories tall with a French mansard roof. The second story, without interior walls, was the setting for annual Mossback balls. In this photo, A. D. Fochtman's original wooden store can be seen to the immediate left. (Courtesy of Little Traverse Historical Society)

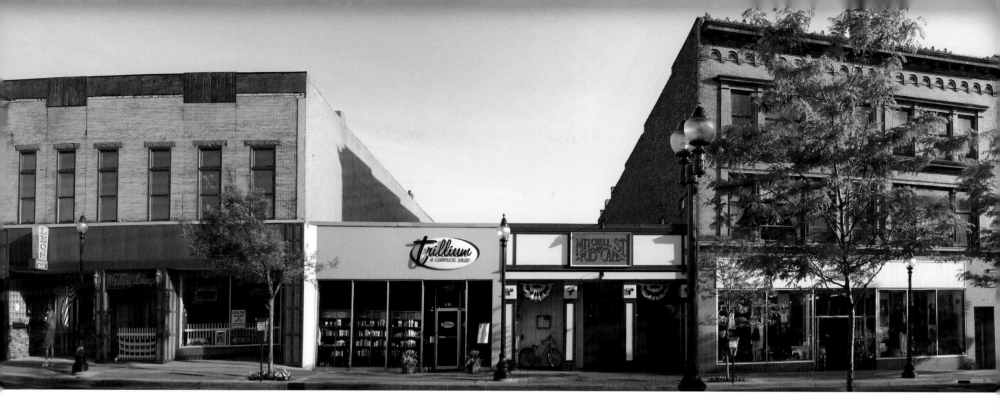

Immediately east of the Fochtman building (at 426 and 430 East Mitchell) are current businesses the Mitchell Street Pub and Trillium. (Courtesy of Little Traverse Historical Society; Rebecca Zeiss)

Aided by a grant from Andrew Carnegie, the Petoskey Public Library was constructed in 1908 and served as the community's library until 2004. In 1919 a young Ernest Hemingway spoke here to the Petoskey Ladies Aid Society about his recent World War I experiences. This historic photo, taken April 1, 1909, shows a Petoskey Brewing Company delivery wagon in front of the library building. (Courtesy of Little Traverse Historical Society; Rebecca Zeiss)

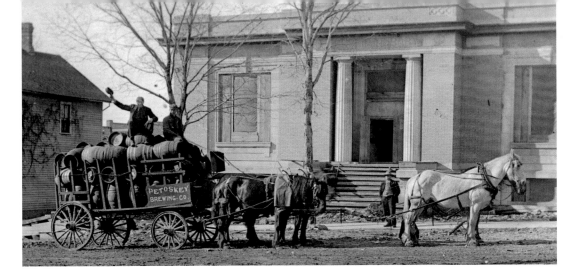

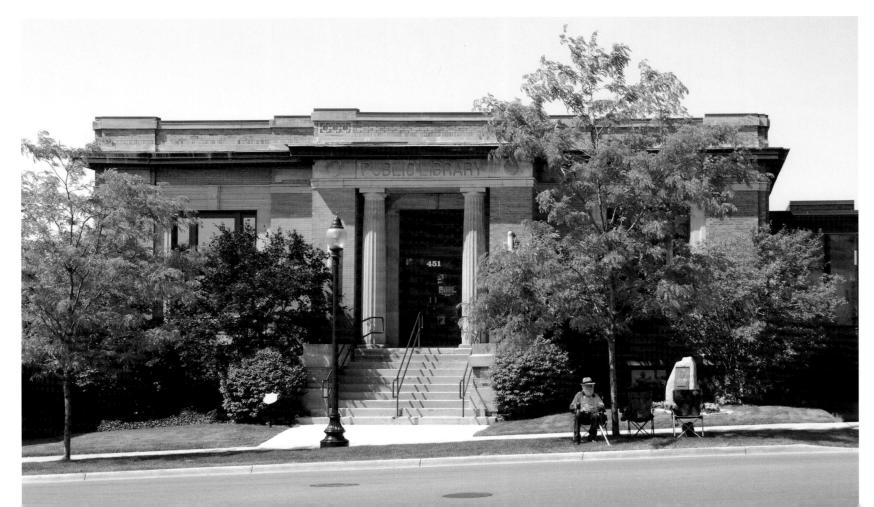

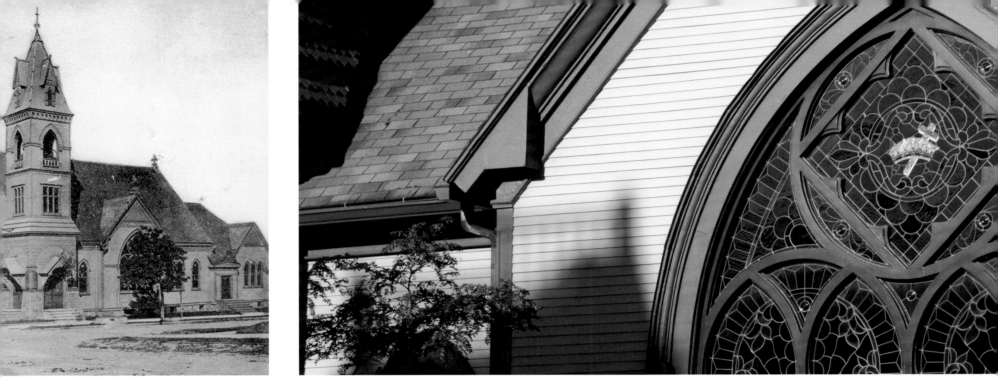

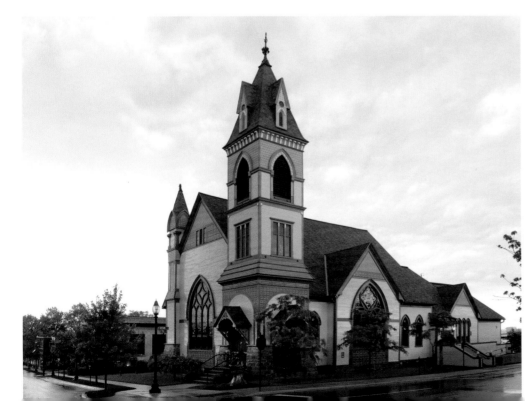

The Crooked Tree Arts Center has made
splendid use of the former Methodist church
at the corner of Mitchell and Division sreets.
(Author's collection; Rebecca Zeiss)

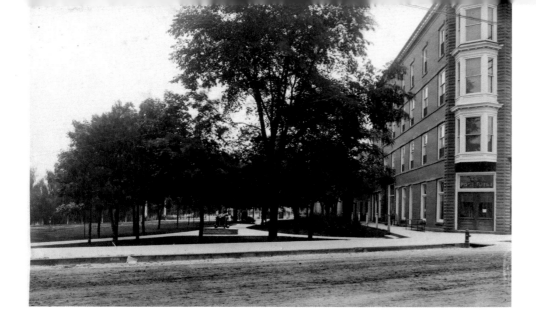

Most customers at the Meyer Ace Hardware store at 421 East Mitchell would be surprised to know that the building began life in 1899 as a four-story, fifty-room brick annex to the Cushman Hotel. When the Cushman was closed in the 1930s, the older wooden structure was torn down, but the newer brick part was saved and converted. (Courtesy of Little Traverse Historical Society; Rebecca Zeiss)

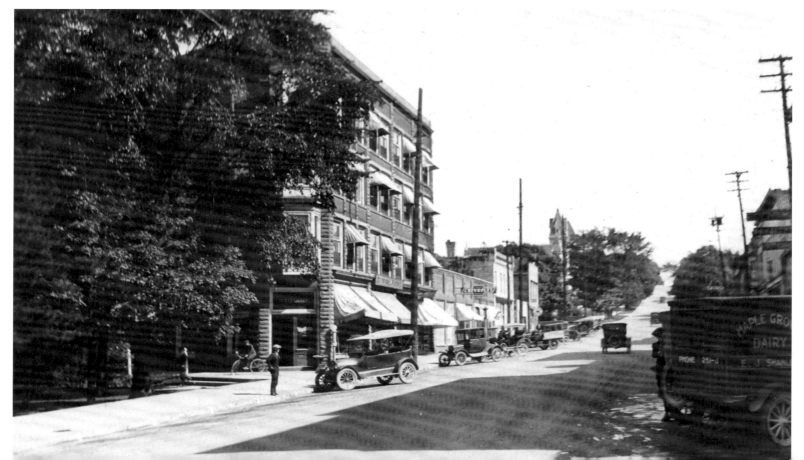

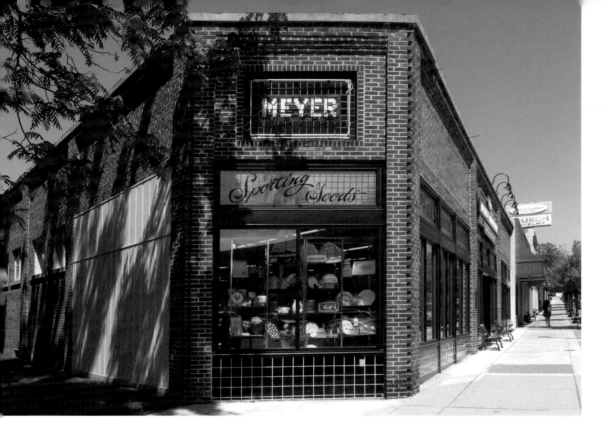

Howard Street

Howard Street has long been a connection between Lake and Mitchell streets. In many ways it is one of the most architecturally unchanged streets in Petoskey. Prominently located on its southwest corner with Lake Street is the original First State Bank building, which retains its original look and purpose. This street has housed drug and shoe stores, barbershops, and the Palace Theater, one of Petoskey's first movie houses. The flatiron building's unique shape has remained unchanged, though the types of businesses occupying its spaces have varied greatly.

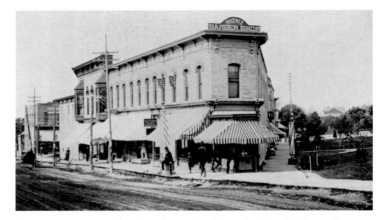

The structure commonly referred to as the flatiron building has housed a number of businesses. For years it was the site of the Phoenix and then McCarthy's barbershops. (Courtesy of Clarke Historical Library, Central Michigan University; courtesy of Little Traverse Historical Society; Rebecca Zeiss)

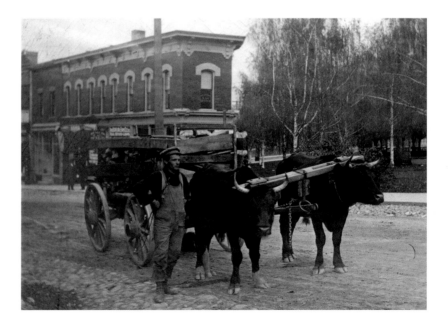

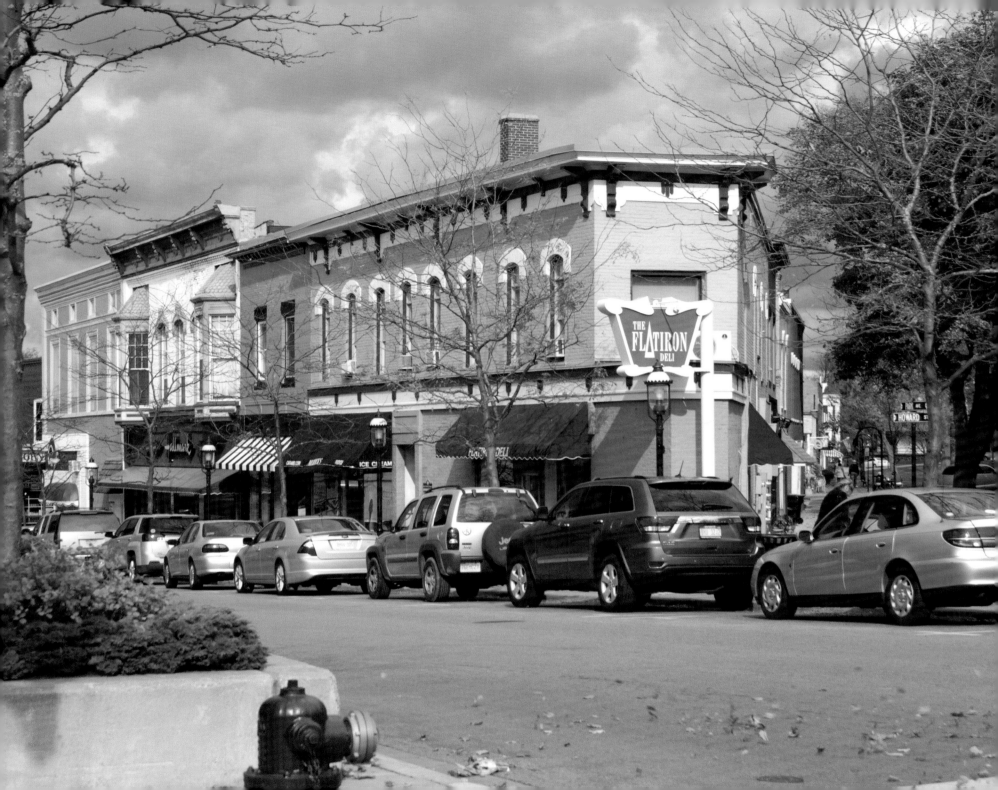

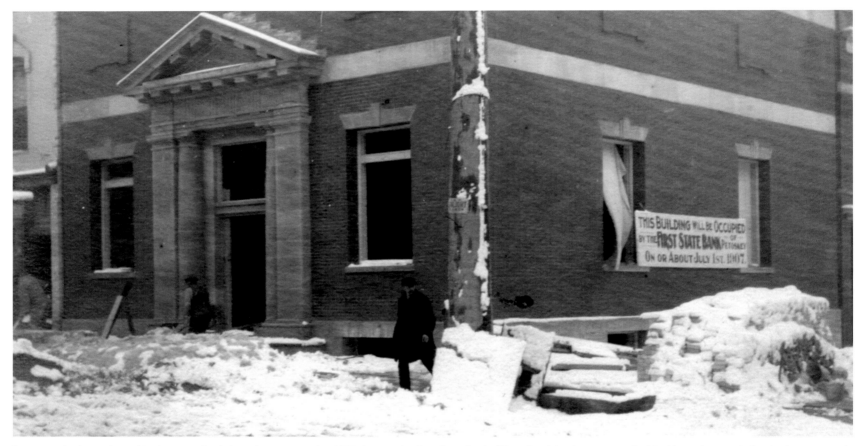

Patrons today know this as Northwestern Bank, but when it opened in 1907, this was the First State Bank of Petoskey. Like the corner at the block's southern end, this site has remained a bank for over one hundred years. (Courtesy of Little Traverse Historical Society)

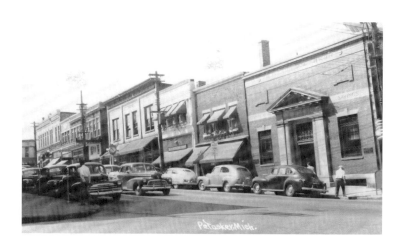

The west side of Howard Street between Lake and Mitchell streets. (Courtesy of Little Traverse Historical Society; Rebecca Zeiss)

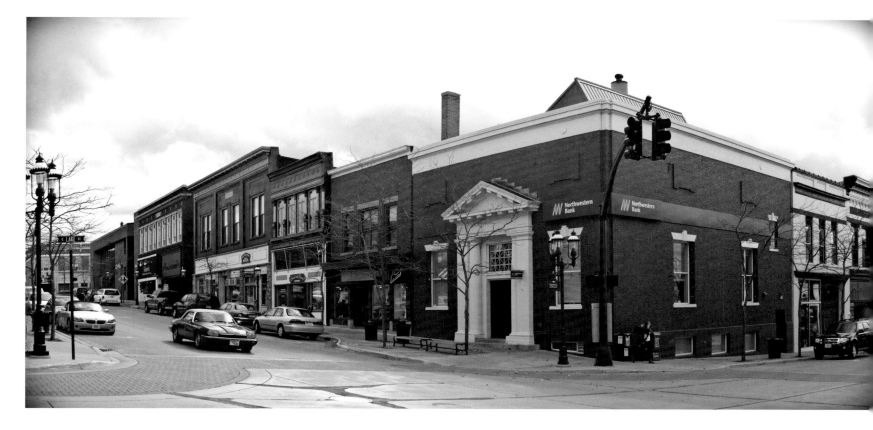

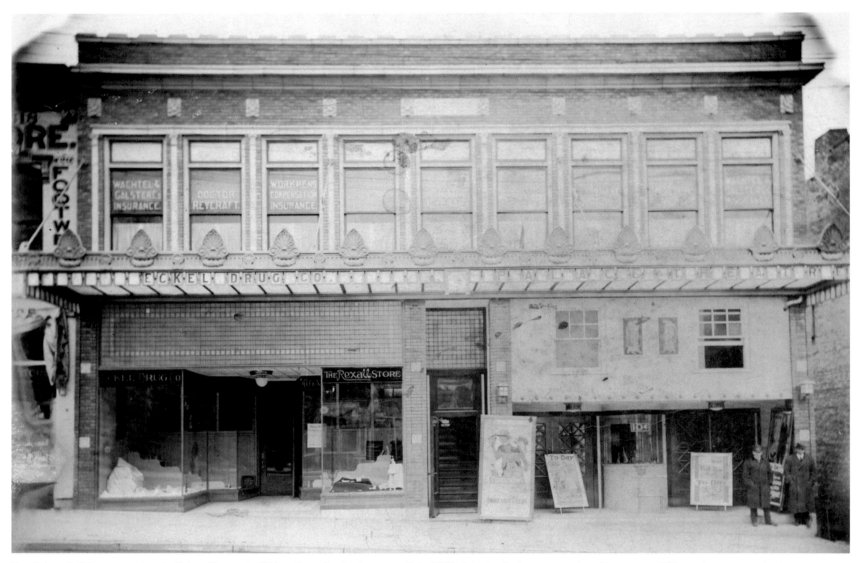

The Galstar Building opened as the Palace Theater in 1916 and remained a theater until the 1950s. It had a single screen and could seat up to 347 people. (Courtesy of Little Traverse Historical Society; Rebecca Zeiss)

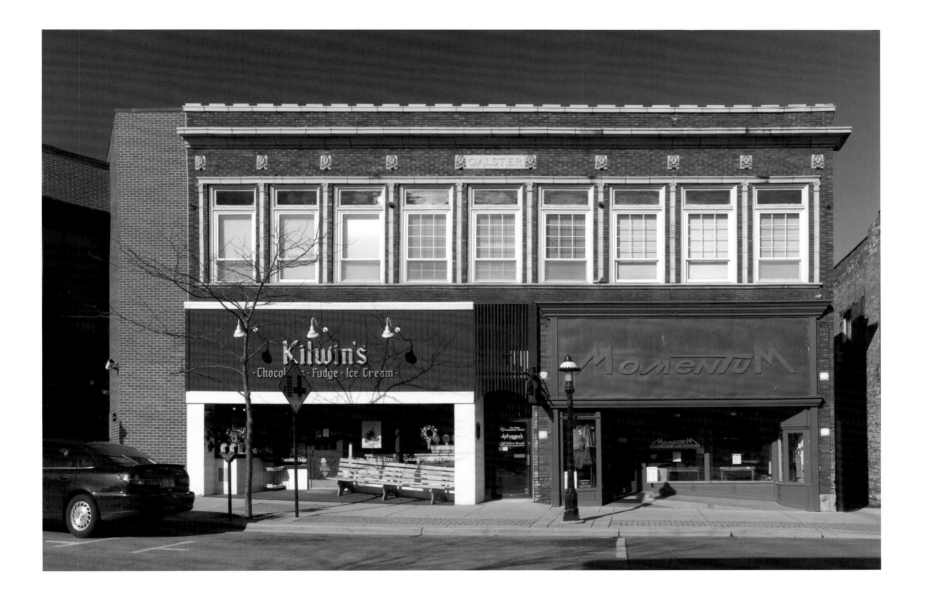

Pennsylvania Park

The green space that spreads between Bay and Mitchell streets is today known as Pennsylvania Park. Its use as a beautiful leisure spot for picnics, gazebo concerts, and art fairs is a far cry from what formerly was a busy railroad thoroughfare where over one hundred trains a day passed on the three side-by-side sets of tracks. Early on, Grand Rapids and Indiana Railroad officials recognized that having a rail yard in the center of a tourist town was not a good idea and set about making it more attractive (and less industrial). To that end they hired a landscape architect to transform it into a "pleasure park" with attractive walks and croquet and archery grounds. A grove of trees was planted and a gazebo was built.

One park landmark known to generations of residents and visitors alike is the nine-inch Dahlgren naval cannon. This particular

This view, taken atop the Cushman Hotel, looks southwest over the park toward the corner of Howard and Mitchell streets. (Courtesy of Little Traverse Historical Society)

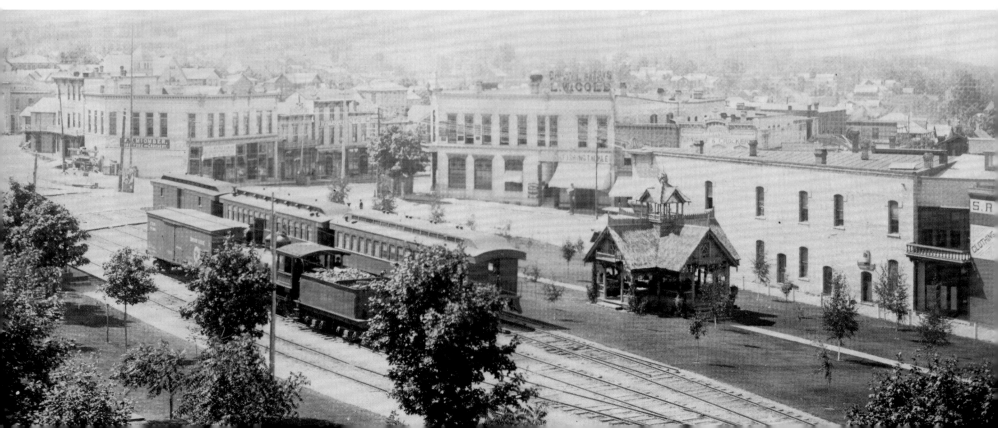

one (number 249) was cast in 1859 in Boston and saw service in the Civil War on Admiral David Farragut's flagship, the USS *Hartford,* during the battle of Mobile Bay in 1864. (This was the battle in which Farragut issued the famous phrase, "Damn the torpedoes, full speed ahead!") It was donated by the Women's Relief Corps

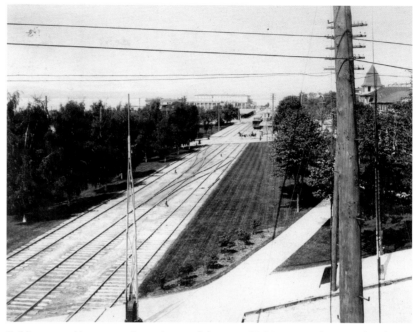

Rail lines stretching across the park toward the main GR & I station. This was taken from Mitchell Street looking north toward Lake Street. (Courtesy of Little Traverse Historical Society)

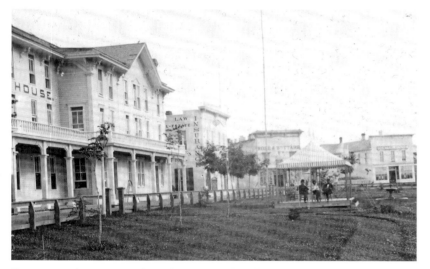

This image, taken ca. 1880, shows the eastern edge of the park with the Cushman Hotel on the immediate left and the Rose and Butters store and Central Hotel on Mitchell Street in the background. Notice that the initial tree planting has begun. (Courtesy of Little Traverse Historical Society)

in honor of the Grand Army of the Republic (GAR) Civil War veterans and was dedicated at the park on July 4, 1905. Since its instillation, it has served not only as a popular gathering spot for people, but also as a climbing challenge for countless children.

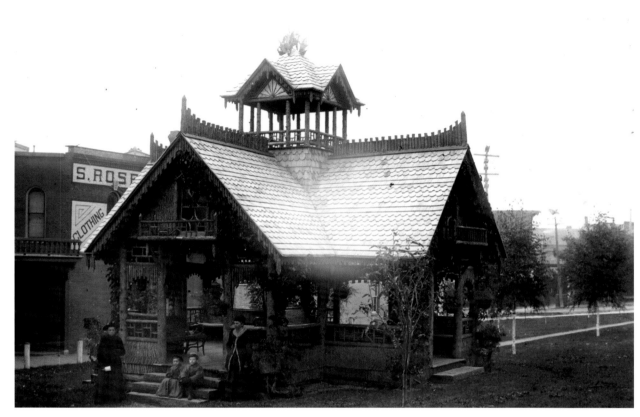

The original park gazebo was created in an Adirondack style. (Courtesy of Little Traverse Historical Society; Rebecca Zeiss)

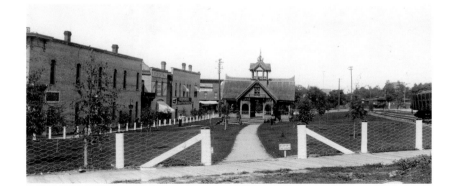

The cannon has been and remains a popular spot to gather.
(Courtesy of Little Traverse Historical Society; Rebecca Zeiss)

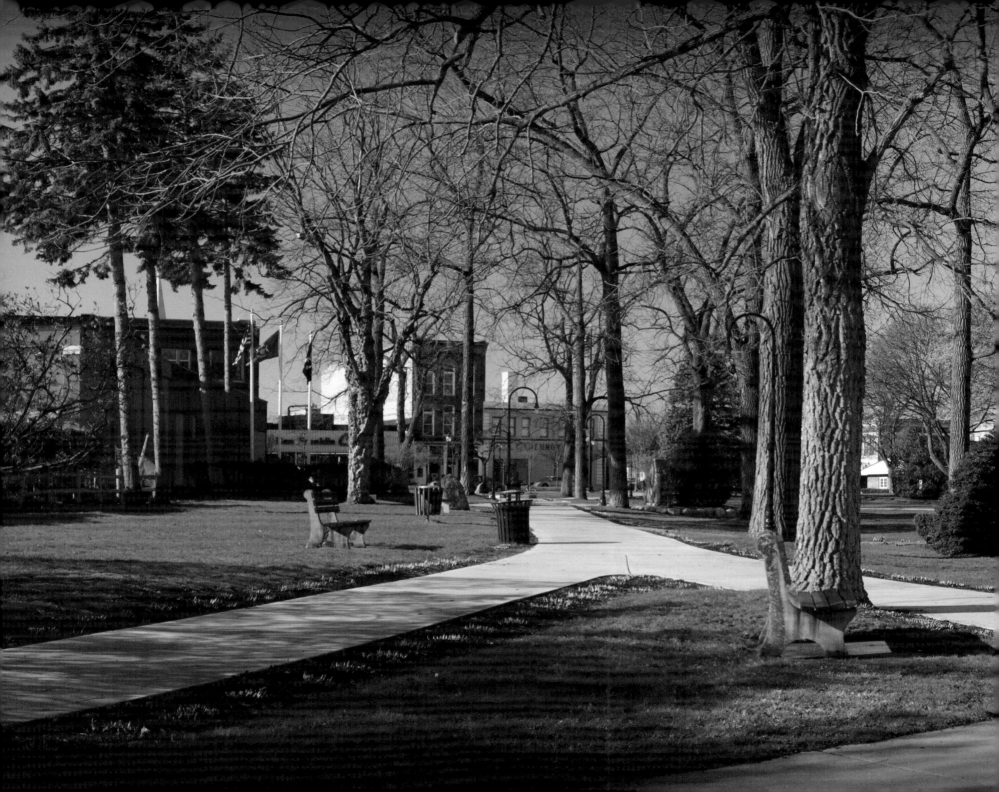

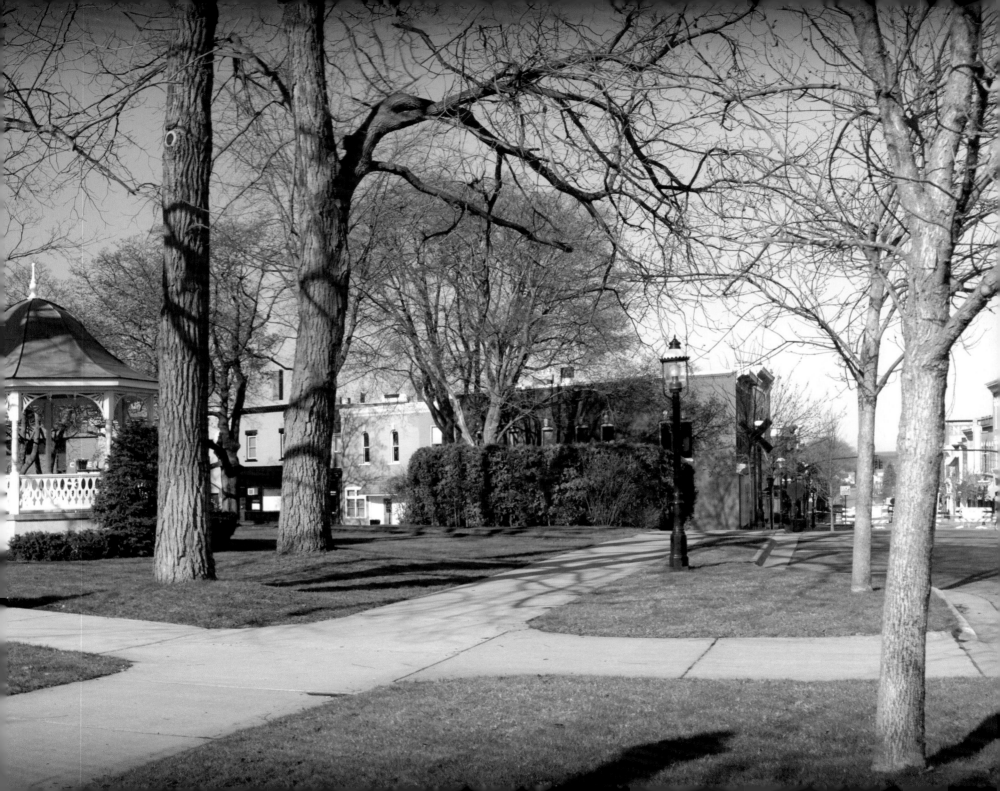

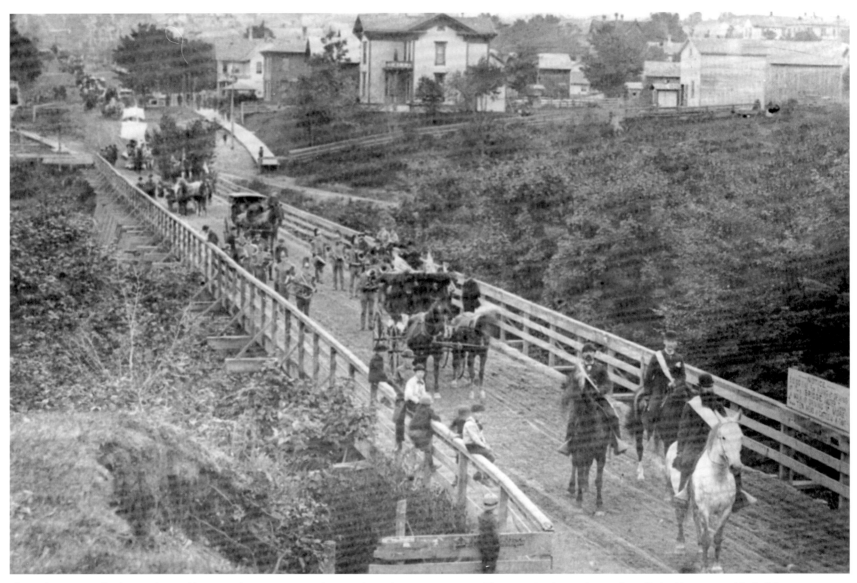

The early Bear River bridge made travel between the river's east- and west-side settlements convenient. This scene is of an early parade and is looking east on Mitchell Street.
(Courtesy of Little Traverse Historical Society)

Bear River

Originating at Walloon Lake, the Bear River snakes its way to Lake Michigan through shallows and swamps until it empties into Little Traverse Bay. Native Americans gathered and camped there for centuries before the first Europeans arrived. As early as 1841, land surveyors identified this stretch as the perfect place for mills. In the last mile before its waters enter Little Traverse Bay, the river drops seventy-five feet over its limestone bed, and the aggressive water flow was ideal for generating power. The first mill was erected by Andrew Porter, a Presbyterian missionary, in 1855. His gristmill was followed by his nephew's sawmill. In 1867 these were sold to Hiram O. Rose, who held them until 1875 when he was bought out. With

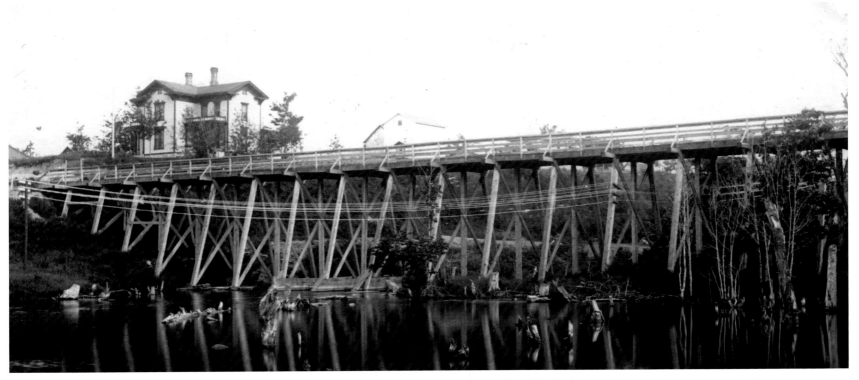

Picture taken from Lake Street looking south. The house remains today and is located at the corner of Mitchell and Elizabeth streets. (Courtesy of Little Traverse Historical Society)

the 1873 arrival of the railroad and with it droves of settlers and speculators, the need for milled wood exploded, as did the number of mills on the river. At the peak of the business, seven mills and five dams were located on the stretch between Sheridan Street and Lake Michigan. The mills processed raw lumber and created everything from broom handles to paper. This truly was a bustling industrial area, with a rugged workforce and mills belching smoke from paper and lumber mills. In those days the environment was of

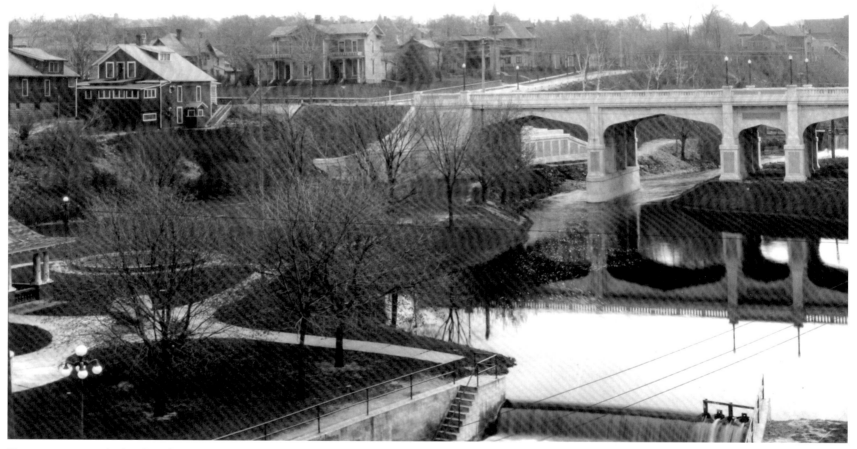

The current concrete bridge dates from 1930 and spans 265 feet. (Courtesy of Little Traverse Historical Society; Rebecca Zeiss)

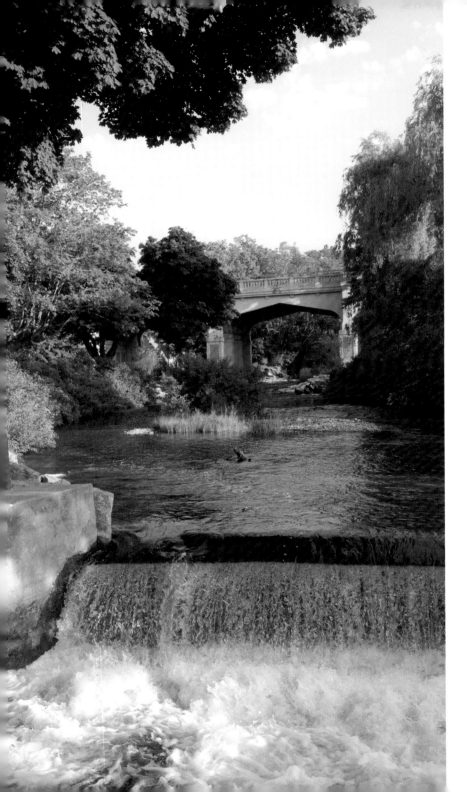

no concern, and millponds were established. The ponds ensured that even when the river ran slowly, there would be an adequate steady stream to power the mills.

Traversing the Bear River valley has always posed a challenge. For goods and passengers, it became increasingly necessary to have the two sides of the river linked (and the city of Petoskey) but the often high sides of the Bear River valley made bridge construction a challenge. The earliest bridges were short spans where the river is narrow at Sheridan Street, but eventually longer and taller spans were added at modern Bridge and Mitchell streets. Made of wood, metal, and concrete, they link the east and west sides of Petoskey and currently offer safe passage to thousands of cars and trucks every day.

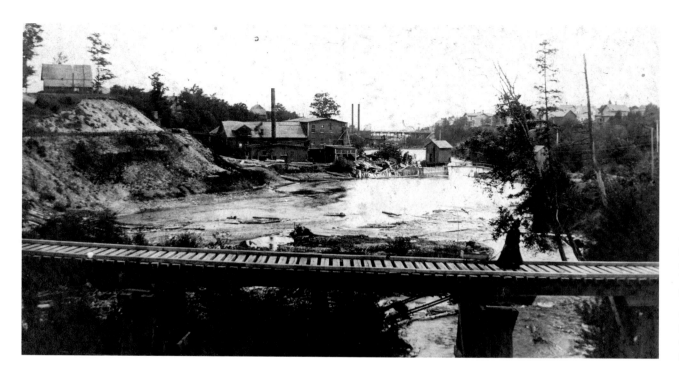

Left: In addition to passenger bridges, ones for railroads also crossed the river. This is looking north toward Little Traverse Bay. (Courtesy of Little Traverse Historical Society)

Below: The Bear River provided the energy for multiple paper-related mills along its banks. (Courtesy of Library of Congress)

The Bear River's banks were often covered with the materials needed to supply the mills. (Courtesy of Clarke Historical Library, Central Michigan University)

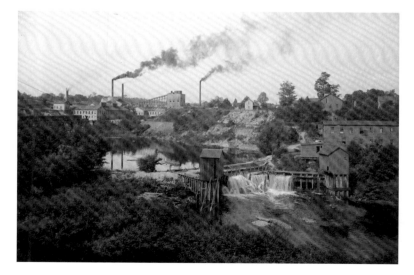

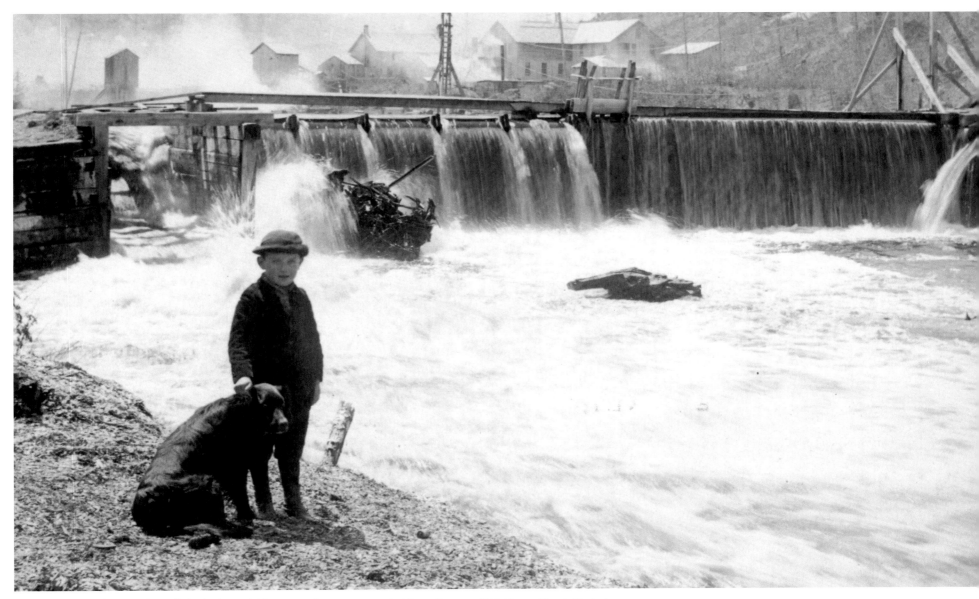

Dams and millponds meant that mills had a dependable source of water to power turbines. (Courtesy of Little Traverse Historical Society)

Harbor Springs

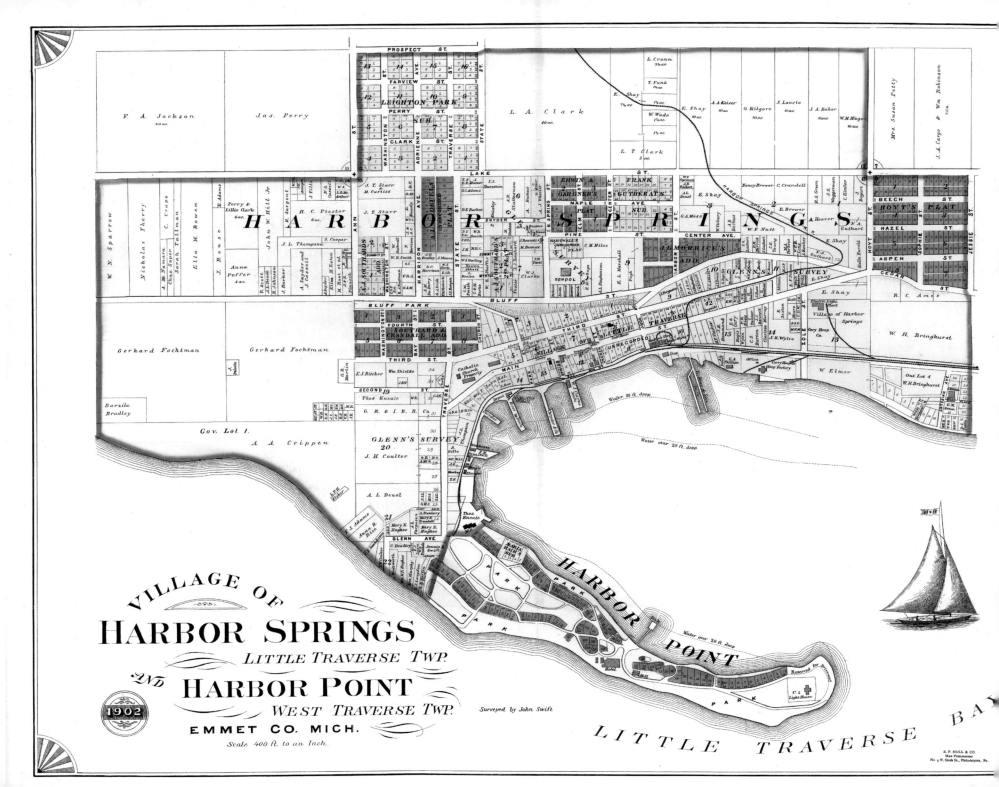

It all began with nature's blessings: a point of land offering protection from waves and harsh west winds, a deep, protected bay, natural water springs along the shore. For centuries Native Americans appreciated and made use of these natural attributes as they traveled Michigan's west coastline. Europeans were introduced to the area with the arrival of French traders and missionaries in the 1600s. By 1800 an Ottawa village was established, and by 1829 Ottawa councils were held at what

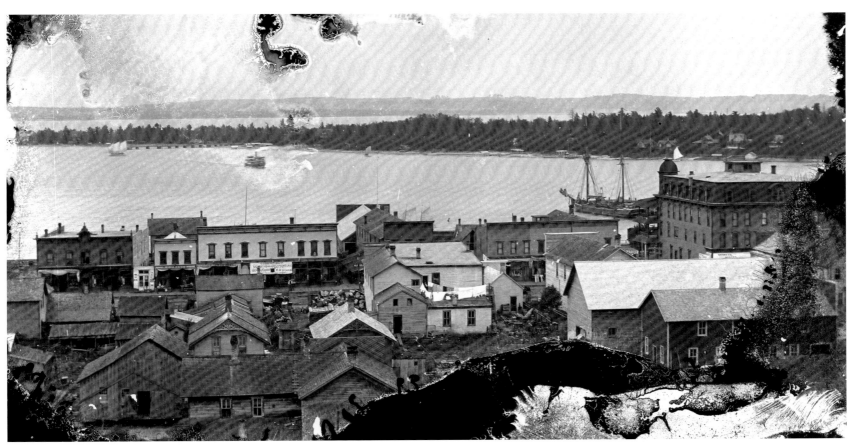

Above and pages 190–191: For over 125 years photographers have taken pictures from Harbor Springs' bluff. (Courtesy of Little Traverse Historical Society; Rebecca Zeiss)

is now Harbor Springs. Because of the large Native American population, the Catholic Church decided to locate a mission in 1829 at the place they named New Arbre Croch, constructing a church, schoolhouse, and priest's home from logs. Two laws were created (and enforced by Ottawa leaders): one prohibiting alcohol and another forbidding traders to live in the village. Both laws were essentially in effect until 1854, when Richard Cooper built his store (the village's first commercial building) and a dock. That building remained until 1882 when it was razed to make way for the Grand

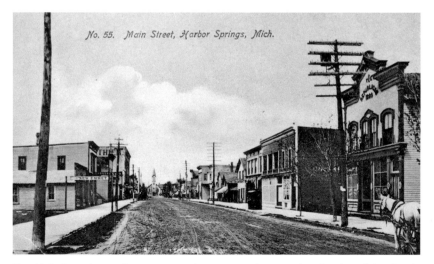

East Main Street has undergone many changes over the years, but the view of the church spire remains familiar. (Courtesy of Little Traverse Historical Society; Rebecca Zeiss)

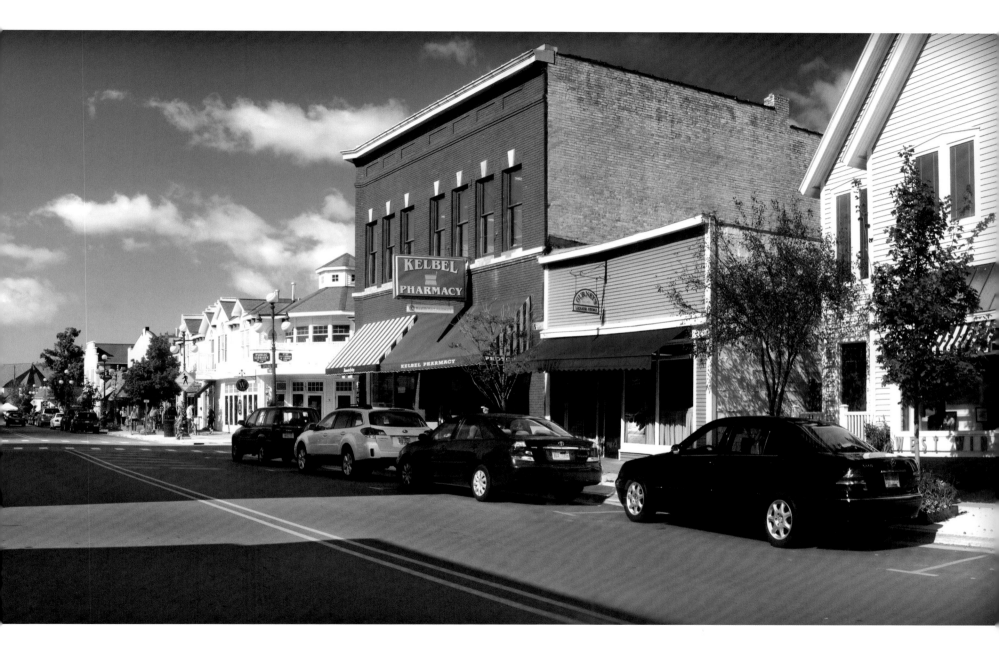

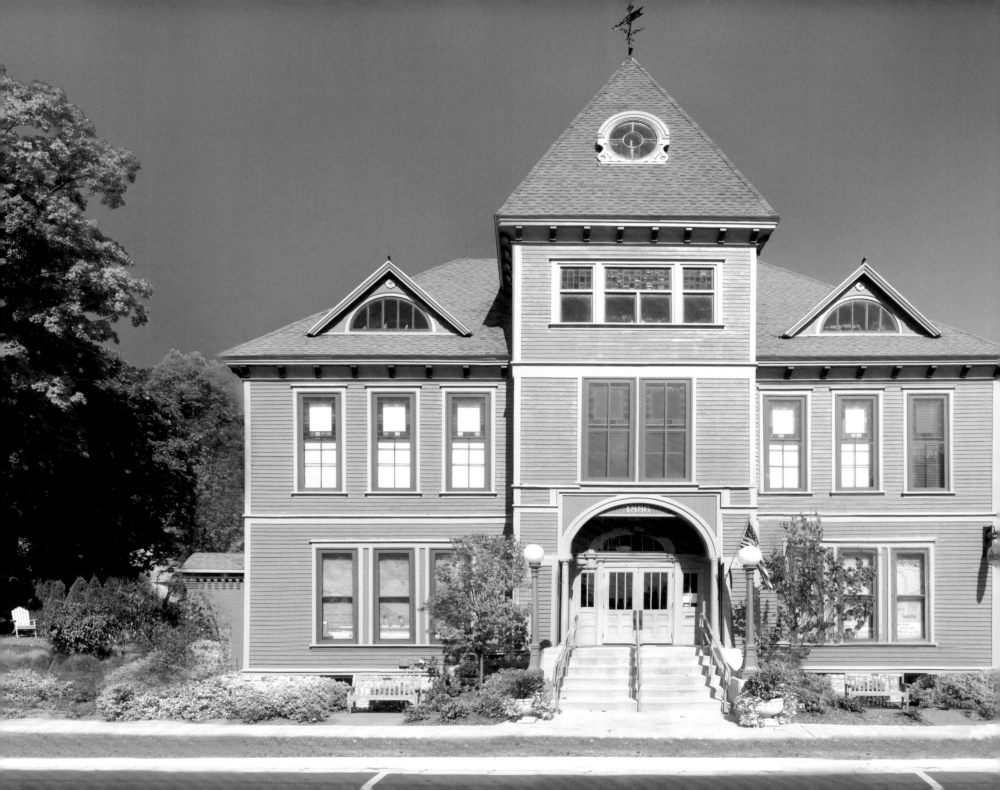

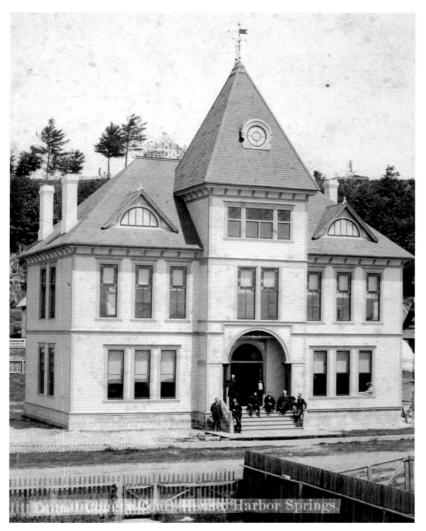

Built in 1886, this building has served as Emmet County's courthouse, the Harbor Springs City Hall, and (currently) the home of the Harbor Springs Area Historical Society and Museum. (Courtesy of Little Traverse Historical Society; Rebecca Zeiss)

Rapids and Indiana Railroad depot. When Emmet County was established in 1855, the village became known as Little Traverse, the name it retained until it became Harbor Springs in 1880. Chosen as the county seat in 1869, the village would stay largely as it had been until 1875, when an influx of white settlers began after Native American treaty limitations were passed and it became possible for non-Natives to buy government-owned land. It was then that the small village began to become a town.

By 1881 Harbor Springs' population had risen to six hundred, and nearly one hundred buildings were in place, including many fine stores. With such growth, it became clear that better transportation was needed. In 1874 regular railroad service had reached Petoskey, resulting in freight and passenger service being readily available regionally—but not to Harbor Springs. People there recognized that extending the line around the bay would be advantageous— particularly with the establishment of the Harbor Point and Wequetonsing associations. By 1882 residents and businesses had jointly raised enough money to extend rail service to Harbor Springs, meaning goods and people could finally travel economically

around the bay. In 1902 the county seat moved to Petoskey, which had become the region's largest city and economic hub, and by 1906 the business district of Harbor Springs had expanded to roughly the dimensions it retains today.

Currently Harbor Springs has a year-round population of approximately twelve hundred, but in the summer months finds itself a very busy community with the arrival of summer residents and tourists. The beautiful bay and delicious bluff views are a wonderful surprise to newcomers and an old friend to annual visitors and year-round residents.

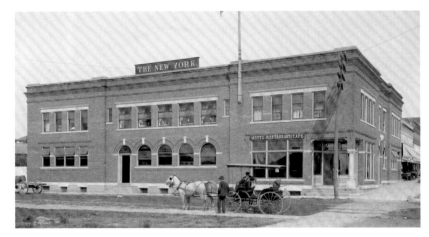

The New York Hotel opened in 1904. (Courtesy of Library of Congress; Rebecca Zeiss)

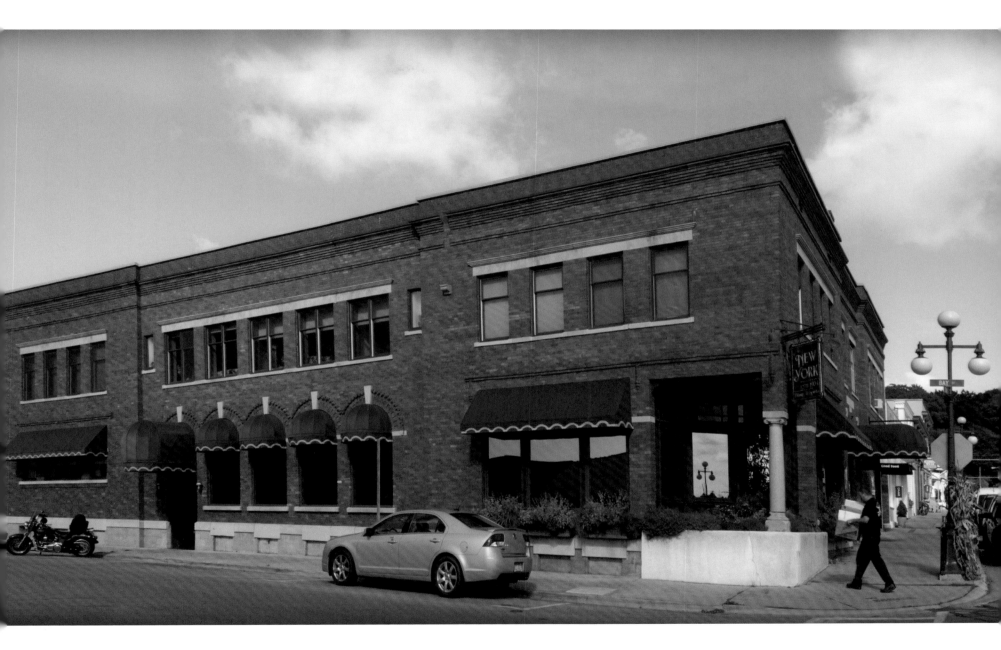

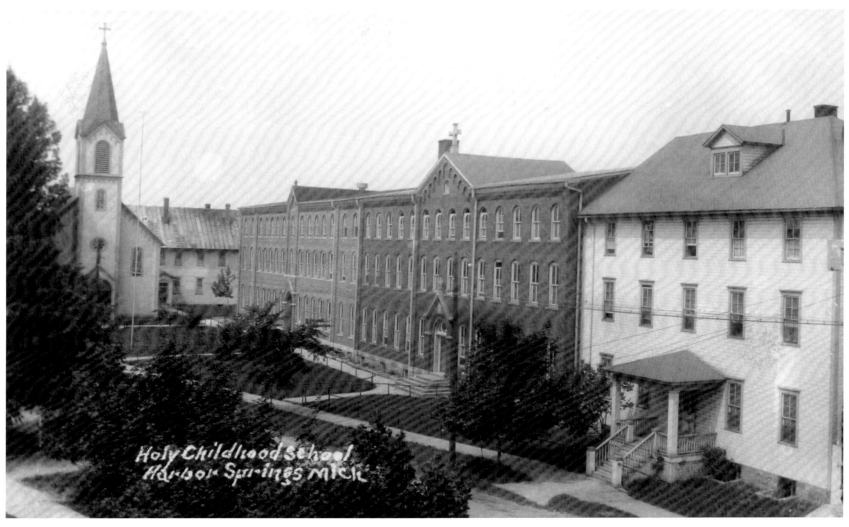

The current Holy Childhood Church is the fourth to stand at this site since the first in 1829. In addition to offering worship services, the church also operated the Holy Childhood Indian School, which closed in 1983. (Courtesy of Little Traverse Historical Society; Rebecca Zeiss)

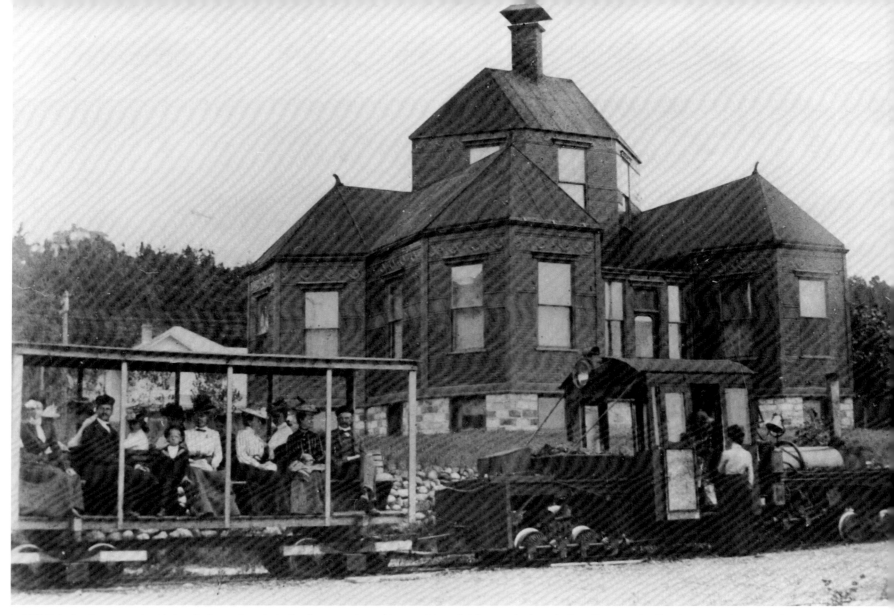

In 1888 Ephraim Shay moved to Harbor Springs, where he built a hexagon-shaped house with steel siding overlooking the bay. Known as the Shay locomotive's inventor, he operated the Hemlock Central between 1902 and 1912. For a minimal fee, summer visitors were taken north of town on an authentic lumber line. This photo shows both the Hemlock Central and Shay's unique home. (Courtesy of Little Traverse Historical Society)

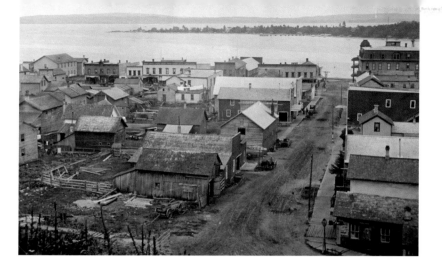

The view looking down State Street has changed over the years. (Courtesy of Little Traverse Historical Society; Rebecca Zeiss)

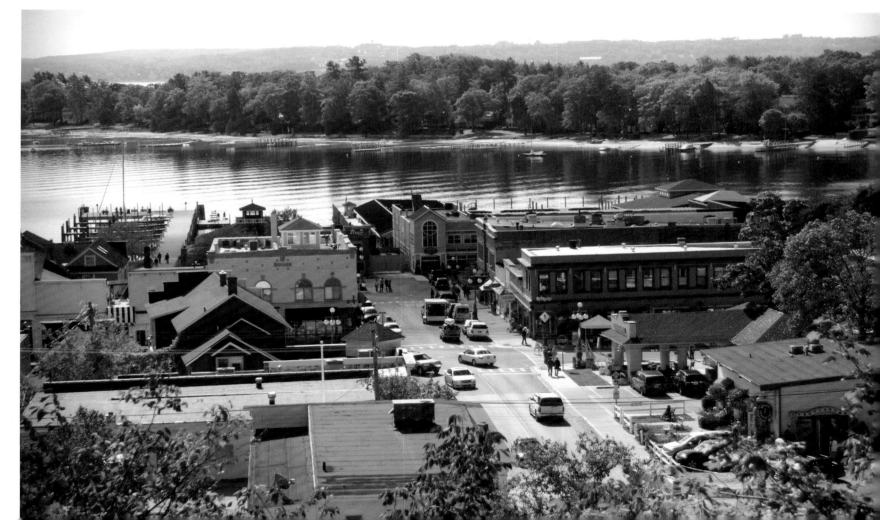

Steamships

Great Lakes Ships

While train service was undoubtedly historically important to the region, so was the influence of passenger ship travel—especially to Harbor Springs. Unlike Petoskey, Harbor Springs is blessed with one of Lake Michigan's best natural harbors. Protected by the point, its waters are deep and sheltered, so that the lake's largest ships could easily dock there, buffered from rough seas. By the 1890s steamship companies running between Chicago and Mackinaw were making regular stops here. While it was easiest for railroad travelers

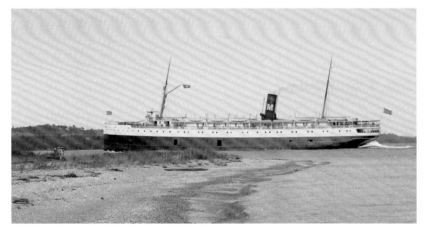

The *Manitou* rounding Harbor Point and heading to the Harbor Springs dock. (Courtesy of Library of Congress)

EXPRESS Steamship "MANITOU"

NORTH BOUND.

	Tues.	Thur.	Sat.
Lv Chicago	9 00 am	11 00 am	4 00 pm
Lv Charlevoix		Fri. 5 00 am	Sun. 10 15 am
Lv Harbor Springs	Wed. 4 15 am	Fri. 7 00 am	Sun. 12 15 pm
Ar Petoskey, (Ferry or rail)	Wed. 5 00 am	Fri. 8 30 am	Sun. 1 30 pm
Ar Mackinac Is.	Wed. 8 15 pm	Fri. 11 00 am	Sun. 4 15 pm

SOUTH BOUND.

	Wed.	Fri.	Sun.
Lv Mackinac Is.	9 00 am	11 45 pm	5 00 pm
Lv Petoskey, (Ferry or Train	Wed. 11 30 am	Fri. 3 00 pm	9 00 pm
Lv Harbor Springs	Wed. 1 15 pm	Fri. 4 15 pm	Sun. 9 30 pm
Lv Charlevoix	Wed. 2 45 pm	Fri. 6 00 pm	
Ar. Chicago	Thur. 9 00 am	Sat. 12 15 pm	Mon. 4 30 pm

Manitou schedule, 1900. (Courtesy of Little Traverse Historical Society)

to stop in Petoskey, steamship patrons would most often disembark at Harbor Springs. Those traveling from Chicago on one of these steamers would do so in a luxurious environment—especially if they were on the *Manitou*. Built in 1893, the ship was 297 feet long and 42 feet wide. It made three trips per week between Chicago and Mackinac Island. The fare in 1898 was $5 each way, with meals

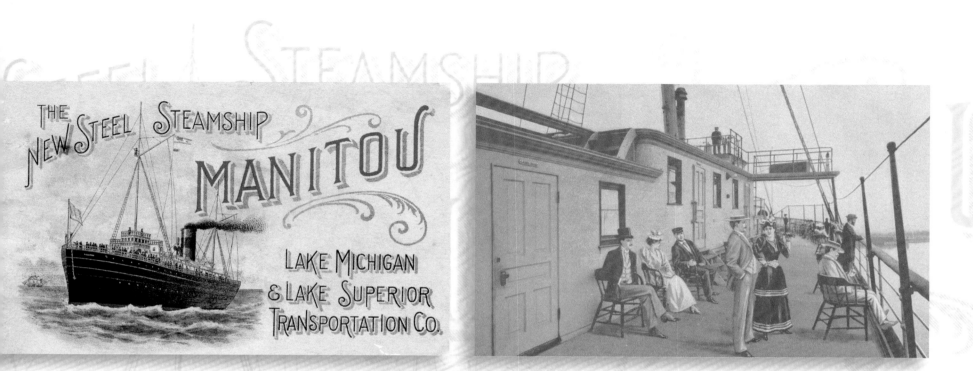

Manitou promotional booklet, 1893.
(Courtesy of Clarke Historical Library,
Central Michigan University)

and a berth extra. Passengers boarded at a Chicago River wharf, and during their twenty-four-hour trip to Mackinac Island, they could enjoy the view from the deck, eat in the ornate dining room, relax in a lounge, or rest in a small berth. Arrival at Harbor Springs was announced with a deafening blast of the ship's steam whistle, signaling the immediate start of activity on shore. Attendants readied carts to move trunks and suitcases to trains or bay steamship ferries, those anticipating guests' arrivals came to the dock to greet them, and the souvenir sellers prepared for business.

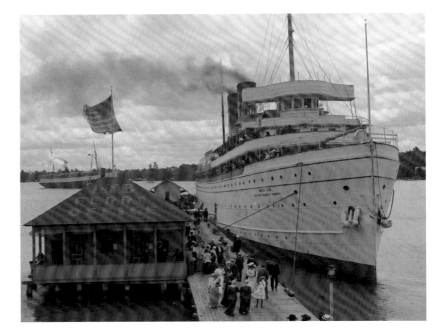

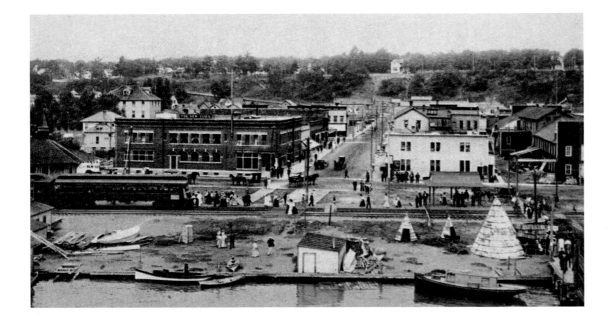

Above: The *North Land* at the Harbor Springs dock. Built in 1885, it was 358 feet long and 44 feet wide. Renamed the *Admiral Nicholson*, it was pressed into service during the First World War. It did not return. (Courtesy of Library of Congress)

Left: View of Harbor Springs from a ship's deck. (Courtesy of Little Traverse Historical Society)

(Rebecca Zeiss)

(Rebecca Zeiss)

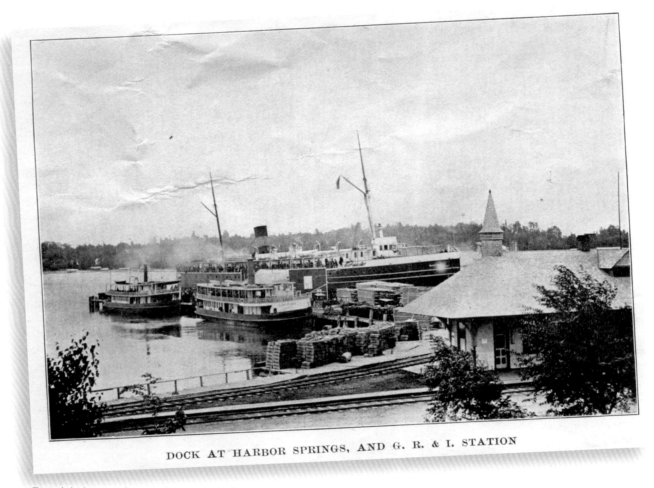

DOCK AT HARBOR SPRINGS, AND G. R. & I. STATION

Typical dock scene showing the proximity of the Great Lakes steamships, bay ferries, and railroad station. The steamship is the *Manitou* and the ferries the *Gracie Barker* and *Thomas Friant*. (Courtesy of Clarke Historical Library, Central Michigan University)

Bay Ferry Steamers

Passengers disembarking from a Great Lakes steamship at Harbor Springs (or a long-haul train at Petoskey) who wanted to travel on to further destinations needed a way to get there. Regional roads were nonexistent (or primitive at best), and hiring a wagon was expensive. After the rail line between Petoskey and Harbor Springs was completed in 1882, transfer to a local-service train was often easiest, as porters could quickly move trunks and packages to the train bound for stops on the bay or for destinations further afield, such as Walloon Lake or Crooked Lake. Offering competition to the railroads (and options to travelers) was a popular bay steam ferry service. Beginning in 1874, Philo Chrysler started regular ferry

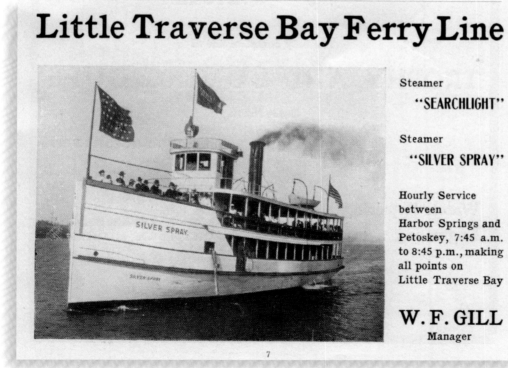

(Courtesy of Clarke Historical Library, Central Michigan University)

service between Petoskey and Harbor Springs that expanded greatly over the years until it was eventually discontinued in the 1930s. Visitors boarded one of the small ferry steamers, which typically docked alongside the larger Great Lakes vessels. Depending on its scheduled route, a steamer could then go directly across the bay to Petoskey or travel around the bay stopping at the docks of major resorts such as Wequetonsing, Roaring Brook, or Bay View. Tickets cost as little as 15¢, and combination ticket booklets—good for either steamer or train transportation—were available. Essentially

acting as "water taxis," these ships offered a viable alternative to trains for those departing from or arriving in the area or for those simply taking a day trip to somewhere else.

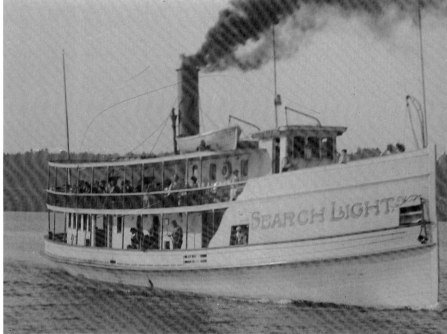

Above: The *Searchlight,* with Harbor Point in the background. It was seventy feet long and fifteen feet wide. (Courtesy of Little Traverse Historical Society)

Left: The *Gracie Barker* at Wequetonsing's dock. This ship would later burn and be rebuilt as the *Hazel.* (Courtesy of Little Traverse Historical Society)

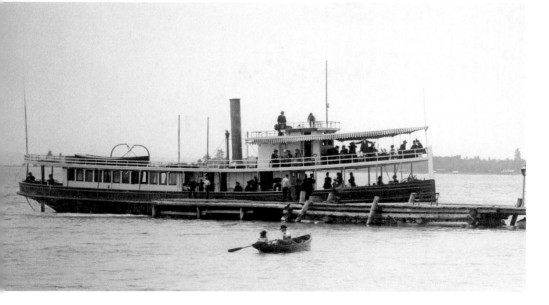

STEAM FERRY LINE.

➤STEAMERS➤
HAZEL AND SEARCHLIGHT.

SUMMER TIME CARD.

GOING SOUTH.	am	am	am	am	am	am	pm	pm	pm	pm	pm	pm	pm	pm	pm	am
Lv Harbor Springs	6 45	7 30	8 30	9 30	10 30	11 45	1 00	2 00	3 00	4 00	5 00	6 00	7 00	8 00		
Harbor Point		7 35	8 35	9 35	10 35	11 50	1 05	2 05	3 05	4 05	5 05	6 05	7 05	8 05		5 00
Wequetonsing		7 40	8 40	9 40	10 40	11 55	1 10	2 10	3 10	4 10	5 10	6 10	7 10	8 05		flag.
Roaring Brook		7 45	8 45	9 45	10 40	11 55	1 10	2 10	3 10	4 10	5 05	6 05	7 05	8 10		
Bay View		flag	9 05	10 05	10 45	12 m	1 15	2 15	3 15	4 15	5 10	6 10	7 10	8 10		
Ar Petoskey	7 10	8 15	9 15	10 15	11 15	12 30	1 35	2 35	3 35	4 35	5 15	6 15	7 15	8 15		5 25
							1 45	2 45	3 45	4 45	5 45	6 45	7 45	8 35	8 45	5 35

IN EFFECT JULY 1, 1900

GOING NORTH.	am	am	am	am	am	pm	pm	pm	pm	pm	pm	pm	pm	pm	am
Lv Petoskey	7 30	8 30	9 30	10 30	11 30	1 00	2 00	3 00	4 00	5 00	6 00	7 00	8 00	9 00	5 45
Bay View		8 40	9 40	10 40		1 10	2 10	3 10	4 10	5 10		7 10			
Roaring Brook		9 00	10 00	11 00	11 50	1 30	2 30	3 10	4 10	5 10		7 10			
Wequetonsing	7 50	9 05	10 05	11 05	11 55	1 30	2 30	3 30	4 30	5 30		7 30			flag.
Harbor Point	7 55	9 10	10 10	11 10	12 M	1 35	2 35	3 35	4 35	5 35	6 20	7 35	8 25	9 25	
Ar Harbor Springs	8 00	9 15	10 15	11 15	12 05	1 40	2 40	3 40	4 40	5 40	6 25	7 40	8 30	9 30	
						1 45	2 45	3 45	4 45	5 45	6 30	7 45	8 35	9 35	6 15

Trips 1, 2, 3, and 4 daily except Sunday. Trips 29 and 30 Wednesday only. All others daily.

Bay ferry schedule, 1900. (Courtesy of Little Traverse Historical Society)

3

Summer Communities

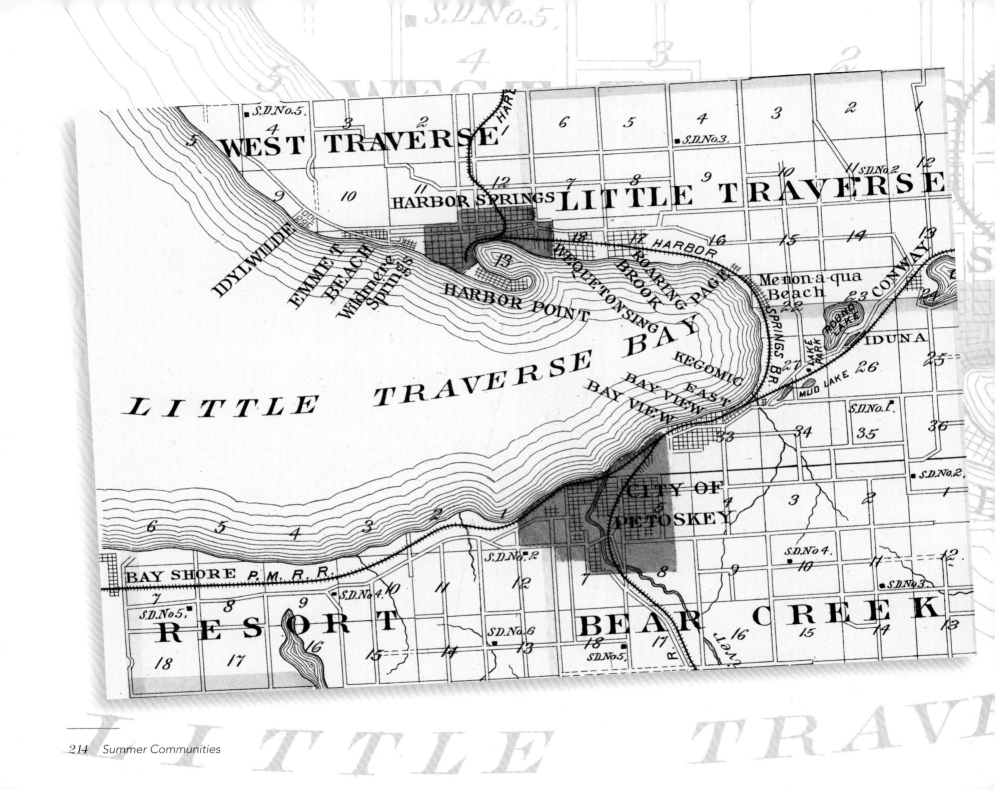

With improvements in transportation and with the area becoming increasingly popular with visitors, summer communities grew around the bay. Rather than stay only for a short while, families were encouraged to spend their entire summers far from the stifling heat and humidity of midwestern cities. Middle- and upper-class families enjoyed nature and summer society in cottages that would be shut up at the end of the season, not used again until the next summer. In most cases these dwellings were relatively inexpensive to maintain. For summer use only, they did not need to be heated through frigid northern winters, and they were typically furnished with cast-off furniture from their owners' primary home—a tradition that continues today. Likewise, clothing was more casual; there was not an expectation that the same standards of formality that obtained back home. It should be noted, however, that while life was leisurely for the summer visitors, it was anything but for the locals whose hard work (often behind the scenes) served the needs of these long-term vacationers—that made for long hours and personal sacrifices. Because the local economy was so dependent on the summer trade, it was crucial to earn as much as possible then to make it through the slow off-season months. This remains a familiar theme today.

Some of these cottages were and are in formal "associations" located on the shores of Little Traverse Bay. These associations were formed when individuals decided to join together as a group under mutually agreed-upon guidelines and beliefs to purchase and jointly enjoy a parcel of land. Some were religious in origin (Bay View and Wequetonsing) and others not (Harbor Point). While rules might vary, they do have in common that the associations (rather than individuals) own the property on which cottages and public buildings are built. This structure allows for shared responsibility and benefits and has resulted in generations of families continuing to celebrate their common bonds.

Bay View

In 1875 a group representing Michigan's Methodist Church conferences began looking for a place to hold summer camp meetings. A selection committee visited and considered various sites, eventually recommending land just east of Petoskey. The committee members chose this site because of its beauty and the ease of transportation but also because of the deal they were offered. Local leaders (including H. O. Rose and the Grand Rapids and Indiana Railroad) raised $3,400 to buy 338 acres from the Native Americans who owned it. They then offered the land free of charge to the Methodists in exchange for a promise to make at least $10,000 in improvements to the property by 1890 and to hold annual meetings there for at least fifteen years. The Methodists agreed to these terms and formed the Michigan Campground Association to oversee the grounds and activities there. In 1876, it cleared land and held the first summer meeting. The meeting lasted six days, with hundreds of attendees gathering around the "preaching stand" for talks and sermons. Thus began a tradition still in place today.

Initially these camp meetings lasted only a few days, with attendees literally camping in tents, but soon plans were made to allow people to stay longer and more comfortably. To this end, the property was platted with streets and lots were identified. While the association retained ownership of the land, individual families could lease lots with Lake Michigan views for as little as $5 per year. By 1877 20 cottages were in place, and by 1887 that number had grown to 120, with the campus also hosting a rail station, a chapel, and a hotel. Eventually the total number of cottages would reach 400 (most of them built by 1900) and over 30 public buildings were erected—including an auditorium that seated over fourteen hundred people.

In addition to the religious camp meetings, other programs were initiated to entertain and educate Bay View summer residents. In 1885 John M. Hall was elected superintendent of Bay View's Chautauqua Educational Department. During his nearly thirty-year tenure, his initiatives included a summer university, a reading circle, a literary magazine, and an eight-week summer assembly program that brought in notable national figures—including Helen Keller,

Booker T. Washington, Jane Addams, Carl Sandburg, and William Jennings Bryan.

Today Bay View, designated a National Historic Landmark in 1987, remains a vibrant community where religious, cultural, recreational, and social activities abound. Generations of families continue to enjoy the opportunities the association provides, and people come from near and far to admire the spectacular Victorian cottages.

Transportation

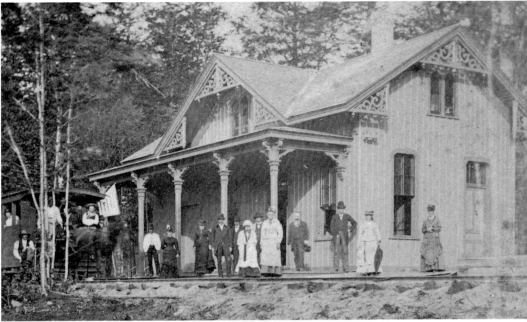

Two early views of Bay View's original train station. In one the coach is about to be pulled back to Petoskey using a horse or mule. In the other a steam engine is pulling the coaches. This station would remain in use until it was replaced in 1896. (Courtesy of Little Traverse Historical Society)

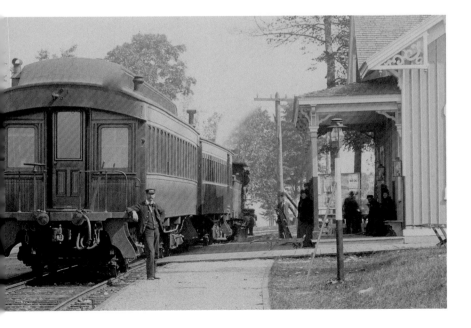

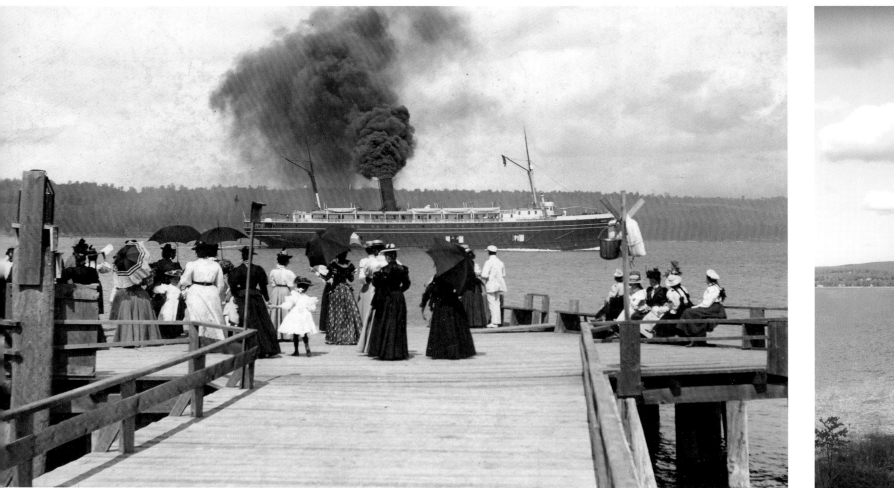

In addition to trains, the ferry service was a popular way to travel to and from Bay View.

(Courtesy of Little Traverse Historical Society; Rebecca Zeiss)

Public Buildings

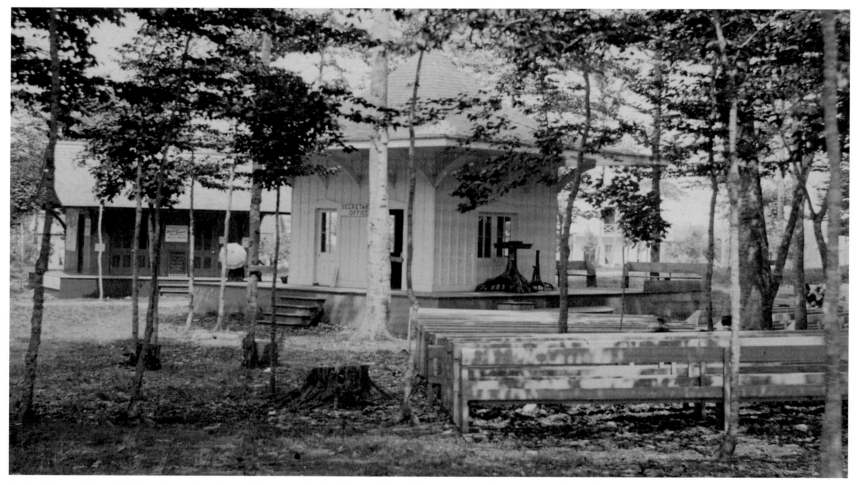

The building on the right is the oldest at Bay View and has served as the Speaker's Stand, the secretary's office, an art studio, and Boys' and Girls' Clubs. Built in 1881, the building on the left was for many years a bookstore. Currently, both act as the Bay View Museum and are open to the public. (Courtesy of Little Traverse Historical Society; Rebecca Zeiss)

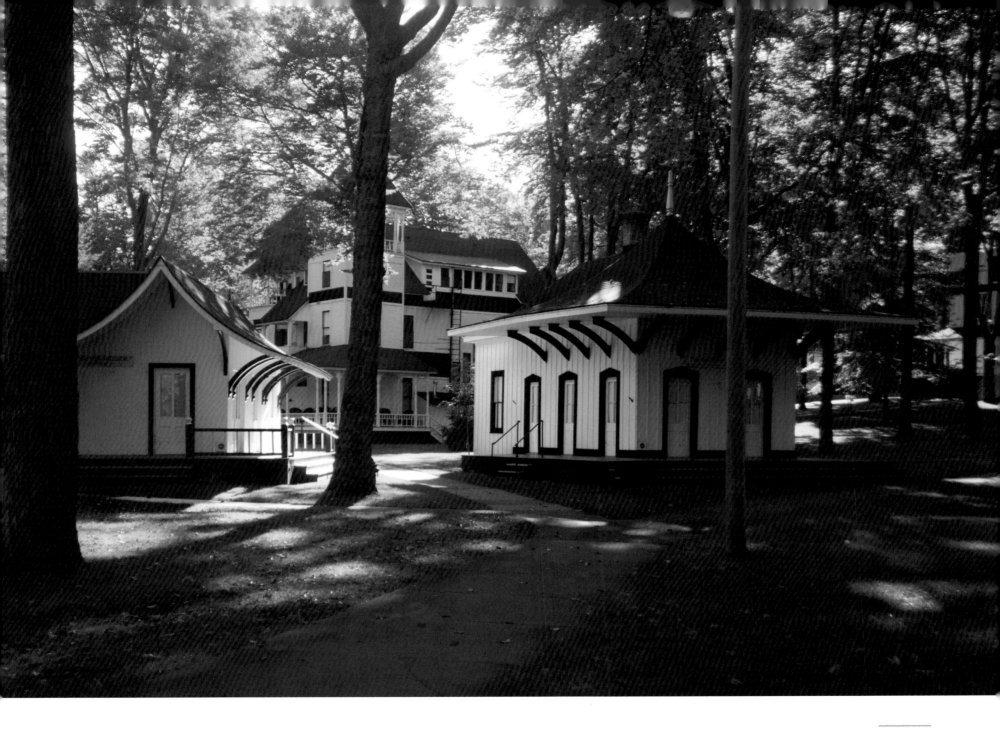

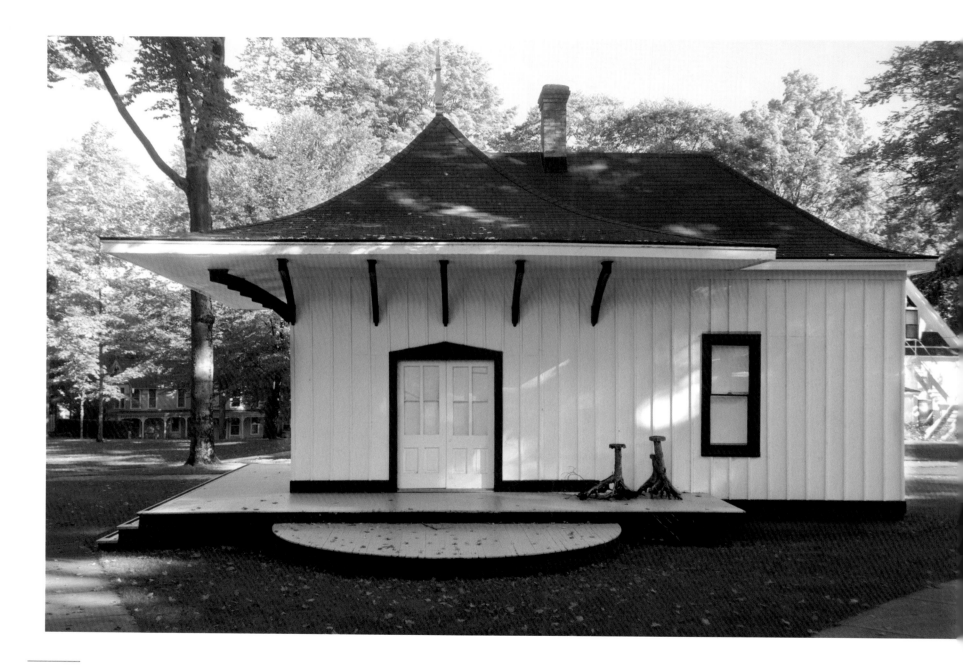

Built in 1876, the deck of this building was where sermons and talks were given. It featured a rustic pulpit made of intertwined hemlock stumps and was surrounded by benches for the attendees. In this 1878 photograph, "Chief" Ignatius Petoskey is seated behind the pulpit. (Courtesy of Little Traverse Historical Society; Rebecca Zeiss)

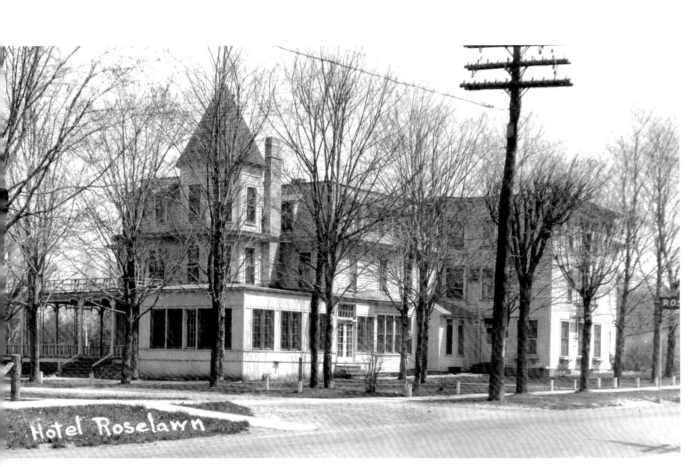

Hotel Roselawn

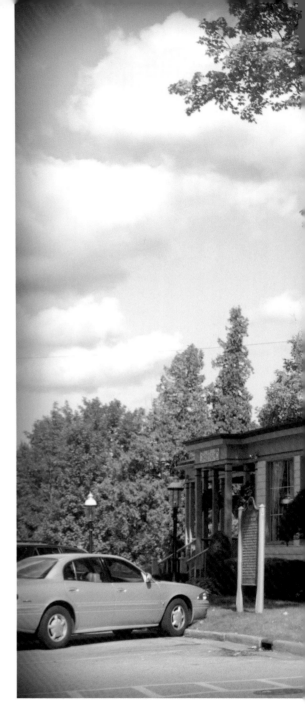

Built in 1886 by John Wesley Howard, the structure currently known as Stafford's Bay View Inn was previously named the Howard Inn and later the Roselawn. Regardless of the name, for over a hundred years people have enjoyed leisurely dining and comfortable lodging here. (Courtesy of Little Traverse Historical Society; Rebecca Zeiss)

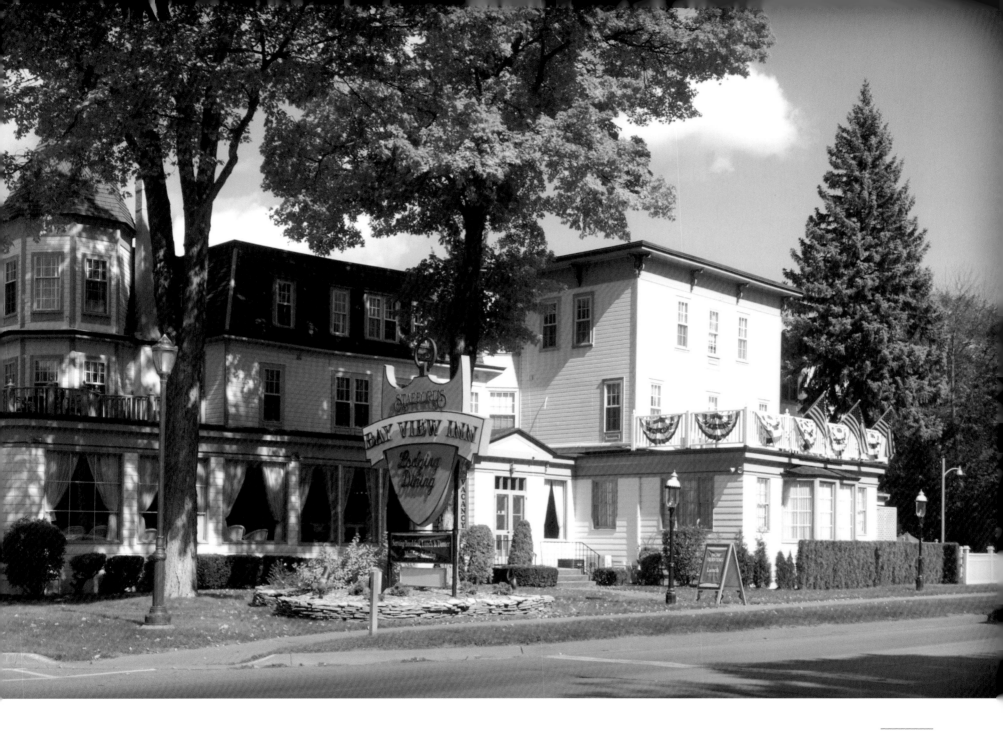

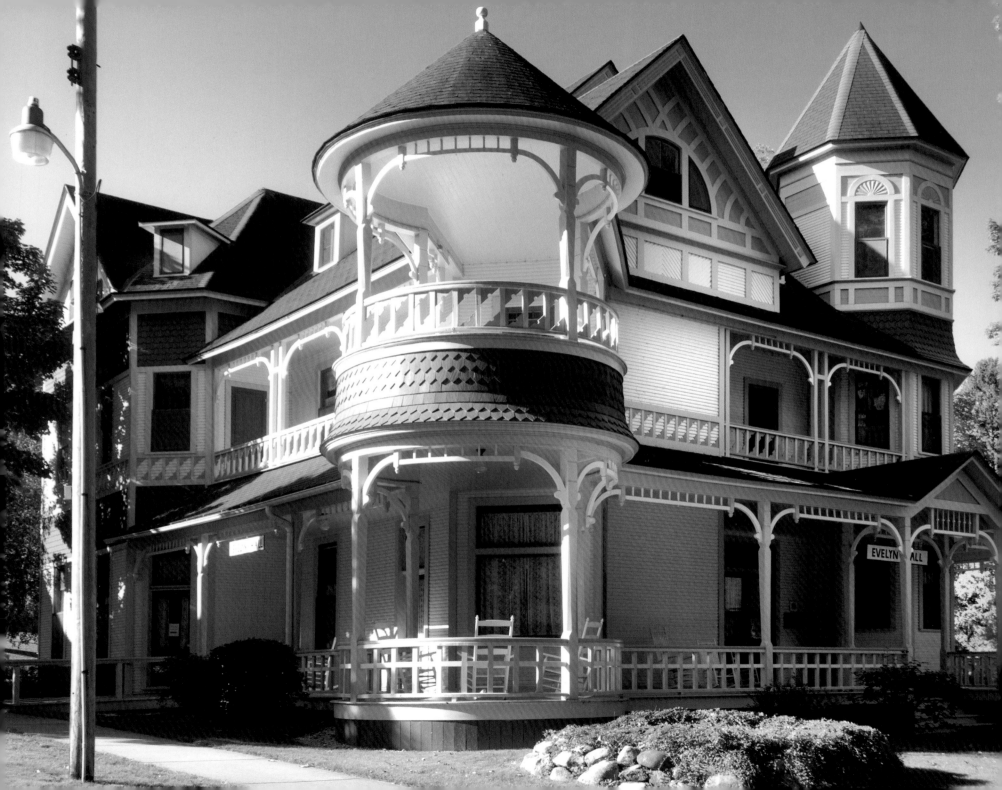

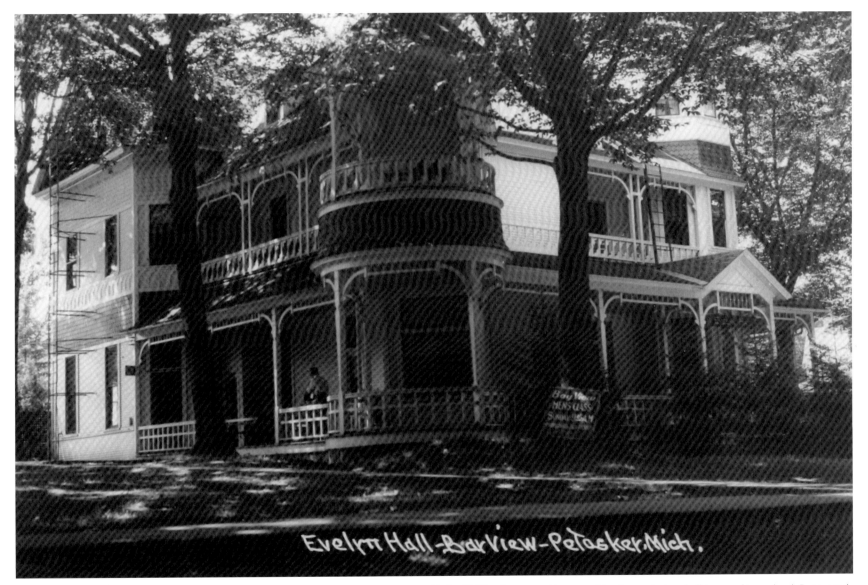

Evelyn Hall - Bay View - Petoskey Mich.

Originally built as the summer headquarters for the Women's Christian Temperance Union, Evelyn Hall has been used for everything from a lecture hall to a cooking school. Renovated in 1995, it is a delightful example of Victorian architecture. (Courtesy of Little Traverse Historical Society; Rebecca Zeiss)

This auditorium was a gift from John M. Hall, after whom it was named. Dedicated in 1915, it replaced the original 1887 auditorium and originally seated twenty-one hundred people. The auditorium is used for worship services, concerts, and recitals—thousands of people enjoy it every summer. (Courtesy of Little Traverse Historical Society; Rebecca Zeiss)

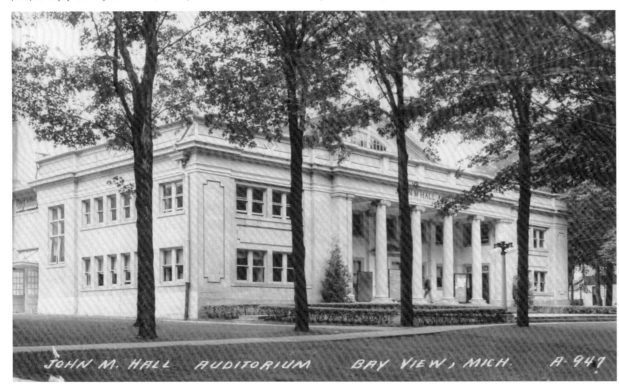

JOHN M. HALL AUDITORIUM BAY VIEW, MICH. A-947

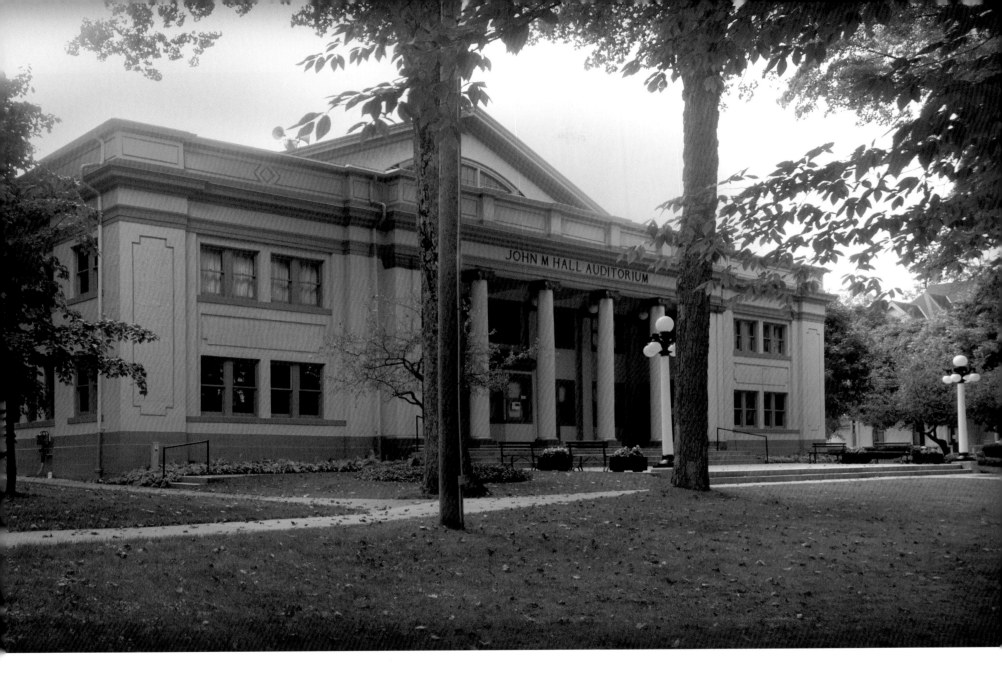

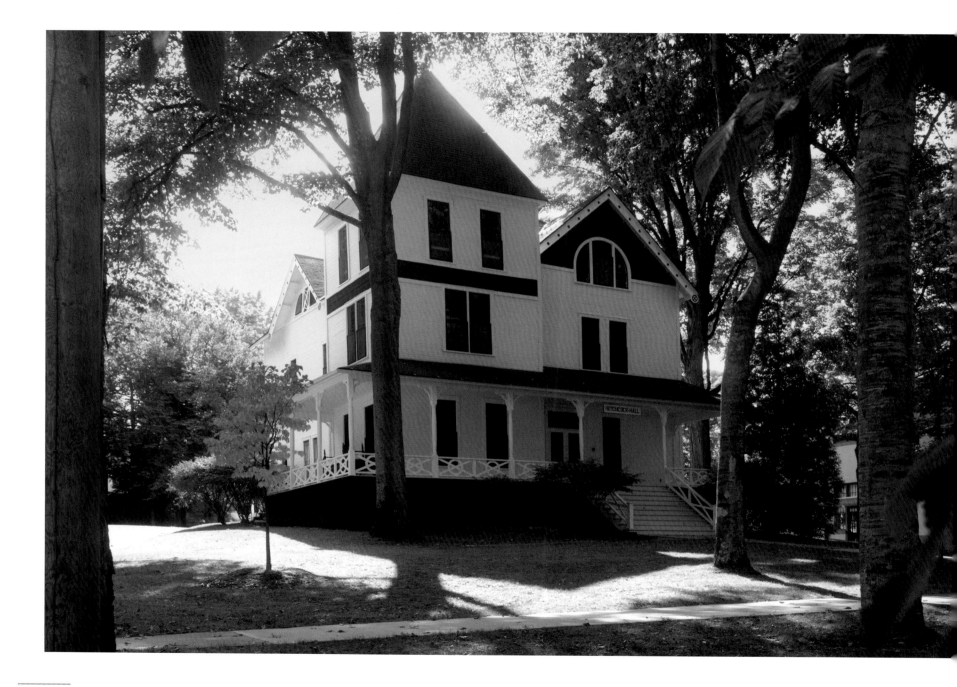

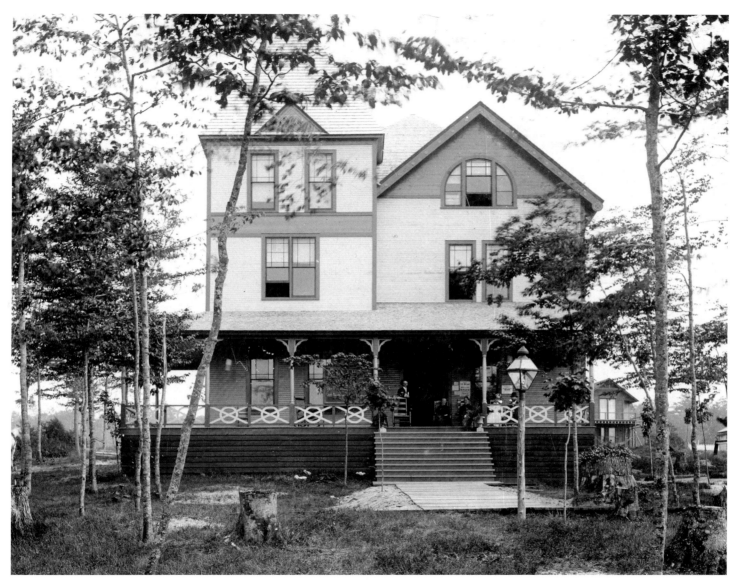

Hitchcock Hall was built as place for Sunday school workers to use for teaching Bible study. Over the years it has provided rehearsal space for music students, served as a men's dormitory, housed the Bay View College of Liberal Arts, and been an indoor center for young children. (Courtesy of Little Traverse Historical Society; Rebecca Zeiss)

Residences

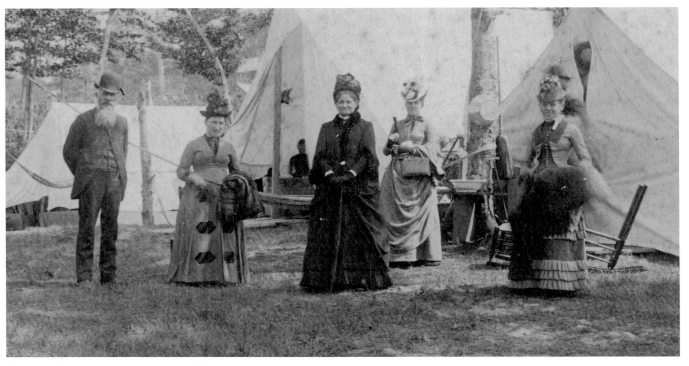

Those who first came to Bay View camped in tents. (Courtesy of Little Traverse Historical Society)

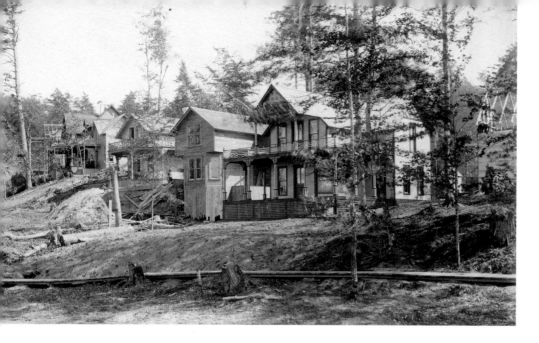

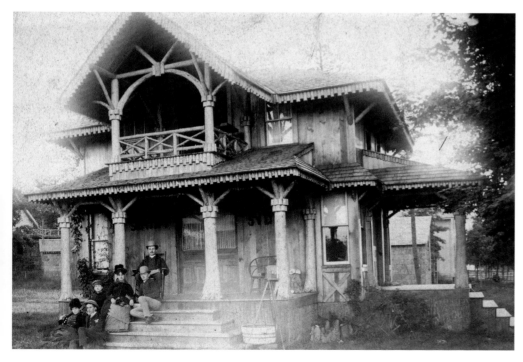

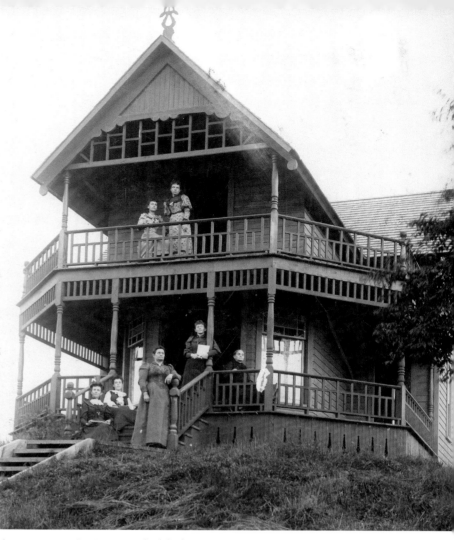

Most cottages at Bay View were built before 1900. (Courtesy of Little Traverse Historical Society)

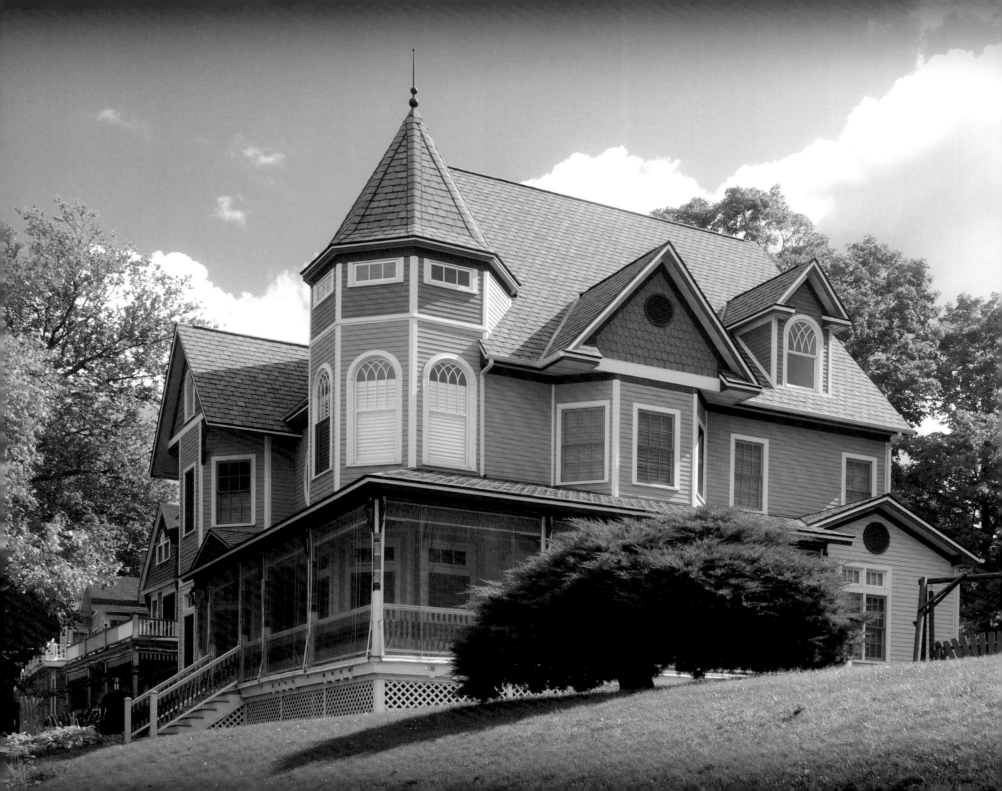

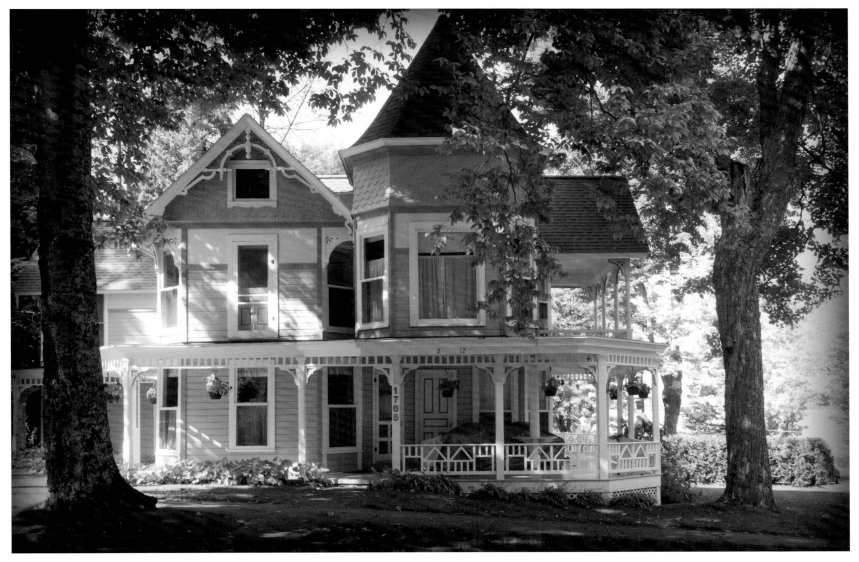

(Rebecca Zeiss)

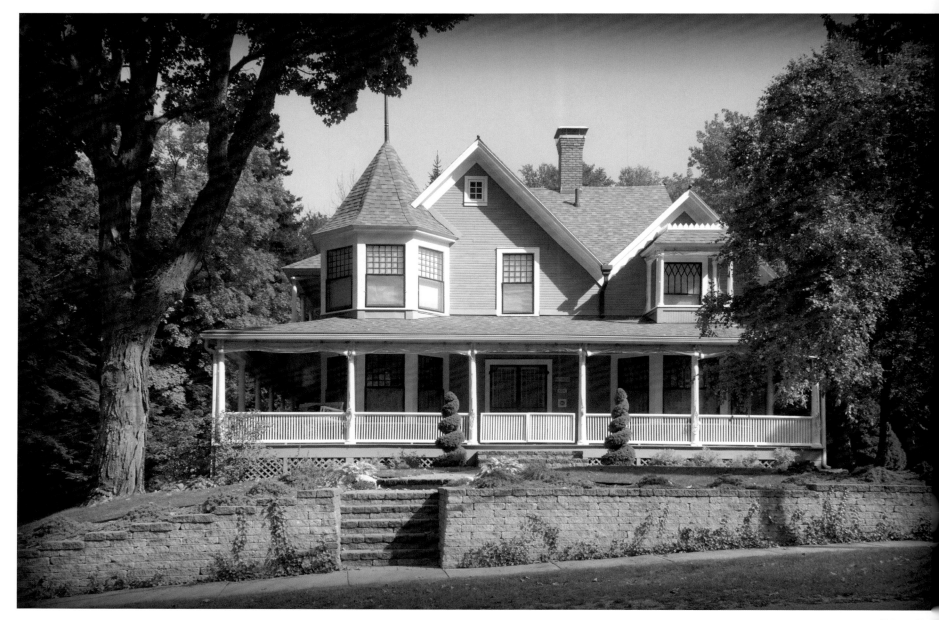

(Rebecca Zeis

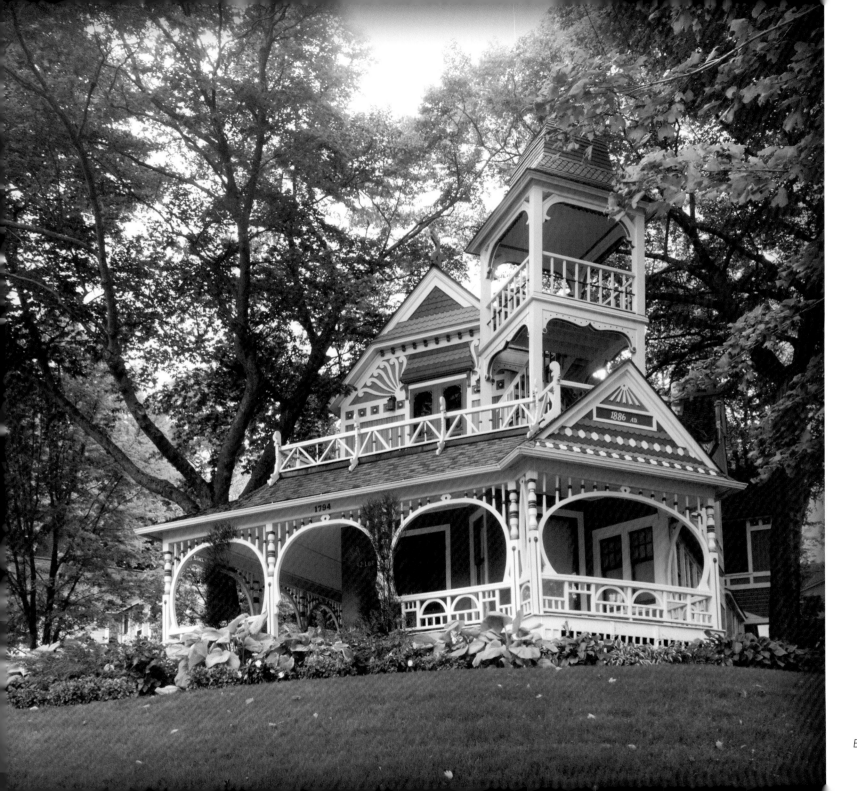

Harbor Point

The Harbor Point Association was first known as the Lansing Resort. It was established in 1878 when a group of friends from Lansing camped on the property and then purchased it from a local priest, Father Weikamp. Twenty-two of them bought the fifty-two acres for $1,300, and in 1880 hired John Swift to plat roads, walks, and lots. Space was set aside for around one hundred cottages (most of which were built by 1890), none was to be built for less than $100 to ensure that all would be substantial structures. A hotel was constructed, as were boathouses, bathhouses, and a dock.

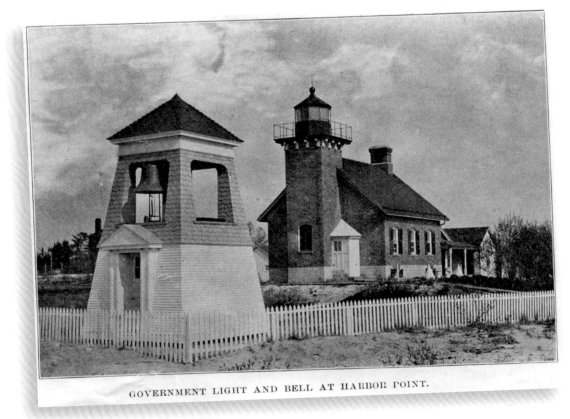

GOVERNMENT LIGHT AND BELL AT HARBOR POINT.

(Courtesy of Clarke Historical Library, Central Michigan University

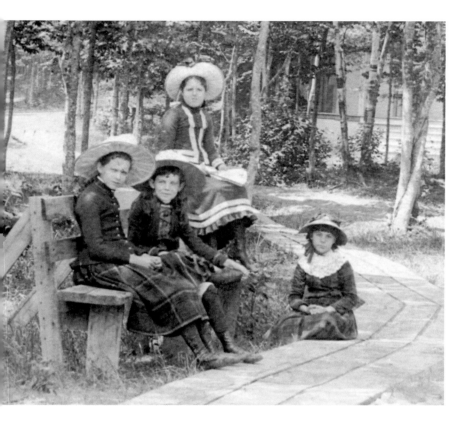

the property was sold back to the Harbor Point Association. Today many of the families who originally founded the resort still live there. Unlike other resorts, Harbor Point is a gated community that does not allow public access.

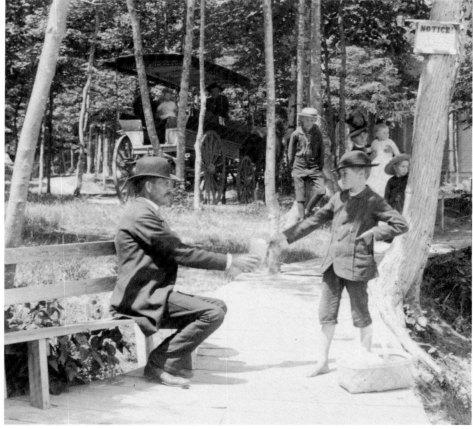

At Harbor Point, summers were social occasions. (Courtesy of Little Traverse Historical Society)

The twenty-two-room hotel was built at a cost of $1,800 and served as a social center where many of the residents took their meals. In 1883 the U.S. government purchased three and a half acres at the point's tip on which it built a lighthouse in 1884. In 1896 the government installed a 1,800-pound fog bell that struck every thirty seconds in bad weather. When the light was retired in 1963,

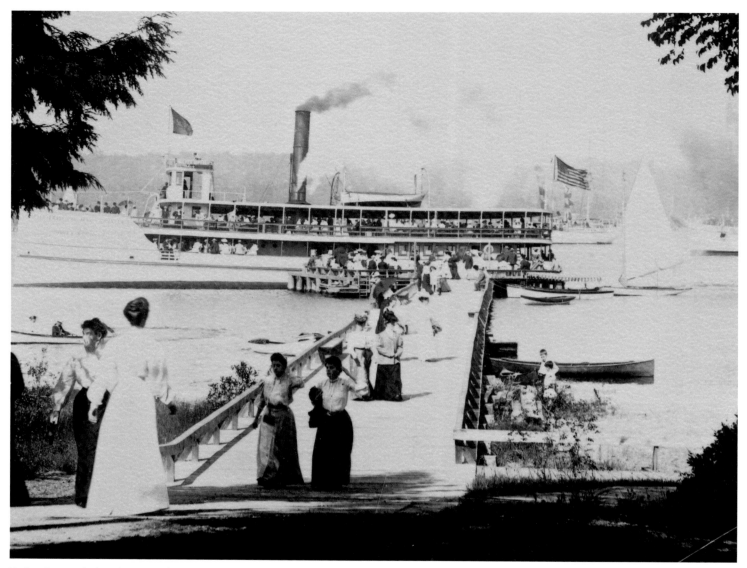

Harbor Point with the Silver Spray ferry pulling away. (Courtesy of Little Traverse Historical Society)

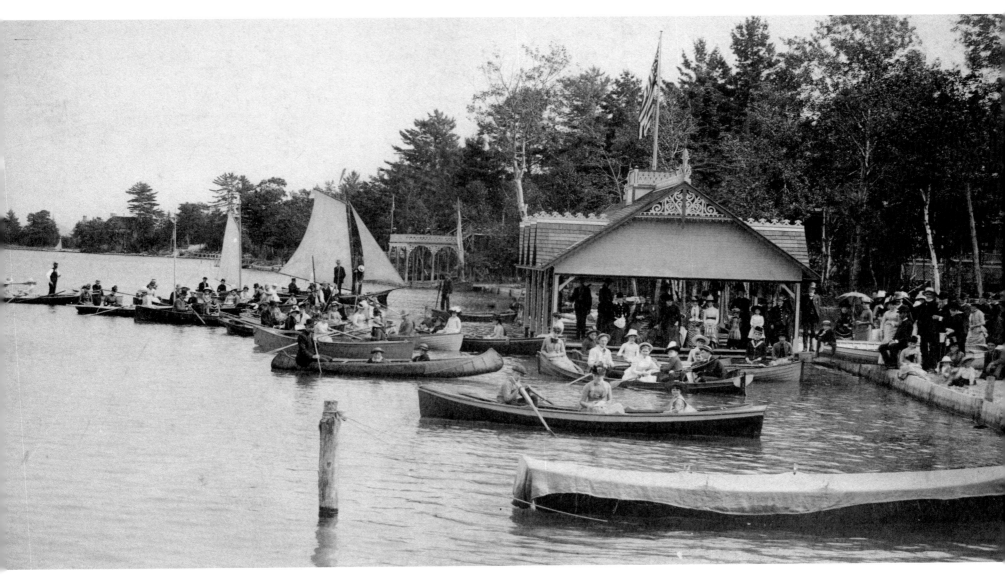

A busy afternoon on the water, ca. 1890. (Courtesy of Little Traverse Historical Society)

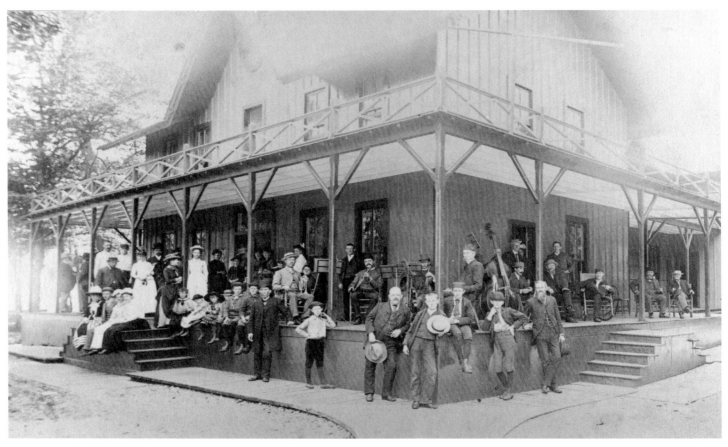

The original Harbor Point Club was built in 1880 and provided twenty-two guest rooms and meals for summer residents. It was replaced in 1897 by a new club building. (Courtesy of Little Traverse Historical Society)

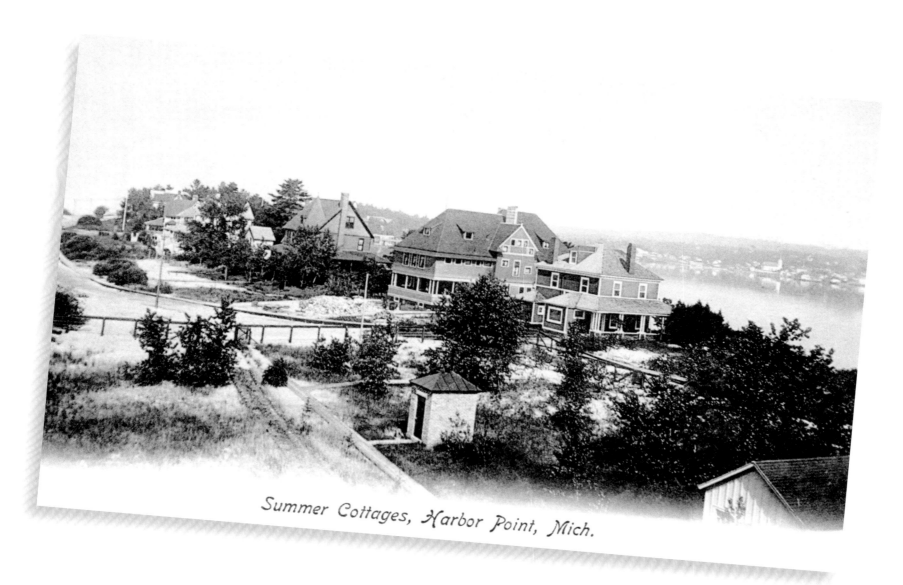

Summer Cottages, Harbor Point, Mich.

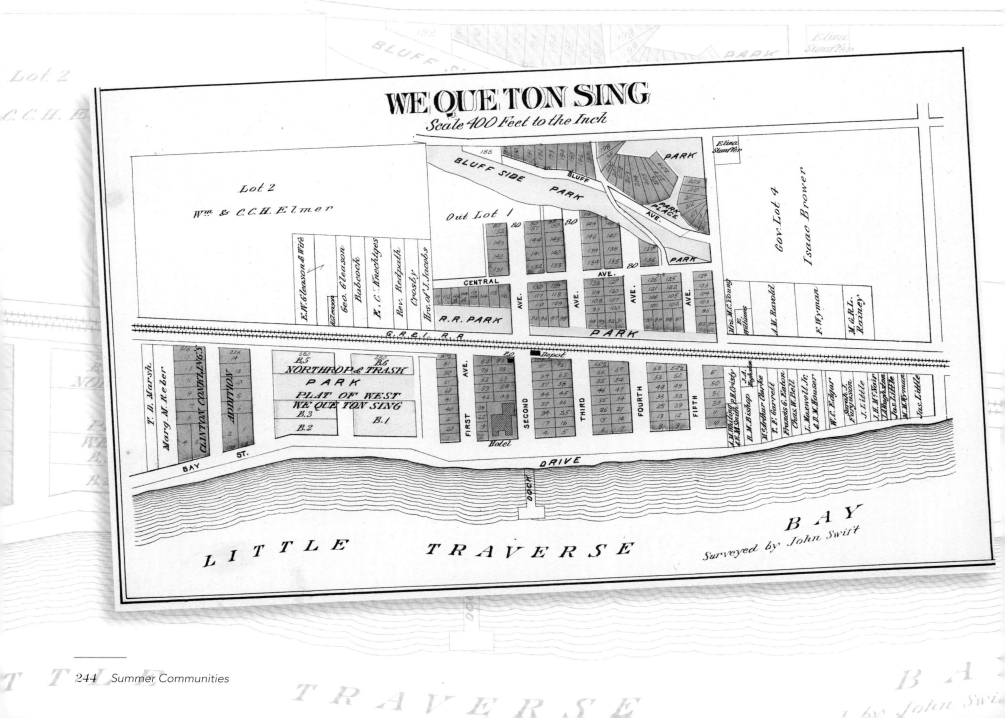

WE QUE TON SING

Scale 400 Feet to the Inch

Wequetonsing

Wequetonsing (originally known as the Presbyterian Summer Resort Association) began in 1877 when the citizens of Little Traverse (Harbor Springs) donated eighty acres for a Presbyterian summer resort just east of the village. The grounds were laid out and construction of a hotel began that summer. Opened in 1881, the hotel had 109 rooms that were available only for association members. It eventually expanded to accommodate up to four hundred guests and, like the hotel at Harbor Point, it served meals

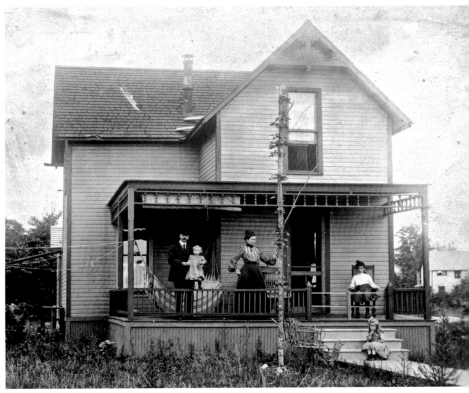

Wequetonsing's earliest visitors stayed in tents until cottages were built.
(Courtesy of Little Traverse Historical Society)

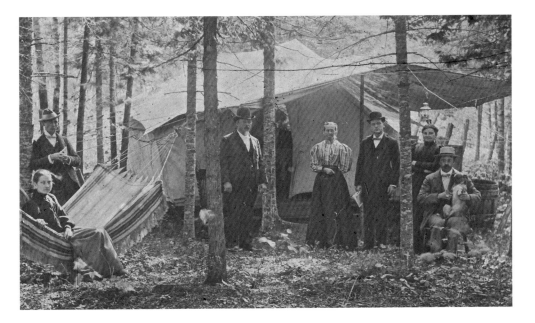

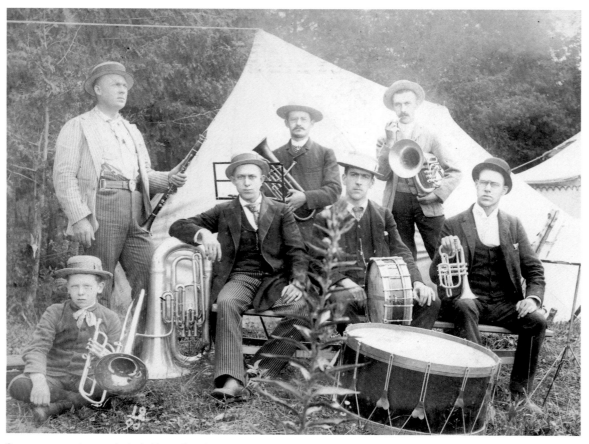

Summer entertainment included brass bands. (Courtesy of Little Traverse Historical Society)

to many association members and was a popular gathering spot. The hotel was torn down in 1964; its location is now a park. Wequetonsing came to include a post office, train depot, golf course, bathing beach, dock, and assembly hall. Eventually it would grow to one hundred cottages and expand to two hundred acres with the creation of West Wequetonsing (thirty-six cottages) and East Wequetonsing (twenty cottages). As is true of so many of these summer communities, the original families' descendants create their own summer memories walking the same streets as previous generations did.

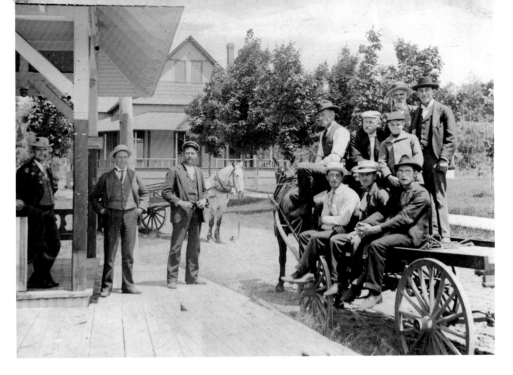

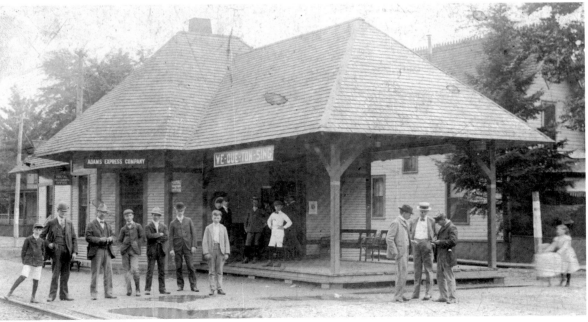

The Wequetonsing depot. Note the men ready to help move arriving goods to cottages. (Courtesy of Little Traverse Historical Society)

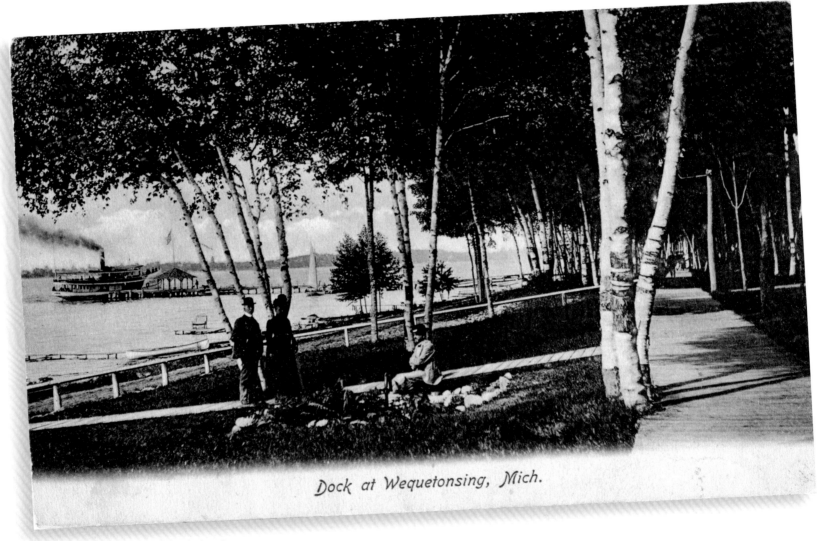

Dock at Wequetonsing, Mich.

Those not arriving by train did so by bay ferry. (Courtesy of Little Traverse Historical Society)

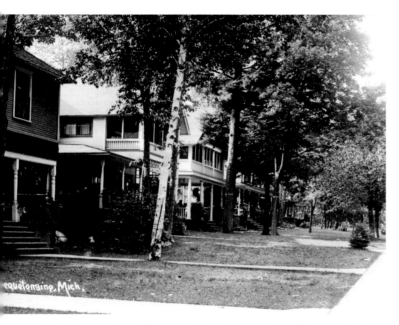

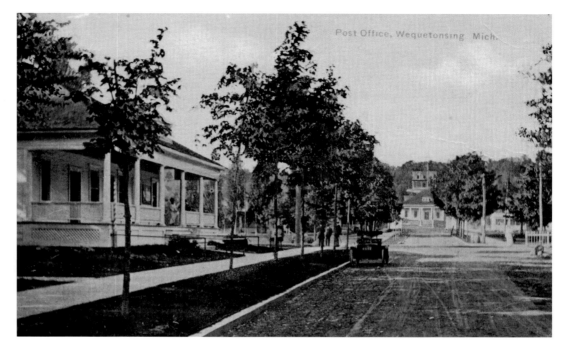

Post Office, Wequetonsing Mich.

Over the years, beautiful summer homes began to line Wequetonsing's streets. (Courtesy of Little Traverse Historical Society)

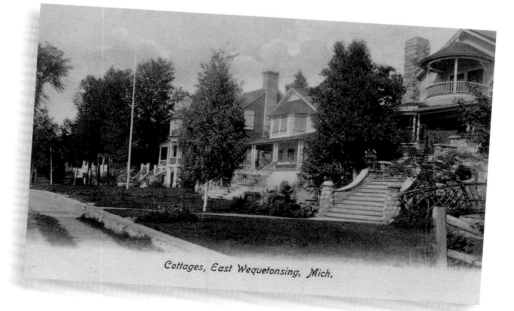

Cottages, East Wequetonsing, Mich.

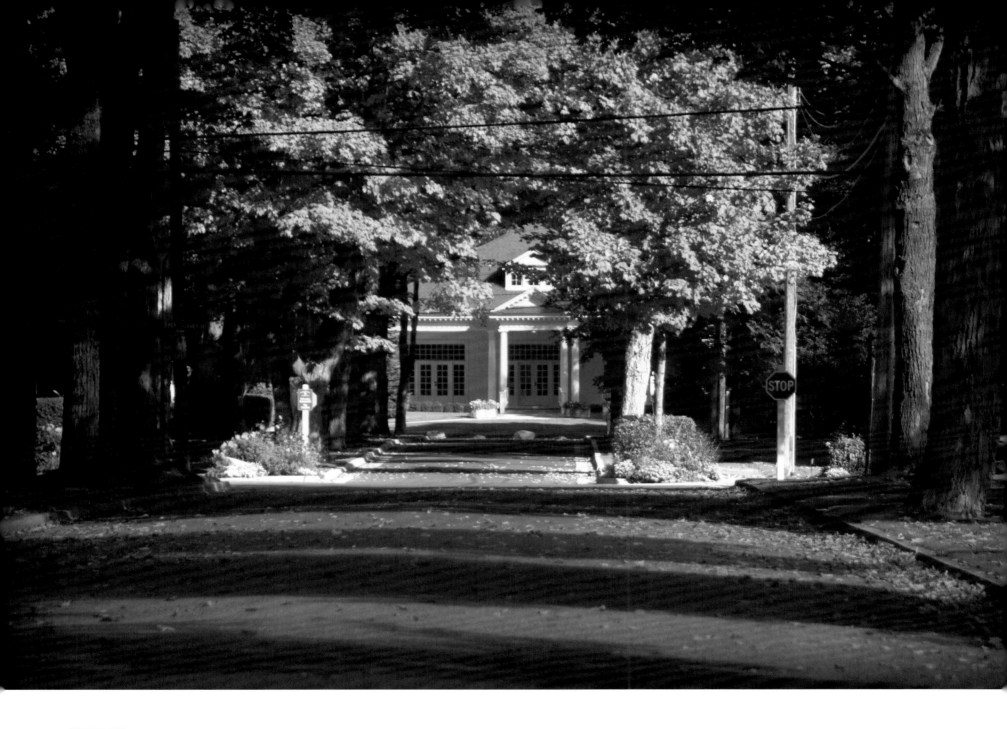

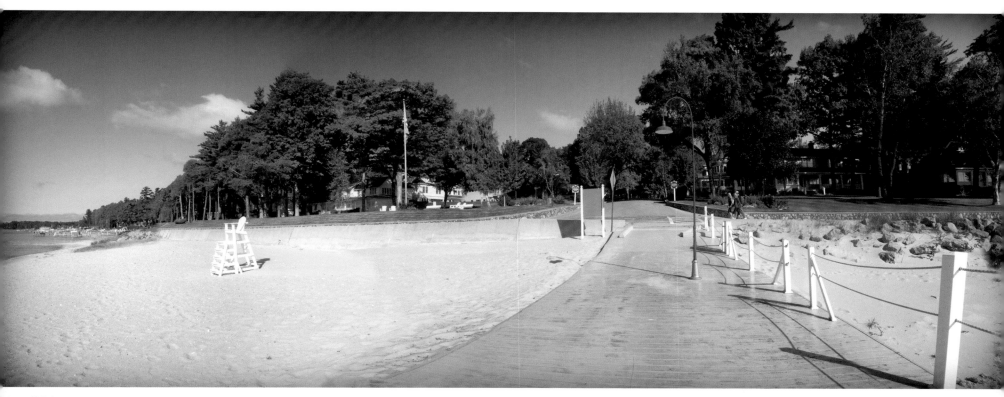

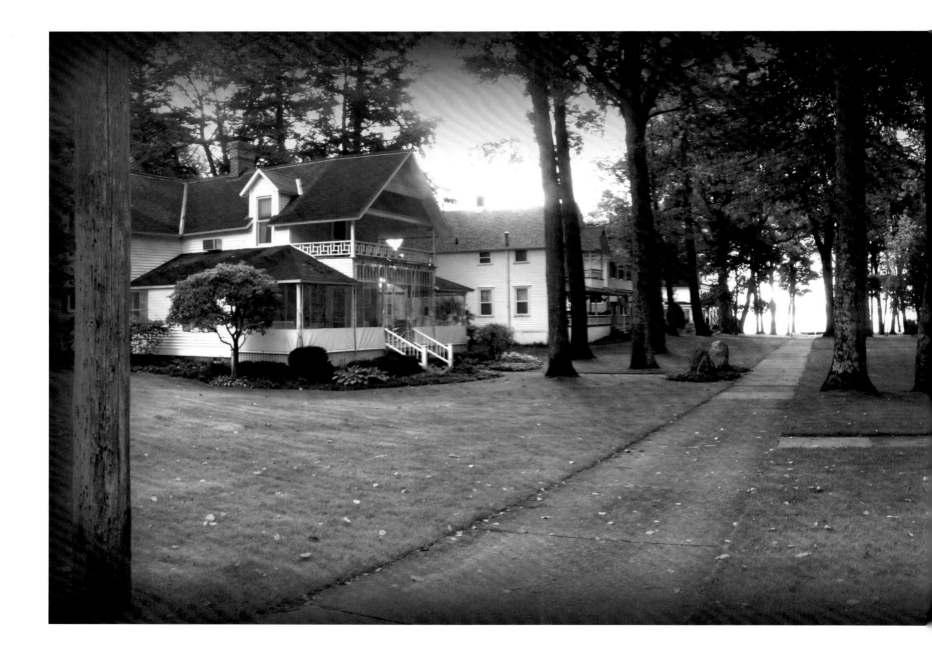

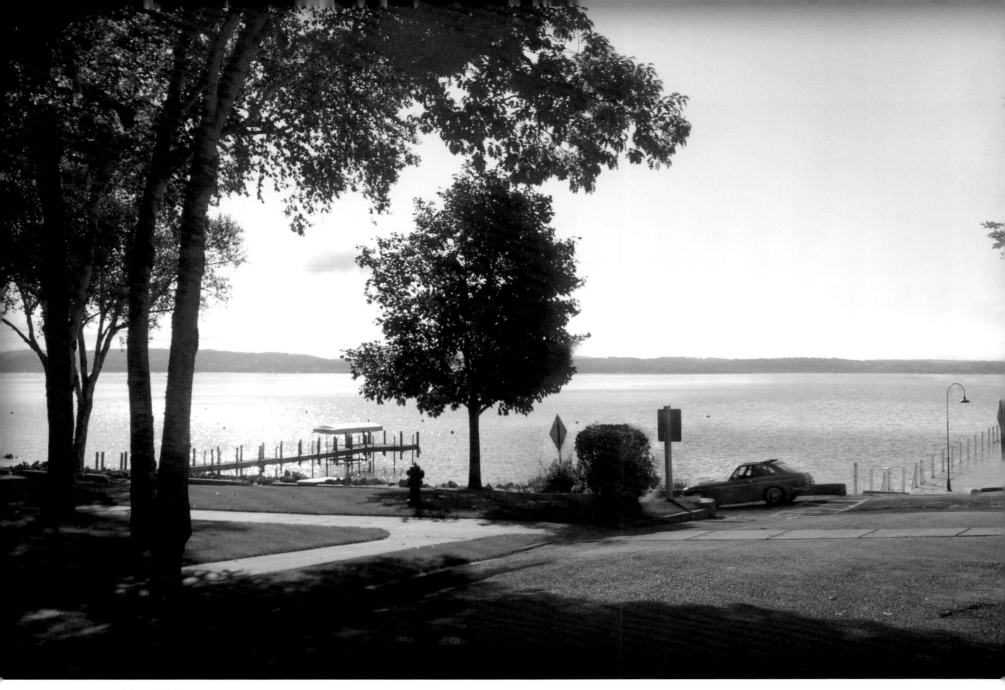

(Rebecca Zeiss)

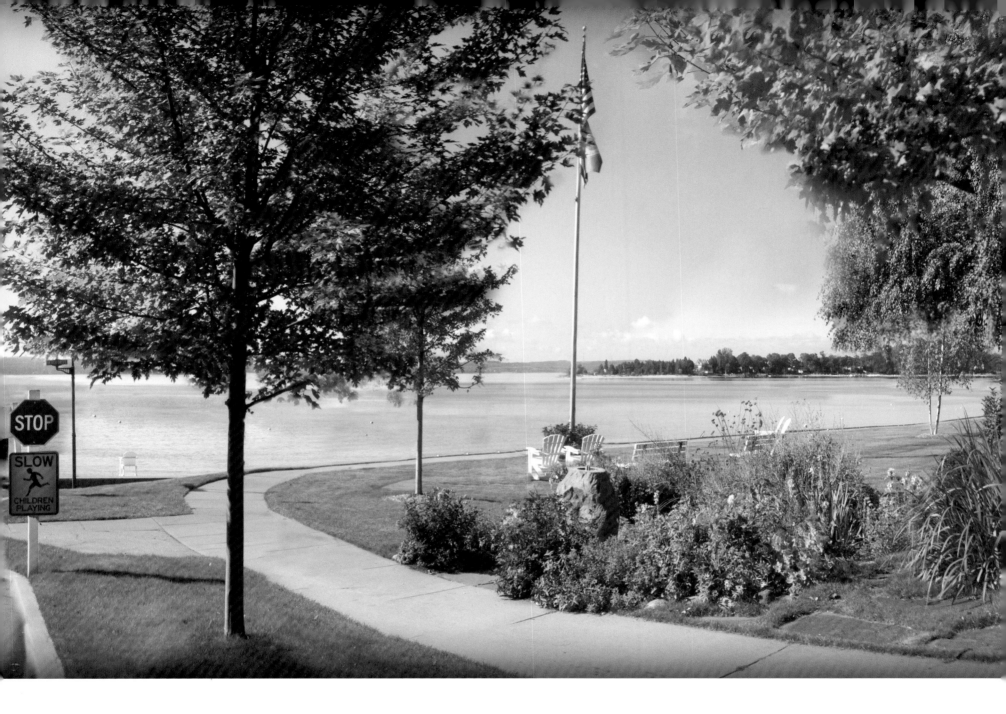

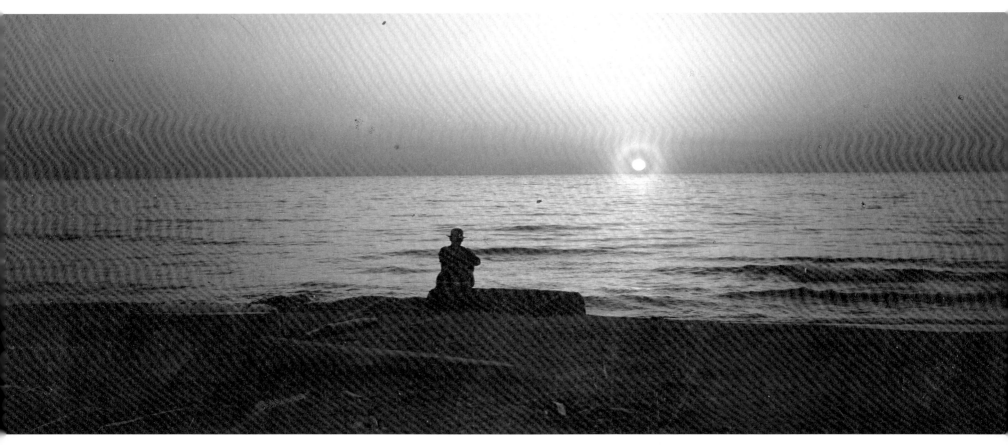

(Courtesy of Little Traverse Historical Society)

256

Conclusion

Those who happen to be on the waterfront at day's end invariably pause as the sun drops into Lake Michigan. It's something of a ritual at this place known for its million-dollar sunsets. For years and years people have done this, and they will continue to do so long after our current generations are gone. These sunsets and the rest of the Little Traverse region's undeniable natural beauty have and always will amaze and impress those who view them. Whether one enjoys this loveliness only briefly on a summer holiday or sees it year-round in all its seasonal glories, the water, hills, and sunsets will continue to bring pleasure.

Although the sunsets remain as they have always been, the same is not true of the bay communities. Over time the old has often made way for the new, but occasionally it has endured. These pages are testament to both the things that were and the things that are.

But the past is present not only in structures but also in lifestyles. While transportation, buildings, and towns may have undergone physical evolutions, the tourist economy that arrived with the railroads (and the ways of life it created) remains today. This is true for day visitors, who try to see and do everything they can in the short time they have; for summer residents, who return every year to friends, seasonal homes, and favorite meals and experiences; and for year-round inhabitants, whose time for relaxing and enjoyment of their region often happens outside of the frantic summer months. It's also true that although all these groups share the same physical space, unquestionably this region does not have "a story"—but rather multitudes of unique stories. To understand the present we need to know these past stories, accept them for what they are, and look forward to creating our own future ones.

Bibliography

Armstrong, Louis Oliver. *"Hiawatha" or "Nanabozho:" An Ojibway Indian Play; Descriptive Notes and Excerpts to Be Used as a Libretto for "Hiawatha" or "Nanabozho."* N.p., ca. 1901.

Baker, Emma Lamb. *Stories of Bay View: A Book of Reminiscences and Romances.* Detroit: Caxton, 1925.

Banwell, Yolanda. *Alanson, Our Town, 1882–1982.* Alanson, MI, 1982.

Bay View and Petoskey Souvenir. Grand Rapids, MI: Revival Band, 1898.

Bay View, the Summer City of Michigan. New York: Albertype, 1894.

Blackbird, Andrew J. *The Indian Problem, from the Indian's Standpoint.* N.p., 1900.

Browne, Arline M. *In the Wake of the* Topinabee: *Cherished Memories of Lakeside Cottagers.* Lancaster, CA, Hubbard Map Service, 1967.

Byron, M. Christine. *Vintage Views of the Charlevoix-Petoskey Region.* Ann Arbor: University of Michigan Press; Traverse City: Petoskey Publishing, ca. 2005.

Creecy, John. *A Century at Harbor Point, 1878–1978.* Grosse Point Farms, MI: Madrus, ca. 1978.

Directory of the City of Petoskey and the Adjacent Summer Resorts, Bay View, Wequetonsing and Harbor Point. Petoskey: Independent Democrat, 1899.

Doerr, Mary Jane. *Bay View: An American Idea.* Allegan Forest, MI: Priscilla, 2010.

Fennimore, Keith J. *The Heritage of Bay View, 1875–1975: A Centennial History.* Grand Rapids, MI: Eerdmans, 1975.

Fitzsimons, Candace Eaton. *A Look Around: Little Traverse Bay.* Petoskey: Little Traverse Historical Society, 2007.

Friday, Matthew J. *The Inland Water Route.* Charleston, SC: Arcadia, 2010.

Graham, Floy Irene. *Petoskey and Bay View in Ye Olden Days.* Petoskey: C. E. Garvin, 1938.

Grand Rapids and Indiana Railroad Company. *$4,000,000 First Mortgage Sinking Fund Seven Per Cent Bonds of the Grand Rapids and Indiana Railroad Co.* Pittsburgh: Grand Rapids and Indiana Railroad, 1870.

———. *A Guide to the Health, Pleasure and Fishing Resorts of Northern Michigan, Reached by the Grand Rapids & Indiana Railroad.* Grand Rapids, MI: Grand Rapids and Indiana Railroad Passenger Dept., 1879.

———. *A Guide to the Health, Pleasure, Game and Fishing Resorts of Northern Michigan.* Chicago: Jones Stationery and Printing, 1882.

———. *A Guide to the Health, Pleasure, Game and Fishing Resorts of Northern Michigan, Reached by the Grand Rapids and Indiana Railroad.* Grand Rapids, MI: Grand Rapids and Indiana Railroad Passenger Dept.; Chicago: Jones Stationery and Printing, 1881.

———. *A Happy Summer: Health and Happiness, Fin, Fur and Feather, Found in Northern Michigan by Travelers over the Grand Rapids & Indiana Railroad, the World Famous "Fishing Line."* Chicago: Grand Rapids and Indiana Railroad Passenger Dept., 1884.

———. *Mackinac, the Wonderful Isle, Petoskey, Traverse City and Other Northern Michigan Summer Resorts.* Grand Rapids, MI: Grand Rapids and Indiana Railroad; Chicago: Poole Bros., ca. 1891.

———. *Mackinac, the Wonderful Isle, Petoskey, Traverse City and Other Northern Michigan Summer Resorts.* Grand Rapids, MI: Grand Rapids and Indiana Railroad; Chicago: Poole Bros., ca. 1892.

———. *Michigan in Summer.* Grand Rapids, MI: Grand Rapids and Indiana Railroad, 1904.

———. *The Summer Resorts and Waters of Northern Michigan, Reached via Grand Rapids & Indiana R.R.* Chicago: Poole Bros., 1885.

———. *The Summer Resorts and Waters of Northern Michigan, Reached via Grand Rapids & Indiana R.R.* Chicago: Poole Bros., 1886.

Hall, John, and Marge May, eds. *Memories: Little Traverse Bay.* Petoskey: Little Traverse Historical Society, 1989.

Helper, John. "The Grand Rapids and Indiana Railroad." *Grand Rapids Press,* August 3, 1980.

Hilton, George. *Lake Michigan Passenger Steamers.* Stanford, CA: Stanford University Press, 2002.

Historical Sketch of the Village of Petoskey: Combined with a City Directory, for 1882. Petoskey: City Record Printing House, 1882.

In All the World, No Place Like This: Early Post Card Views of Harbor Springs. Harbor Springs: Harbor Springs Area Historical Society, 2005.

Independent Democrat: May 14, 1895. Reprint. Petoskey: Little Traverse Regional Historical Society, 1975.

Jarvis, Nancy, ed. *Historical Glimpses: Petoskey.* Petoskey: Little Traverse Historical Society, 1986.

Lake Superior Transportation Co. *Summer Sauntering on Northern Waters: The Steamship* Manitou *. . . Season of 1899.* Chicago: Lake Michigan and Lake Superior Transportation Co. Passenger Dept., 1899.

Little Traverse Bay: Petoskey, Bay View, We-que-ton-sing, Roaring Brook, Harbor Springs, Harbor Point. Battle Creek, MI: Headlight Engraving, 1897.

Longfellow, Henry Wadsworth. *The Indian Play "Hiawatha," in the Land of the Ojibways, Wa-ya-ga-mug.* Grand Rapids, MI: Grand Rapids and Indiana Railway General Passenger Dept., 1912.

McConnell, Henry. "Early Days in Petoskey." In *Michigan History.* January–April 1921, 211–16.

Morley, Jan, ed. *Harbor Springs: A Collection of Historical Essays.* Harbor Springs: Harbor Springs Historical Commission, 1981.

Myers, P. A, and J. W. Myers. *Plat Book of Emmet County, Michigan: Drawn from Actual Surveys and the County Records.* Minneapolis: Consolidated, 1902.

Petoskey and Little Traverse Bay. Petoskey: G. E. Sprang, 1895.

Petoskey: Queen City of the North. Petoskey: Petoskey Record, 1908.

Petoskey's Colorful Past: A Historical Sketch of the City. Petoskey: Little Traverse Bay Historic Festival Committee, 1983.

Polk's Petoskey City Directory 1919/20, Including Harbor Springs, Bay View, Harbor Point, Ramona Park, Roaring Brook and Wequetonsing: Also East Bay View. Detroit: R. L. Polk, 1919.

Schloff, Charles. *A Pictorial History of Bay View: Post Cards and Photographs of the Past.* Petoskey: Mitchell Graphics, 2000.

Souvenir of Petoskey and Bay View: Accompanied by a Short History and Points of Interest to Visitors. Detroit: Van Ness, 1895.

Souvenir of Petoskey and Bay View: Accompanied by a Short History and Points of Interest to Visitors. 2nd ed. Detroit: Van Ness, 1897.

Teal, Angeline. "Petoskey and 'The Gem of the Straits.'" *Continent,* January 10, 1883.

Wakefield, Lawrence, and Lucille Wakefield. *Sail and Rail: A Narrative History of Transportation in West Michigan.* Holt, MI: Thunder Bay, 1996.

Wheeler, Clark S. *Bay View: A History of the Bay View Association in Bay View, Michigan . . . from Its Organization in 1875 to Its Seventy Fifth Anniversary in 1950.* Bay View: Bay View Association of the Methodist Church, 1950?

Where to Spend the Summer: Michigan Resorts on Little Traverse Bay. Petoskey, ca. 1904.

Where to Spend the Summer: Michigan Resorts on Little Traverse Bay, Petoskey, Harbor Springs. Petoskey, ca. 1902.

Wright, J. C. *Stories of the Crooked Tree.* Harbor Springs, Lakeside, 1915.

Index

Note: Bold locators reference illustrations in the text.

100, **101, 126,** 204; steamships' role, 6, 12–13, 17–18, **19,** 26, **90,** 90–91, 202, 204, 209–10; Wequetonsing, 245–46
traditions: area activities, 20, **73, 104,** 136, **143,** 217, 257; families, 18, 215, 217, 246, 257
Traverse City, **36**
Treaty of 1855, 23
trolley transportation, 40–42, **44, 106**

US-31, 100, **102,** 130
USS *Hartford* (battleship), 173

veterans monuments, **75, 138–39,** 172–73
veterans parades, **143**
Victorian architecture: Bay View buildings, 217, **224–25, 226, 227, 233, 234, 235, 236, 237;** cottages, 217, **233, 234, 235, 236, 237**

Walloon Lake, 42, 181, 209
Washington, Booker T., 216–17

waterfalls, **104,** 181
waterfronts: Harbor Springs, **204, 205, 206–7, 208;** Petoskey, **28–29, 50–51, 66–67,** 80, **80, 84–85, 86, 87,** 87–88, **89, 98, 99, 102, 103,** 103–4, **106, 107, 108, 109;** boats, **86,** 86–97, **87, 90, 91, 92–93, 94, 96–97, 107;** limestone, **80,** 80–85, **81, 82, 83, 84–85;** midway, **100,** 100–102, **101, 102;** Wequetonsing, **248, 251, 254–55**
Wa-Ya-Ga-Mug, 14–15, **16**
Weikamp, Father, 238
Wequetonsing: bay ferry steamers, 210, **210, 211, 248;** cottages and homes, **245,** 246, **249, 250, 252, 253;** history, **245,** 245–46, **246, 247;** Inland Route access, 18, 195; map, **244;** photographs (modern), **250, 251, 252, 253, 254–55**
West Wequetonsing, 246
whitefish, 11
Women's Christian Temperance Union, **224, 227**
World War I commemoration, **138–39, 143**
World War I ships, **204**